EISENSTAEDT'S GUIDE TO PHOTOGRAPHY

EISENSTAEDT'S
GUIDE TO

A Studio Book ·

PHOTOGRAPHY

Alfred Eisenstaedt

The Viking Press · New York

Acknowledgments

My special thanks go to Christopher Holme, Gael Dillon,
and Bryan Holme for their design and editorial assistance.

Copyright © Alfred Eisenstaedt, 1978
All rights reserved
First published in 1978 by The Viking Press
625 Madison Avenue, New York, N.Y. 10022
Published simultaneously in Canada by
Penguin Books Canada Limited

Library of Congress Cataloging in Publication Data
Eisenstaedt, Alfred.
 Eisenstaedt's guide to photography.
 (A Studio book)
 1. Photography. I. Title. II. Title: Guide to
photography.
TR146.E37 770 78–9567
ISBN 0–670–29081–5

Printed in the United States of America
Set in Caledonia
Second printing 1979

CONTENTS

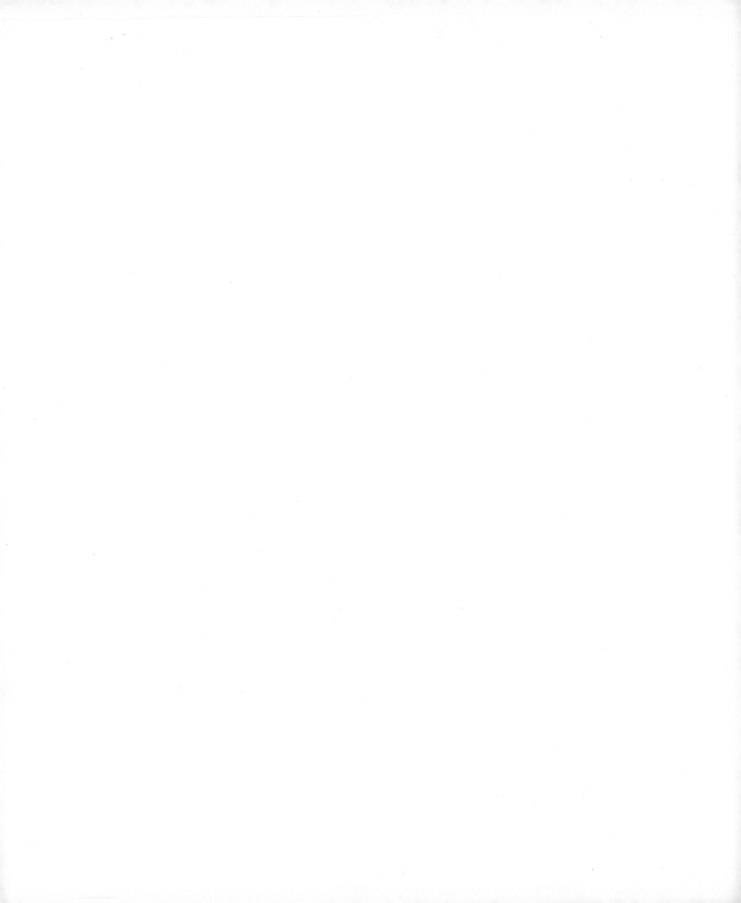

INTRODUCTION

Acquiring skill in any art or craft takes practice. Photography is no exception. After many years as a professional photographer, I find that one never stops learning. I still make mistakes, but by analyzing them I discover what went wrong and thus can, I hope, avoid repeating them in the future.

Good picture possibilities exist everywhere. Although many of my photos were taken on assignment, a lot of my favorite ones were taken for my own personal enjoyment.

Anything that makes you stop, look, and ponder for a second is probably a good picture possibility; anything that doesn't is not likely to be worth photographing. On the other hand, what doesn't particularly interest you may attract another photographer who has other ideas in mind. Everyone's point of view is a little different.

I suggest that whenever you see something interesting you should shoot immediately—get something on film, whether or not you have the right lens. Often there is little or no time to reflect, change lenses, or take a correct exposure reading. When there is time, so much the better, of course.

Usually I carry a 35-mm rangefinder camera with a wide-angle lens preloaded with either color or black-and-white film. For easier operation I dispense with a leather case and hold the camera in my hands. As soon as I arrive at a chosen place I take exposure-meter readings—for darker and lighter areas—before starting to take pictures, and I keep the shutter speed and aperture set accordingly. After taking a few pictures, it is a wise practice to double-check the exposure, then look for variations with the idea of improving on the previous shots.

Some people are under the misapprehension that having the most expensive camera and dozens of gadgets is a sure path to good photography. While good tools can help, good photographs can be taken with the simplest camera. It's the eye behind the camera that counts most.

In the chapters that follow, each of which might be considered a lesson in itself, my aim is to share some of my experiences as well as techniques with readers who I hope might become as interested in photography as I am.

7

EQUIPMENT

A famous saying of artists is "Keep it simple." This holds true for photography in general and for photographic equipment in particular.

The most important thing about a camera is that you feel comfortable with it. Loading the film and setting the controls should become second nature; only when you are completely confident with such mechanics can your mind be free to concentrate fully on the subject.

Selecting a camera is a very personal thing. It is impossible to advise anyone as to which brand of camera he should choose, because there are so many good makes. Furthermore, new models are coming out all the time. A good dealer with salesmen interested in photography, not just in selling, can help you make a decision. The best thing to do is to look at the various cameras, pick them up, feel them in your hands, handle the controls, and decide which one feels the most comfortable to you personally. Before you buy the camera, make sure that you can exchange it if it proves to be unsatisfactory. Any reputable dealer will allow you to do this within a week or two of the purchase. If your dealer won't—do not buy from him, find one who will.

For general purposes I would recommend a 35-mm camera with a 35-mm lens. Though a 50-mm lens is generally considered "normal" for a 35-mm camera, I find the 35-mm lens best suited for the majority of pictures that I take. Its wider angle of coverage is especially useful when shooting people in a confined area.

There is virtually no situation that a 35-mm camera is incapable of handling; further advantages, of course, are its small size and light weight, which make it an easy instrument to use and a convenient one to carry.

There are two basic types of the 35-mm camera: the rangefinder and the single-lens reflex (SLR). I prefer rangefinder cameras, such as the Leica, because they are more compact and quieter than the SLRs. A rangefinder is also easier to focus in dim light, especially when a wide-angle lens is used. Today the more popular of the two happens to be the single-lens reflex camera, which allows you to frame and

8

focus directly through the picture-taking lens. This is essential for taking extreme close-up pictures. The SLR is also better suited for use with the longer telephoto lenses.

A vast array of lenses are available for 35-mm cameras. As already stated, my first choice is the 35-mm lens, and my second would be a 90- or 105-mm lens, either of which is ideal for portraits and for other situations where you cannot get close enough to your subject. Next on my list would be a 50-mm lens. With these four lenses you should be able to handle about 90 percent of all picture-taking situations.

I do carry a camera bag with me, but it is a small one. On extended trips I usually take a tripod in case I should find myself in a dim-light situation requiring a long exposure time. Some people can hold a camera more steadily than others. When using a slow shutter speed, such as 1/30th of a second or less, you can sometimes minimize camera movement by steadying your hand on or against a wall, chair, or any other firm object.

A rangefinder camera (Leica) with 28-mm, 35-mm, 50-mm, and 90-mm lenses, a yellow filter, skylight filter, lens shade, and polarizing filter; and a single-lens reflex camera (Nikon) with 28-mm, 55-mm macro, 105-mm, and 80–200 zoom lenses, a yellow filter, polarizing filter, and Luna Pro and Spectra light meters.

COMPOSITION

Composition is the way an object is placed in relation to the background, or the way a group of objects are arranged in relation to one another and the background. In a good composition the elements of the picture are positioned to give the picture as a whole a unified effect.

Nature arranges things in its own way, and the trick of a photographer is to compose his pictures carefully out of nature's arrangements. Often one or more objects are moving in relation to the background. Birds might be flying across a landscape or horses galloping around a race track. In situations of this kind I take several pictures in quick succession, then choose the best one after the film has been developed.

Above all, patience is required. You can't arrive at a place, quickly snap a picture, and go home expecting it to be a great shot (although this does happen sometimes). If there's time, good results are usually obtained after thoroughly studying the locale, getting into the mood of it, and finding the best angles from which the most interesting elements of a scene could be photographed. Furthermore, when photographing something specific like the facade of a historic building, it is helpful to know the time of day when the light is at its best and when the shadows might add rather than detract from the particular effect you are after.

When photographing fast-moving subjects or candid portraits, you seldom have time for careful composition. Under these circumstances a picture can often be improved by cropping in the final print. Ideally, however, the picture should be carefully composed in the camera at the time of shooting, especially when taking color slides.

There are no rules for composition except good judgment and taste. The more one photographs, the more one becomes aware of balancing light areas with dark ones, large objects with small. I found that studying the work of great painters was most helpful in training me to be aware of good composition. Also, the more one reviews one's own work, the more one comes to recognize which pictures are dramatic, which are flat, and what makes them so. There is no real substitute for experience—in other words, learning by trial and error.

There is little time to concentrate on composition when you want to photograph people on the go or fast-moving objects. At other times you may find that you have hours to spend studying your subject from all angles. This ornate bench near the Thames in London caught my eye, and I spent twenty minutes studying it before I finally took this picture, which is made all the more interesting by the arrangement of the trees and the Houses of Parliament in the background. I used a Nikon with a 35-mm lens.

10

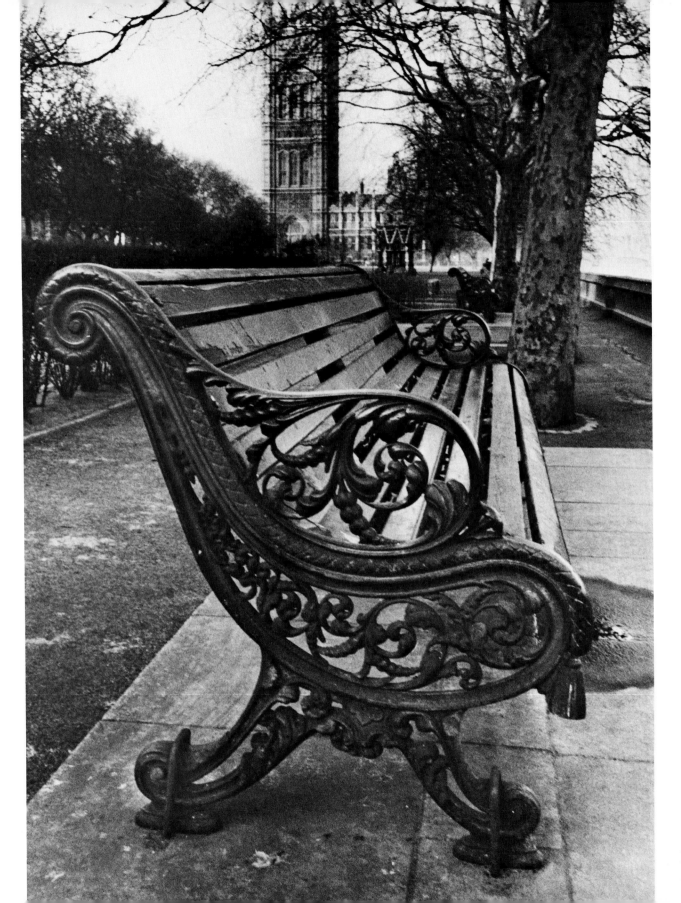

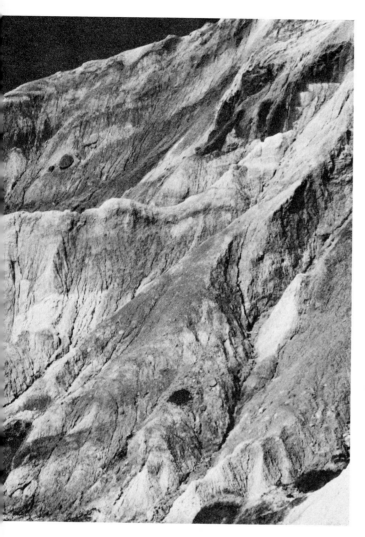

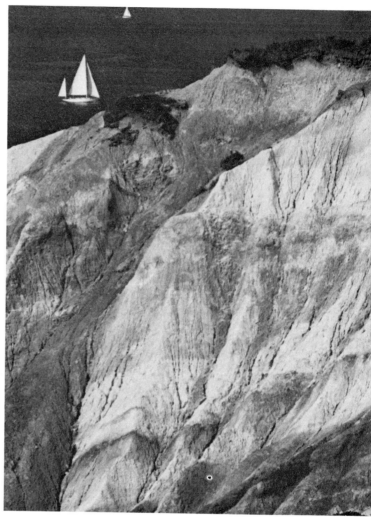

I took these pictures on a lovely August day. When I first arrived I intended to photograph only the cliffs, but when I spotted the two sailboats out near the horizon, I saw that the inclusion of at least one of them would make a better picture. I waited and waited, hoping that the prettier of the two sailboats would oblige. In the end both did. As a lesson in composition, these pictures show three variations: (a) the cliffs alone; (b) the cliffs with the two boats; and (c) the cliffs with one boat. Actually, (c) is the same picture as (b), but the second boat has been cropped from the top of the photograph. To me this is by far the best version. The second boat, instead of adding to the picture, draws the eye to the edge of the picture. Without that distraction, the cliffs become more prominent, which was my intention. For these photographs I used a Leicaflex set on a tripod, a 400-mm lens, and a yellow filter.

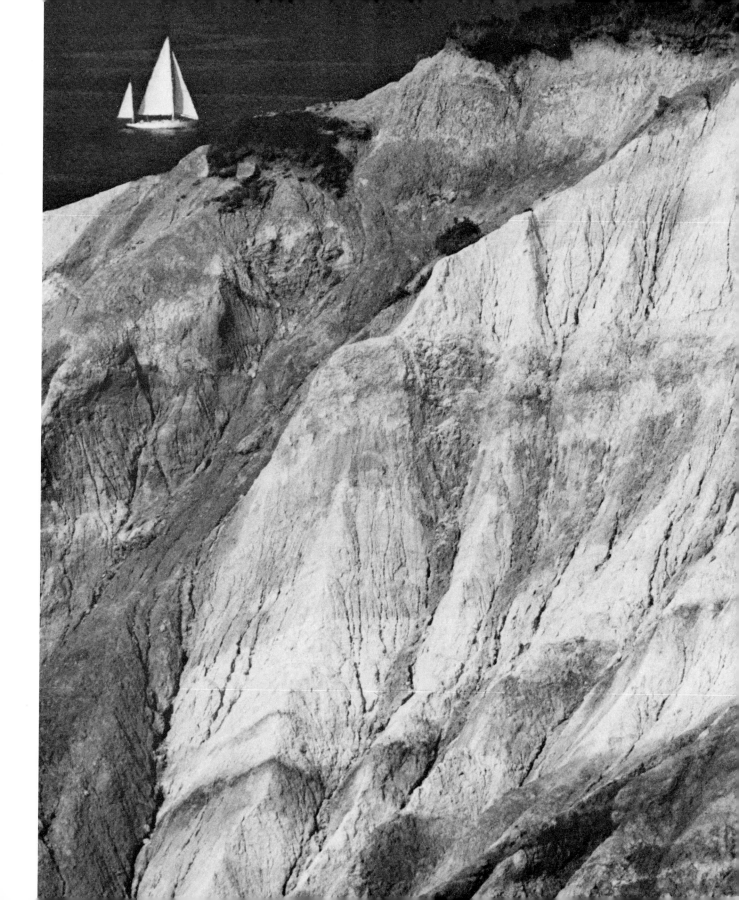

Both pictures were taken with a Leica and a 35-mm lens from an almost identical point in the room where Beethoven was born in Bonn, Germany. The room was closed to visitors, and photographs had to be taken from behind a rope barrier. In the horizontal picture, the sun is hitting the floor with full force. In the vertical, taken about twenty minutes earlier, the light was a bit weaker. From the point of view of both composition and lighting, I prefer the vertical version.

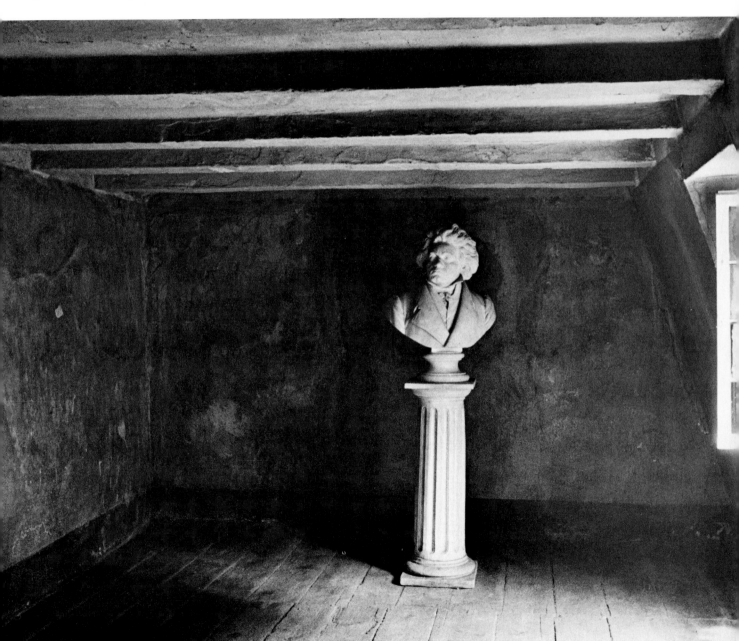

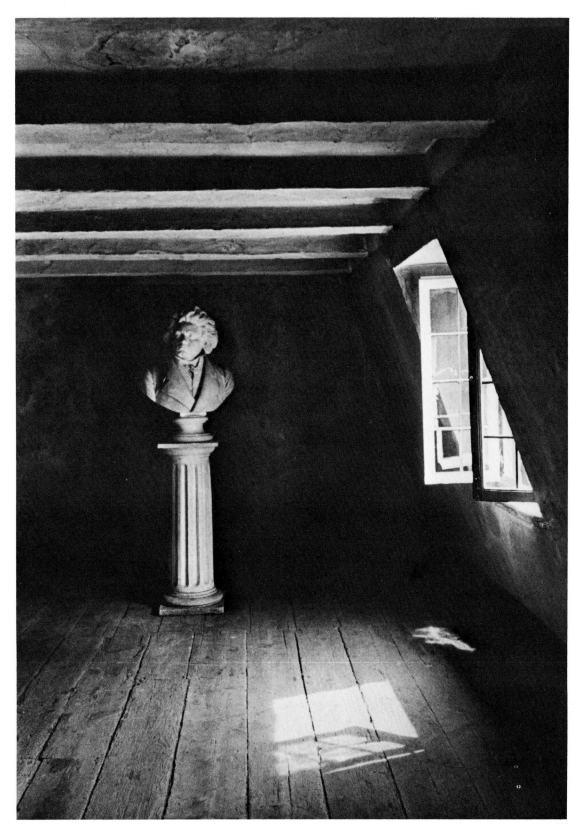

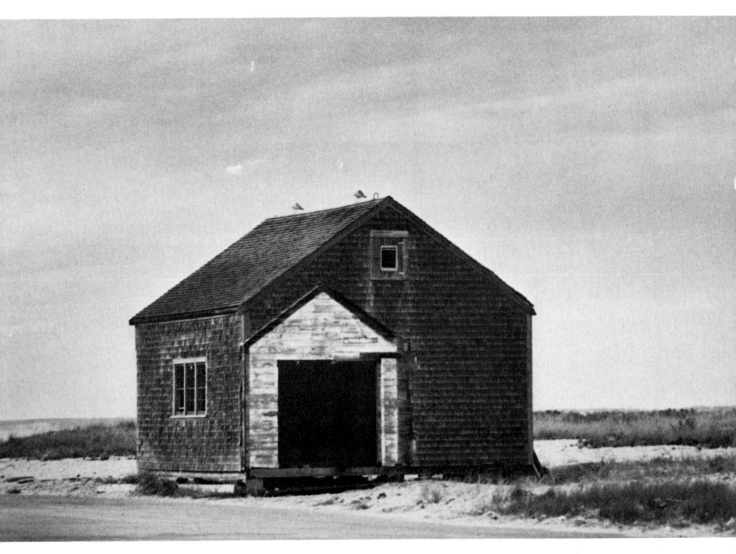

These two photographs of an abandoned barn were taken from different distances with a 35-mm lens. To me a picture looks static when the subject is at dead center. In the scene above, the barn is left of center; in the picture opposite, a portion of the barn is photographed so that everything—lines, color, and texture—is balanced asymmetrically. A lot can be learned about composition by cutting two

L-shaped pieces of paper and arranging them like a frame that can be moved in any direction along a photograph until you see what portion composes itself best.

OVERLEAF: *During an assignment for Life magazine on "Fall Comes to Shenandoah Valley," I came across this open barn door with a white-feathered predatory bird nailed to it. Inside*

the barn a flat wagon was heaped with golden corn. Not only did the scene compose itself well, but it symbolized perfectly the approaching autumn season. To my mind it is the bird which brings the composition together and makes the picture interesting. If you cover the bird with your hand, you will get an idea of what the picture would be like without it.

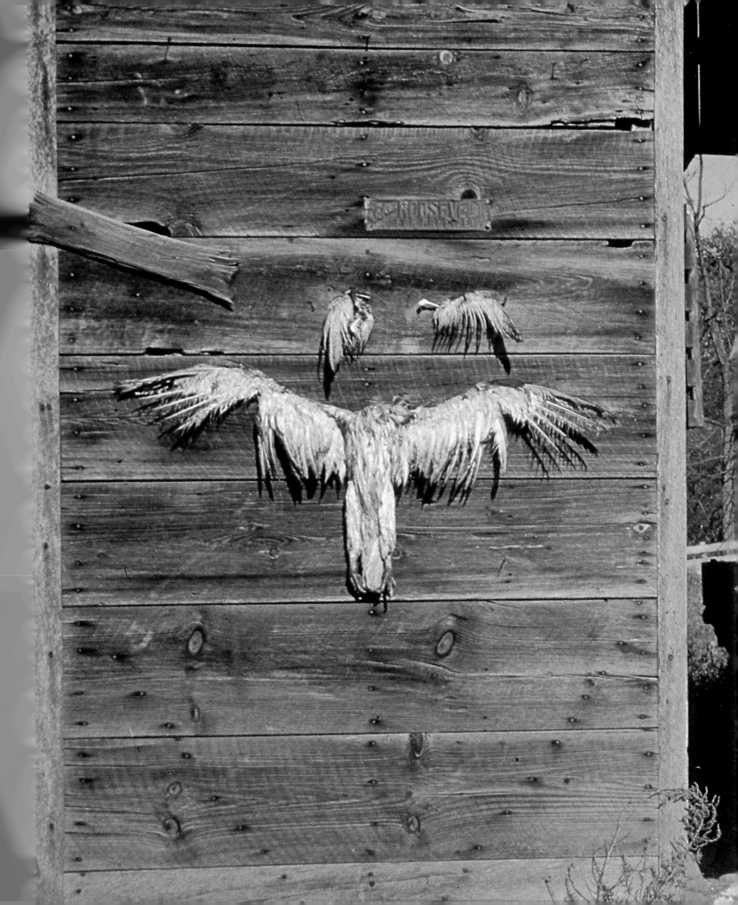

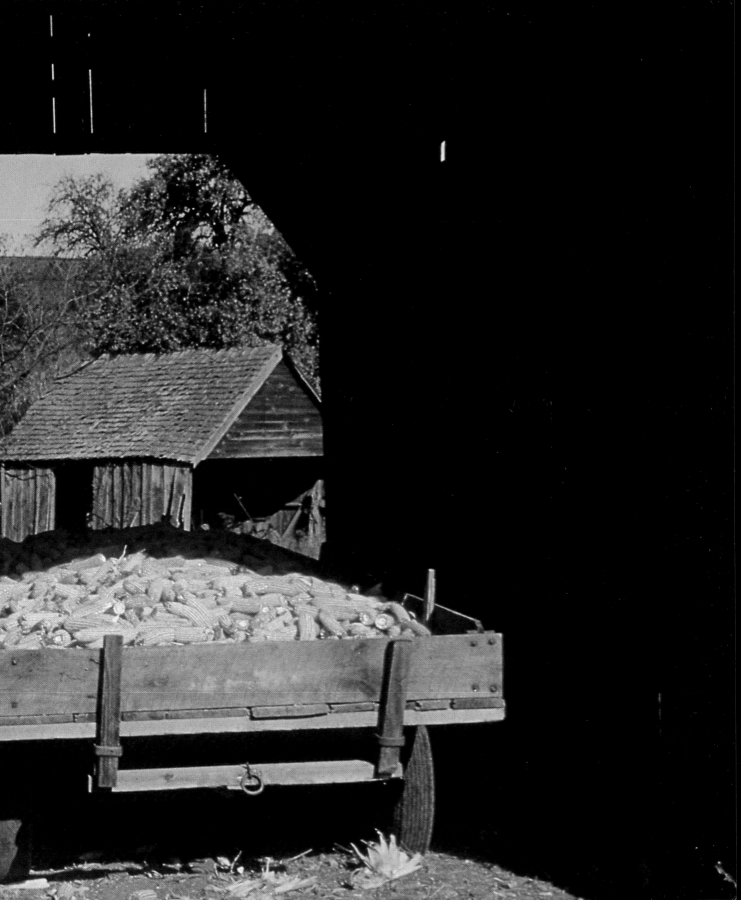

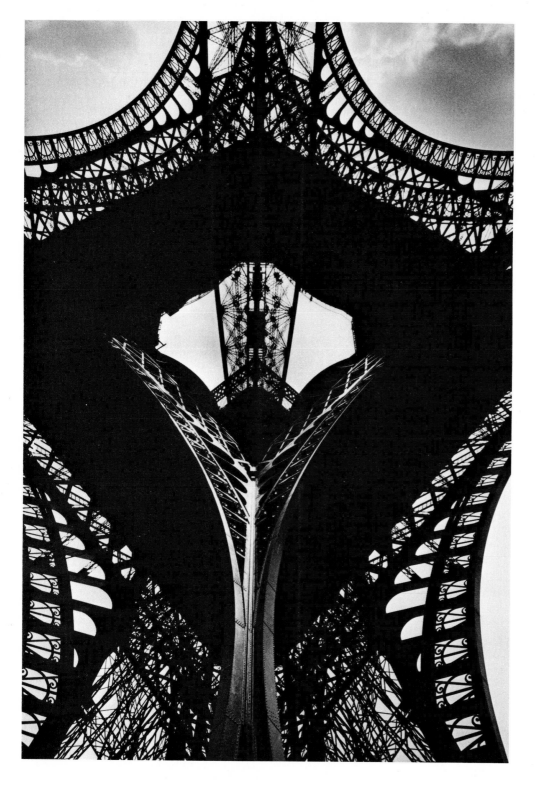

The view of the Eiffel Tower is a case of attempting to photograph a familiar landmark from an unfamiliar point of view and with composition, as always, uppermost in mind. I carefully positioned myself directly under the center of the spire and used a 21-mm wide-angle lens to create the exaggerated perspective. I also photographed the same view in color, but the black-and-white print, as often happens, turned out to be a more powerful statement.

One morning in Paris I came upon this scene and was pleased by the way the two flights of steps composed themselves. At first the street was deserted, and, after studying the scene for a minute or two, I decided that the picture needed one or two pedestrians in it. I had to wait almost an hour before I got approximately what I had in mind. It is the relationship of the woman ascending the steps to the one walking forward that gives the composition the strength that I wanted, and human interest besides. I still have to remind myself that you cannot force a good picture to happen, you have to wait for it. Here I was using a single-reflex camera with a 35-mm lens.

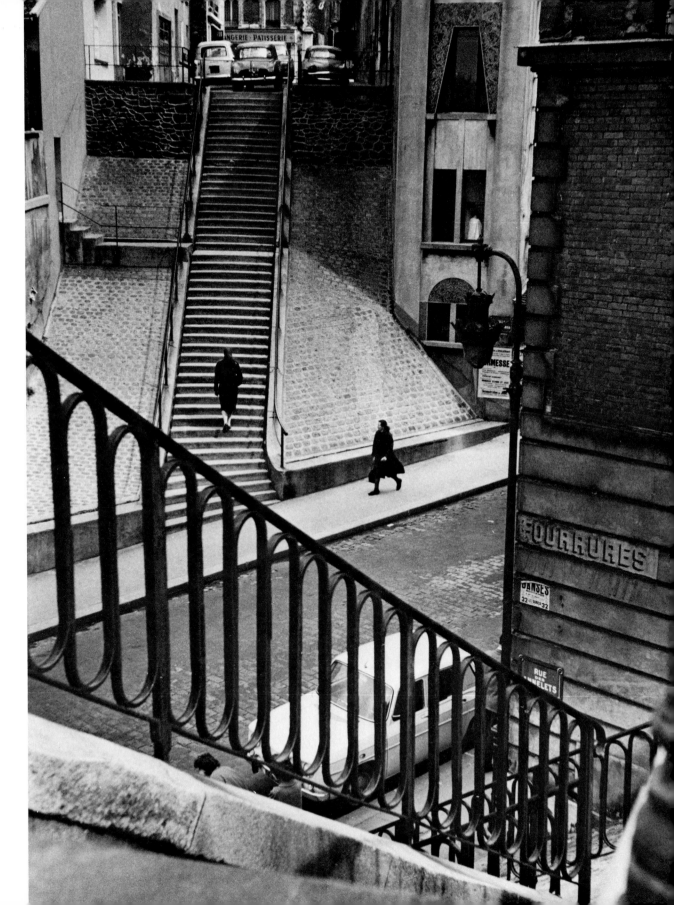

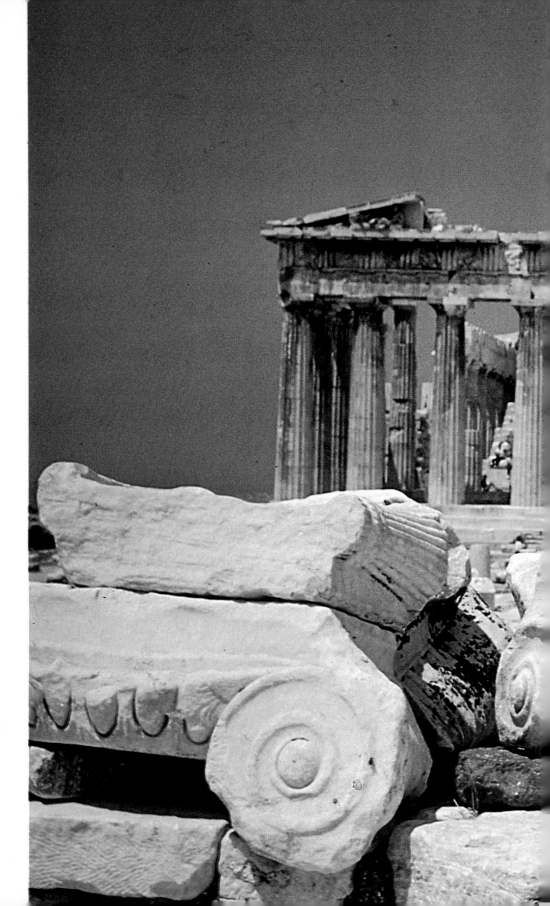

When photographing a famous site, such as the Parthenon, one must take adequate time in searching out new viewpoints while paying the utmost attention to composition at the same time. Millions of pictures of the Parthenon are taken annually, but when I climbed down among a group of scattered relics, moved my camera this way and that, and saw this picture composing itself, I was delighted to see how different it was from the usual picture-postcard view. The objects in the foreground lend drama to the whole scene. Moving the camera a fraction of an inch can make an enormous difference in the effectiveness of any picture.

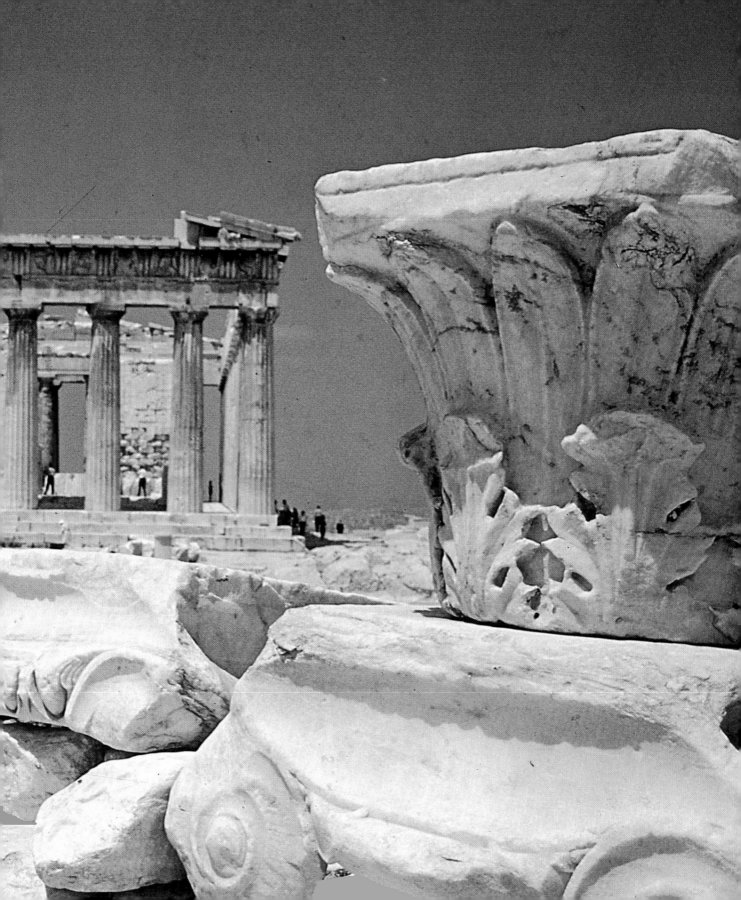

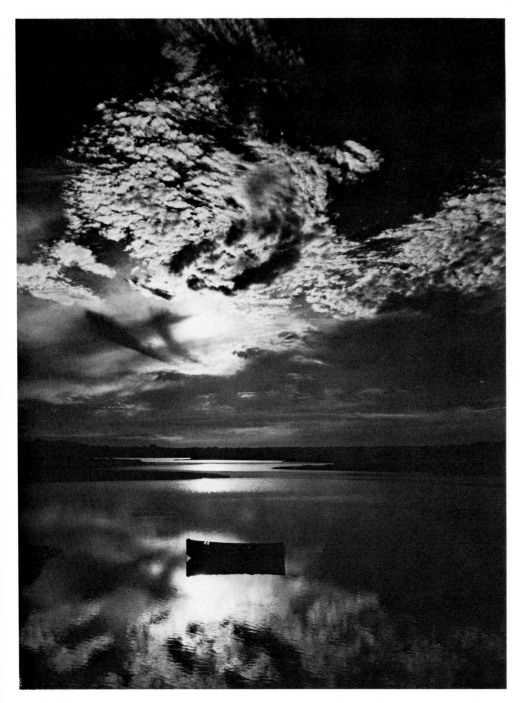

The cloud formation with its dramatic lighting attracted my attention to this scene. Seeing the small boat in the foreground, I decided to include it in the frame for additional visual interest. I used an orange filter to darken the blue sky and water and, in order to emphasize the clouds even more, I underexposed the shot.

I have always loved this picture of a spent wave on a lonely beach. During many a summer vacation since, I have tried to repeat this photograph but have never managed to do better and probably never will. It always seems so extraordinary that every wave and every sunset is just a little different.

The wave and foam pattern on the pure moist sand and the white dunes in the background give this picture grandeur and beauty. Before taking it, I had to make sure that there were no distracting footprints or broken shells in sight. A yellow filter was used with my Leica (and 35-mm lens) to darken the sky and enhance the contrast of the white foam. Without strong sunlight and a deep blue sky this picture would not have been possible.

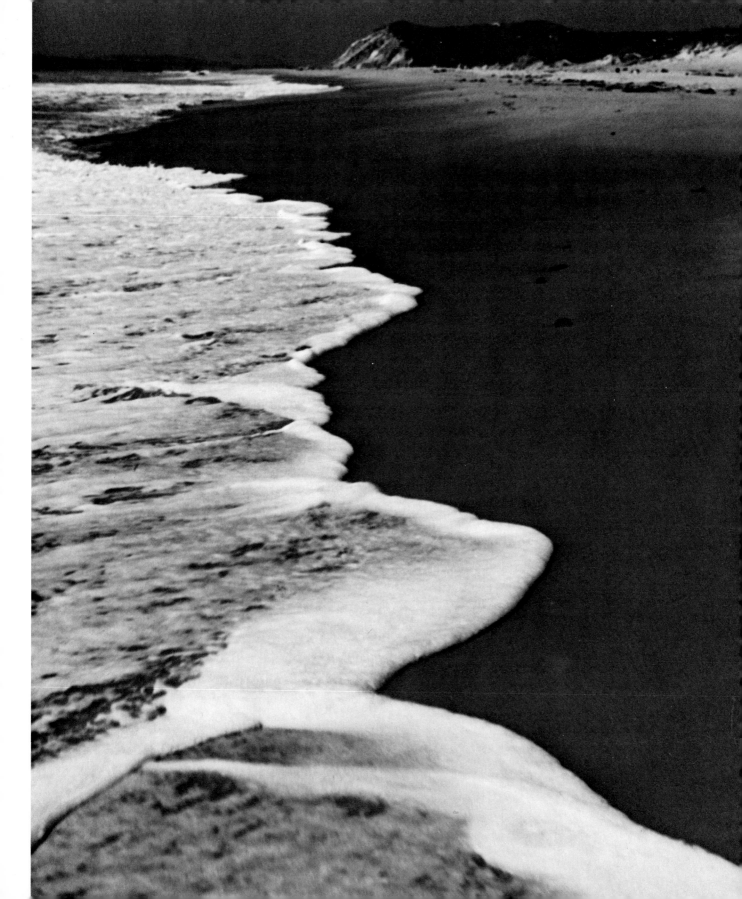

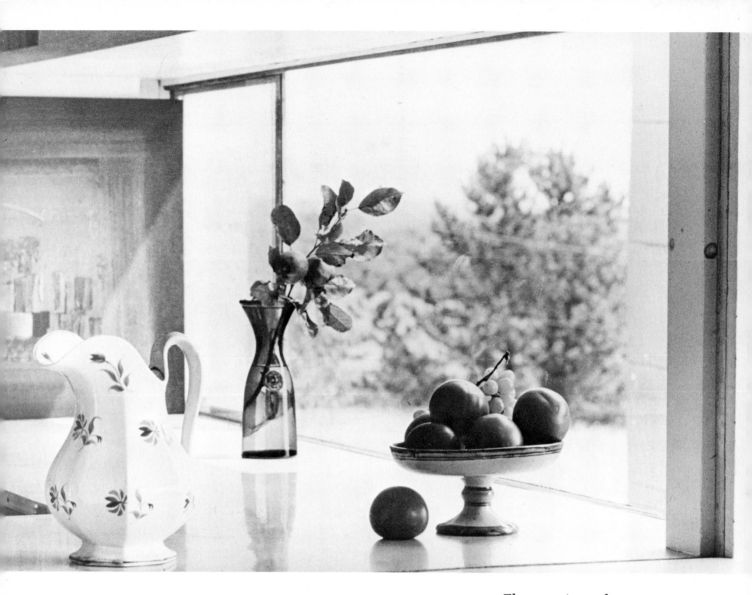

There are times when a rearrangement of objects is required to produce a desired result. While photographing the interior of a house I was attracted by the picturesque window setting shown above. Particularly liking the carafe, I moved it, making it the dominant element, with the oranges providing the necessary balance to the overall composition (opposite). The lens was focused on the carafe while the oranges were intentionally blurred by the use of a large aperture.

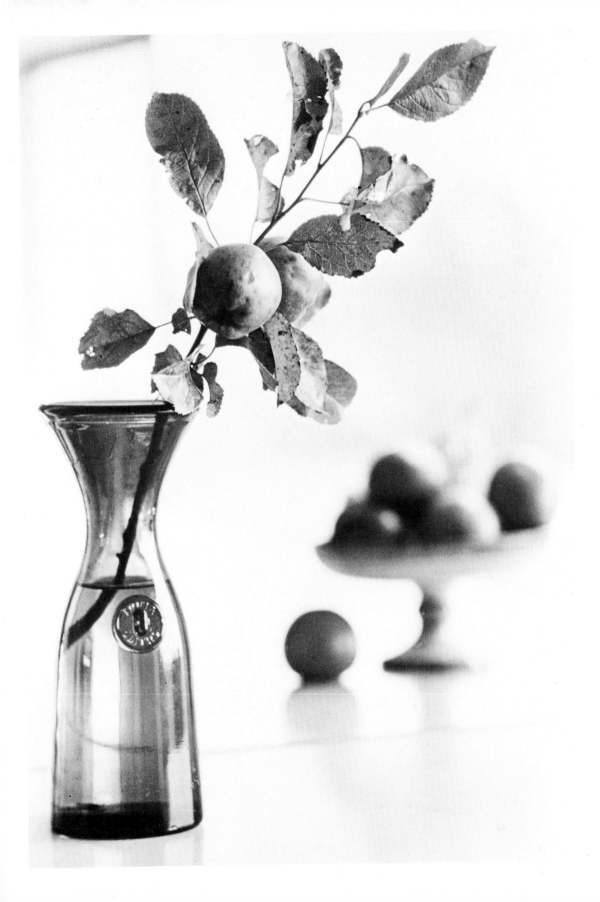

LANDSCAPES

I believe that there are few photographers in the world who don't like to photograph landscapes. Many beginners, and nature lovers especially, start out by thinking of little else but recording the wonders of unspoiled scenery.

Getting a really good photograph of any subject is never as simple as it would seem by looking at the final picture. Merely finding an interesting landscape, pointing your camera, and shooting isn't enough. The result will nearly always be disappointing. One way or another, you must find a way of emphasizing the particular feature that made you want to take the picture in the first place. It may be a dramatic cloud formation, unusual colors, shadow patterns, or possibly a feeling of height or of space. Emphasizing a specific aspect of the scene is likely to increase your percentage of successful photographs. The way different photographers do this sometimes becomes their hallmark.

I find both the 35- and 28-mm lenses very well suited for landscape photography. I occasionally use a polarizing filter either to eliminate unwanted reflections or, for instance, to darken a blue sky and thereby emphasize cloud formations.

A photograph of the same scene taken at different times of day, not to mention times of year, will produce quite different results. As a rule, I try to avoid photographing at midday because then the lighting is at its flattest. When you are traveling and time is limited, you have to take things as you find them, but if I am given a choice, my preference lies in the early morning or late afternoon, when the sun casts longer shadows and a warm glow permeates the entire scene.

For this picture I wanted to include people so that the huge Yellowstone Falls would be seen with a proper sense of scale. Luckily I found a brave honeymoon couple who were willing to pose close to the sheer drop. Without them the picture (made with a Rolleiflex 2¼ × 2¼ camera and a yellow filter) would have been much less interesting.

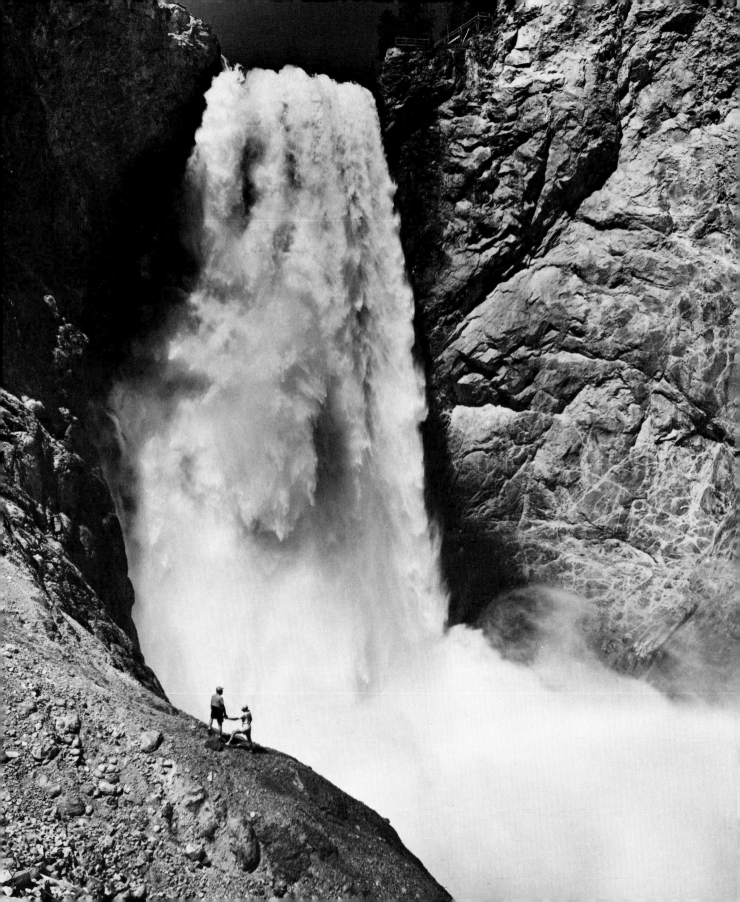

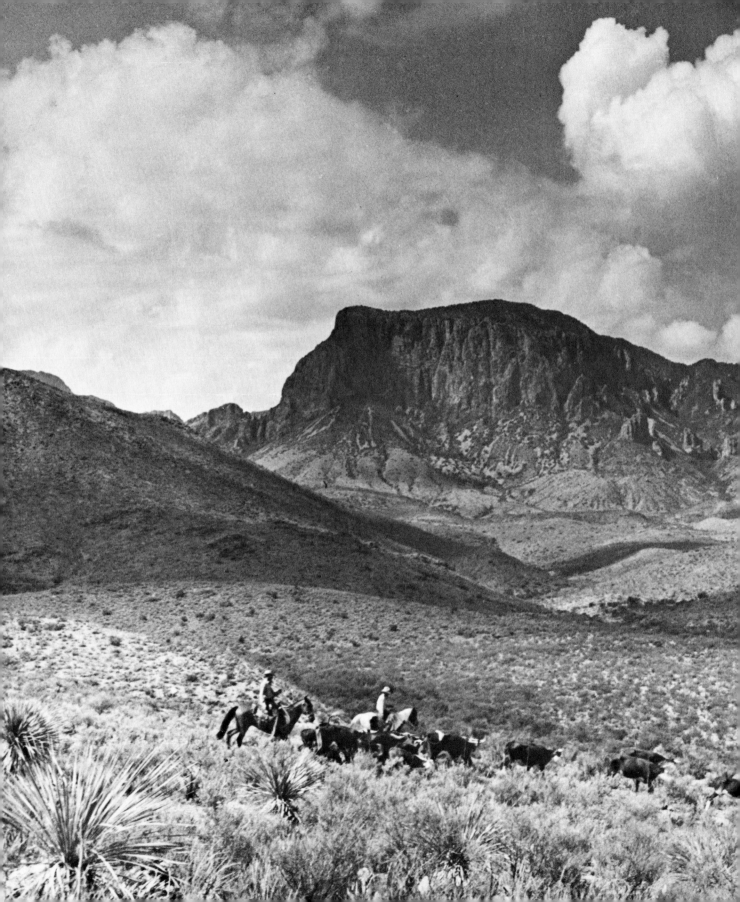

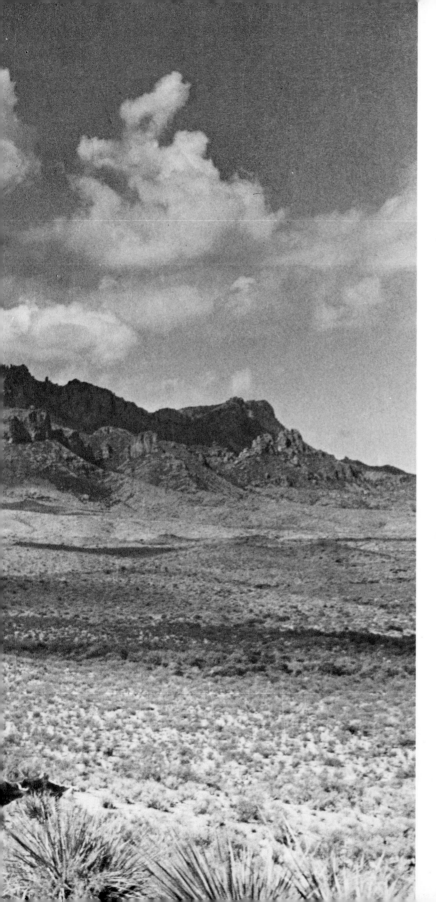

These photographs were taken in the Big Bend country near the Rio Grande in southern Texas with a Rolleiflex camera. The figures in the picture at left not only emphasize the vast space but also add visual interest to the foreground. The two photographs above give an idea of the effect that the presence or absence of a person can have on the whole scene. A yellow filter was used for all three photographs to darken the sky, thus emphasizing the clouds.

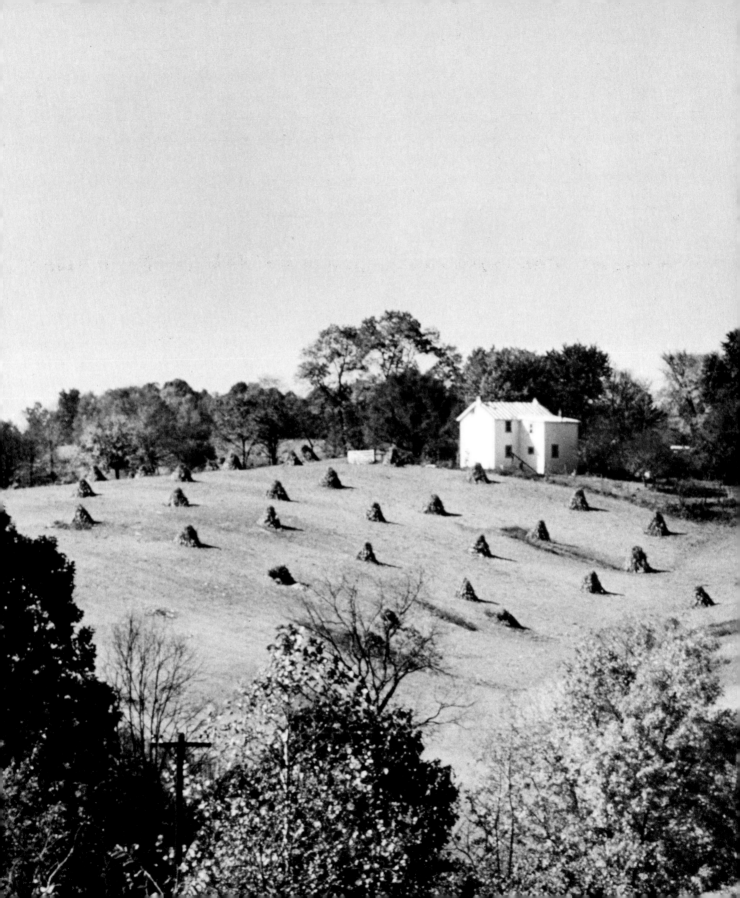

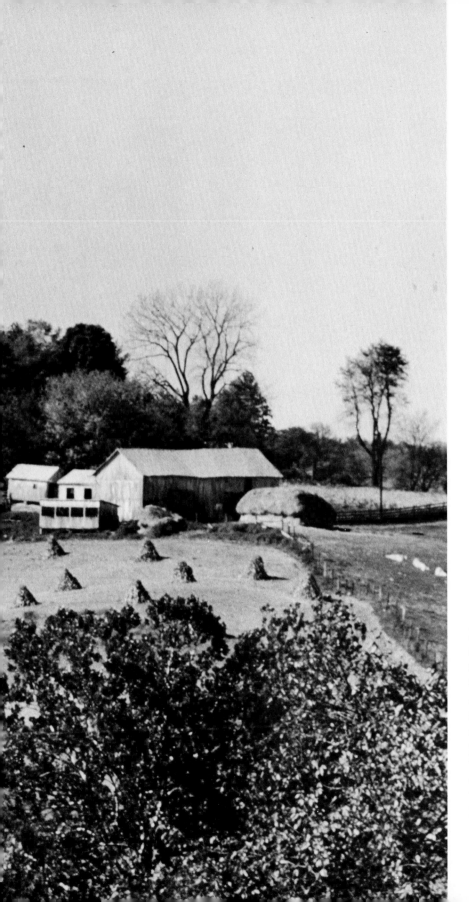

Everyone has his own particular taste about what he wants to photograph and how he goes about photographing it. While driving over the Blue Ridge Mountains in Virginia one autumn afternoon I came upon this pastoral scene and saw that it had picture possibilities. What particularly interested me were the regularly spaced haystacks, accentuated by their shadows, and the typical old-fashioned farm. I photographed it in color, but this black-and-white conversion is just as effective.

33

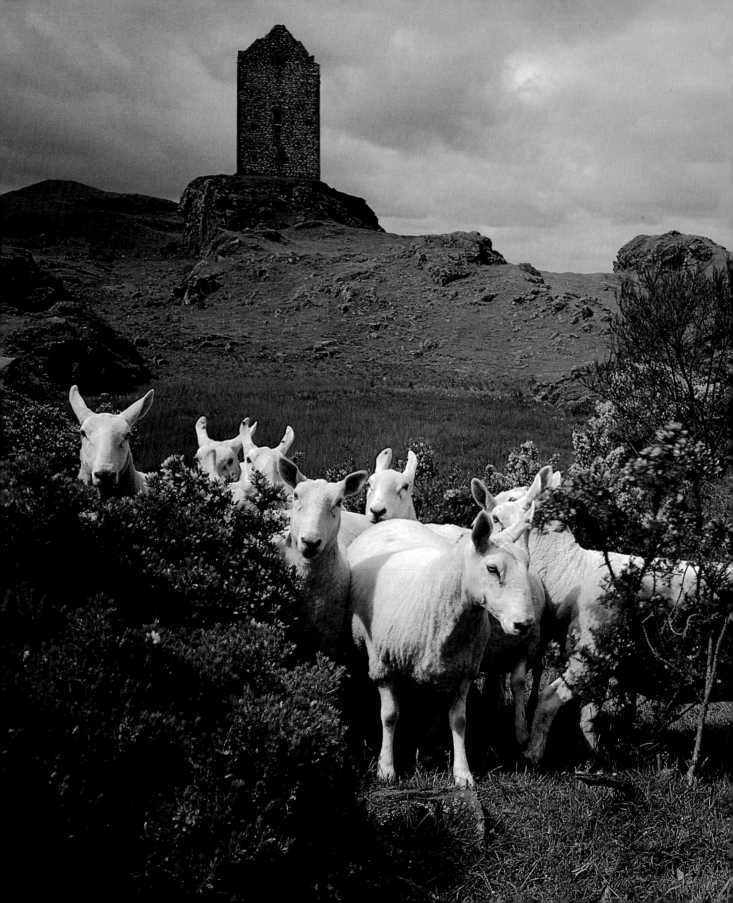

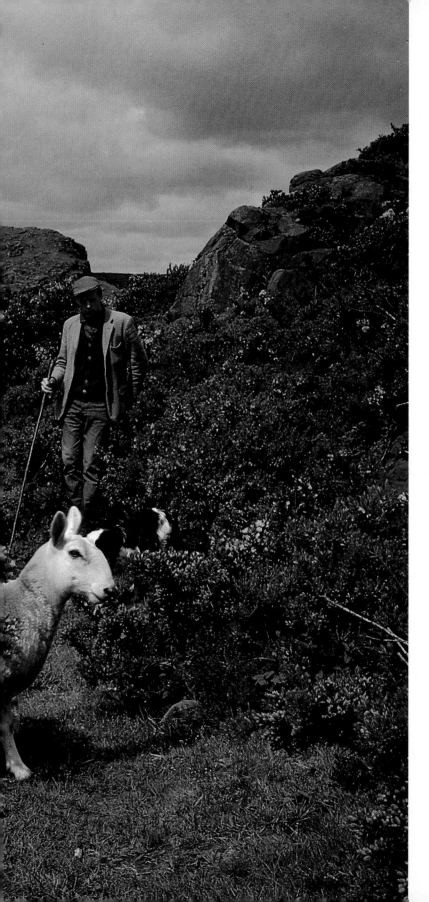

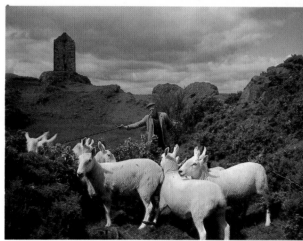

At left is Smailholm Tower, which Sir Walter Scott wrote about in his stories. I arrived at this spot in Scotland around nine o'clock one June morning under a cloudy sky. It was so evenly overcast that there was nothing I could do to create an interesting picture. So I waited. Fortunately a break occurred in the cloud cover, allowing sunlight to add sparkle to the scene. Though most photographers pray for good weather, in this case the effect would have been less dramatic if the sky had been clear blue and cloudless. The two pictures above were taken at the same time. I used a Nikon with a 35-mm lens for all three photographs.

I often walk along the beach looking for things to photograph, and on this occasion the large billowing clouds caught my fancy. A 28-mm lens on my Nikon covered a wide view of the scene. Either a yellow or a polarizing filter would have darkened the sky enough to make the clouds stand out, but I wanted more emphasis on the clouds, so I used both these filters over the lens.

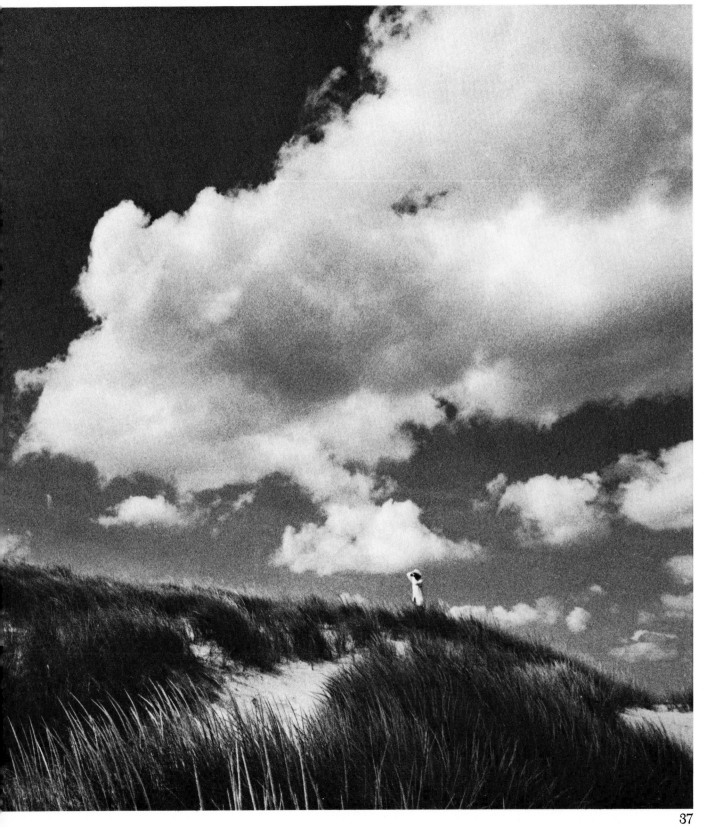

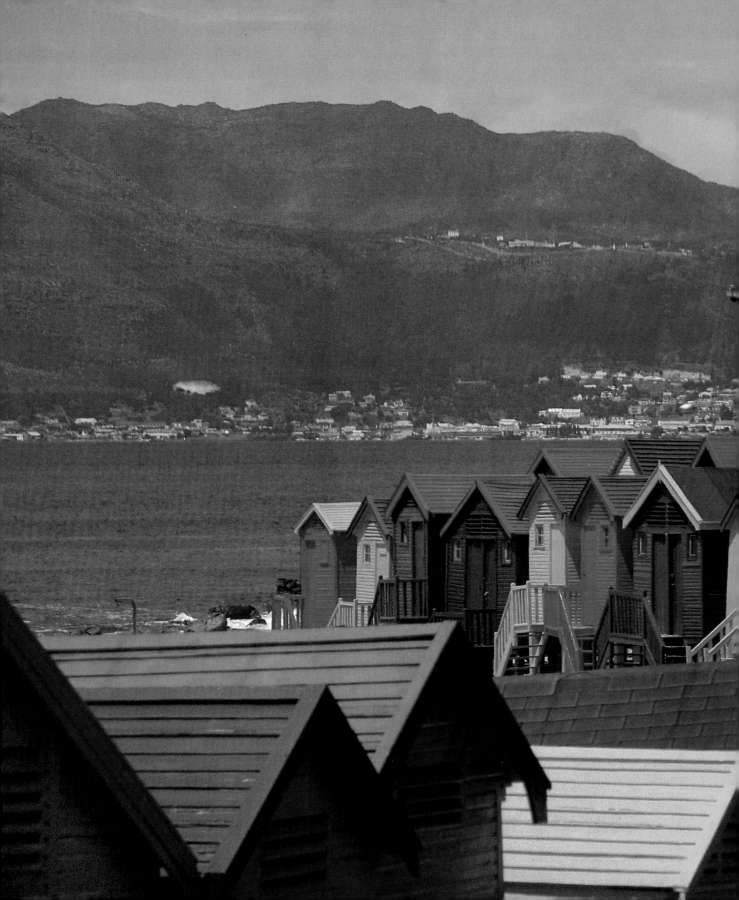

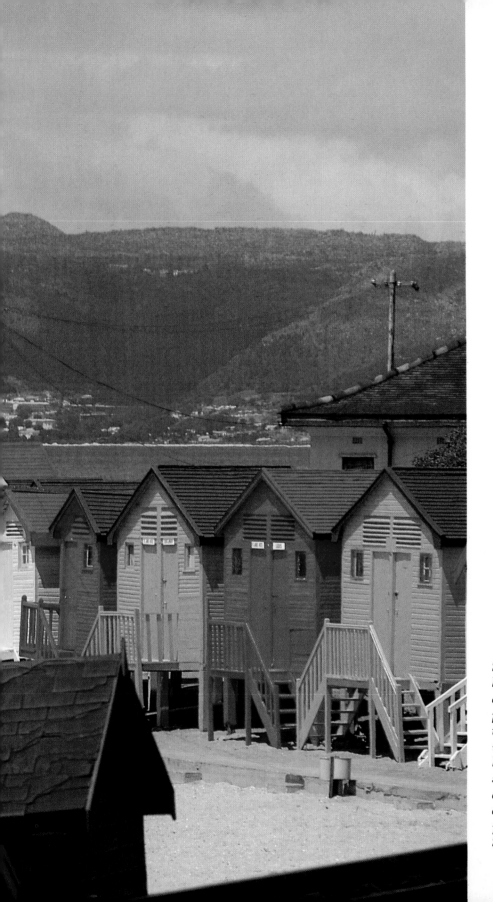

Some scenes like this view of beach houses in St. James, South Africa, are much more dramatic when photographed in color. While the texture of the clapboard siding would have been emphasized in black and white, it was the bright splashes of color that attracted my attention from the distance. Under a midday sun I moved in to get this picture with a 35-mm lens on an SLR camera.

39

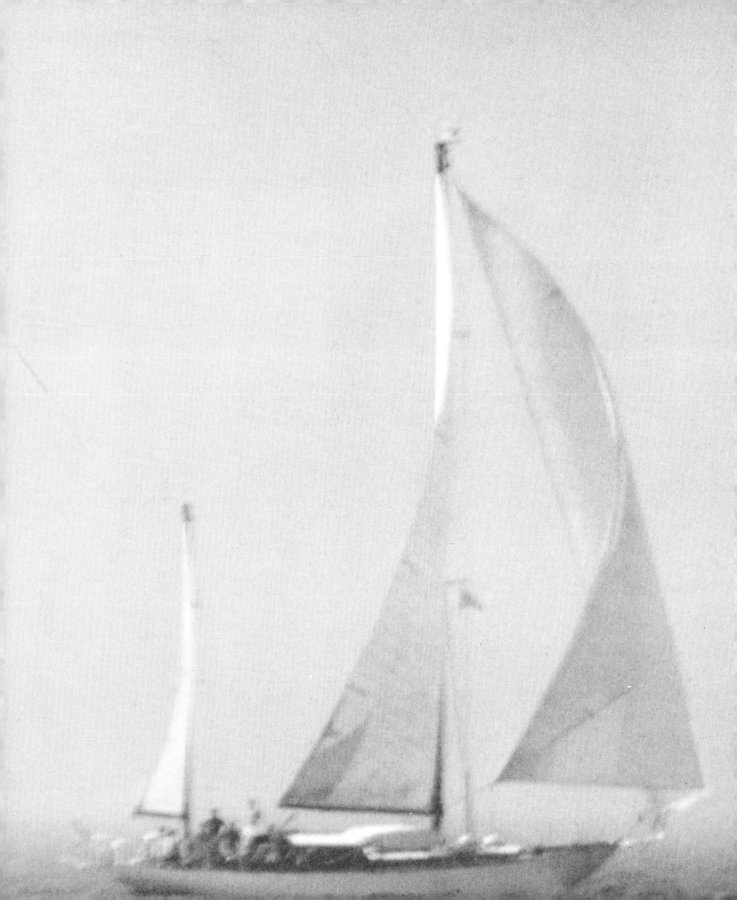

MAKING THE MOST
OF CLOUDY DAYS

I still remember ages ago when Eastman Kodak recommended that the sun should always be behind you when taking pictures. I don't believe that photographing on cloudy days was recommended at all. Even if this were technically possible, the slow speed of films would have left the photographer little or no scope compared with what's possible today.

Over the years tastes have steadily changed and film speeds have increased dramatically without impairing picture quality. Photographs that would have been impossible to take a couple of decades ago, at least without a time exposure, are now so easy that everyone can take a cloudy day in his stride.

That is not to say that ninety-nine times out of a hundred one wouldn't prefer the sun to be visible, particularly when shooting with color. Under a dense, overcast sky the lighting is always flat and everything looks gray. As a result a given scene offers much less contrast than it would if the sun were out.

At the same time, by making the most of such situations you can take unusual and often hauntingly beautiful pictures. For instance, by emphasizing the lack of contrast, as in the photograph of the "ghost" ship shown opposite, you can capture a mood that would be impossible in full sunshine. Other interesting pictures can be made when you find a dark subject that stands out sharply from the background and creates an interesting pattern. The reverse is also true—snowflakes, for instance. I have found that snow photographed in black and white on a dark overcast day can produce much more dramatic results than a similar scene shot in bright sunlight. I always used to shoot snow scenes in bright sunlight; now I am prepared to make the most of whatever the weather man predicts.

This photograph happened quite by accident. While on vacation I had my Nikon and 500-mm mirror telephoto lens on a sturdy tripod, ready to photograph something entirely different, when suddenly, out of the dense haze, this sailboat appeared. Anticipating its immediate course, I was able to get just one picture of it before it was lost once again in the fog.

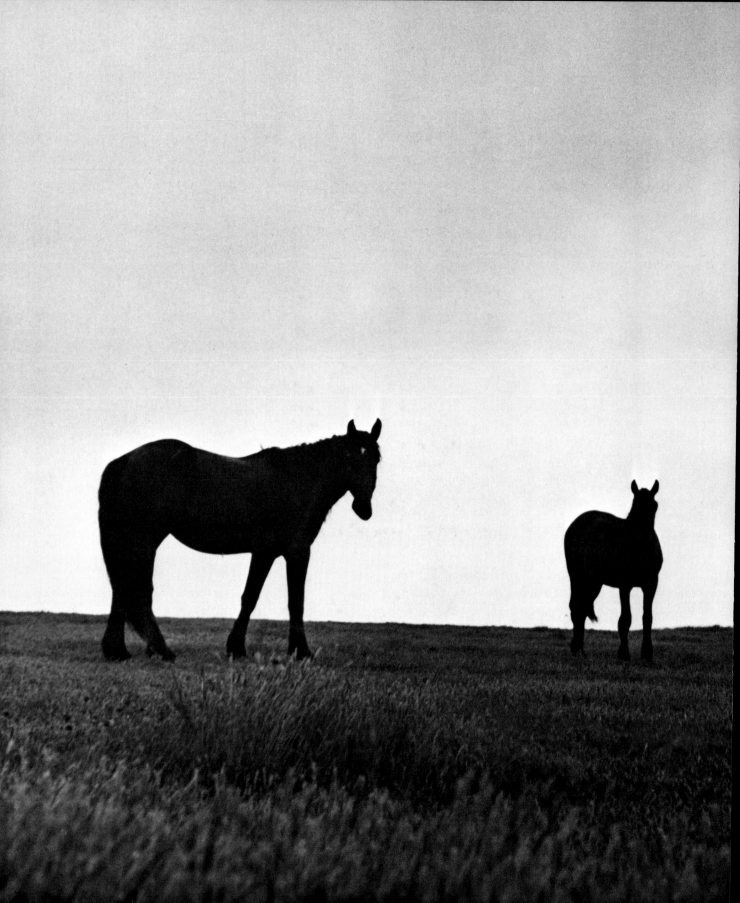

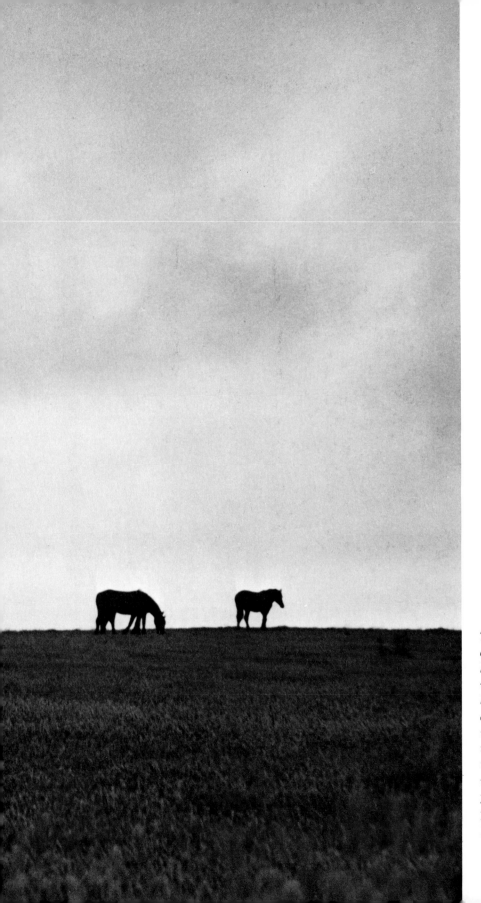

This picture was taken in the flatlands of Oklahoma on a rainy morning. I had hoped for nicer weather, but when I saw these four horses so beautifully spaced and silhouetted against the leaden sky my day was made. One of the first things a photographer has to train himself to do is to make the most out of seemingly impossible conditions. How often he finds himself unexpectedly and pleasantly surprised! I used a rangefinder camera with a 35-mm lens.

43

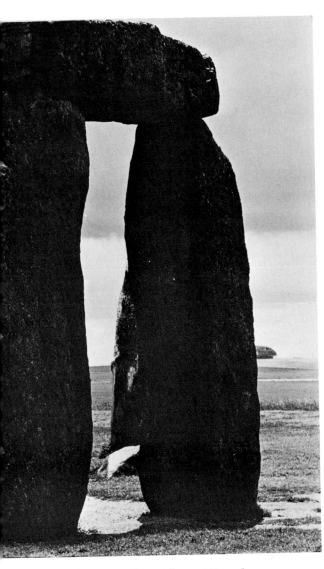

The serenity and grandeur of Stonehenge are
emphasized in these pictures taken on a cloudy
day. At first there were so many visitors that it
was impossible to photograph the monument
without people appearing in every direction I
looked. After two hours of waiting, my luck
arrived in the form of a heavy thunderstorm
which sent everyone but me dashing for shelter.
It was worth getting soaked to see such lovely
emptiness. The picture above was taken after the
shower had passed. For both shots I used a
single-reflex camera and 35-mm lens.

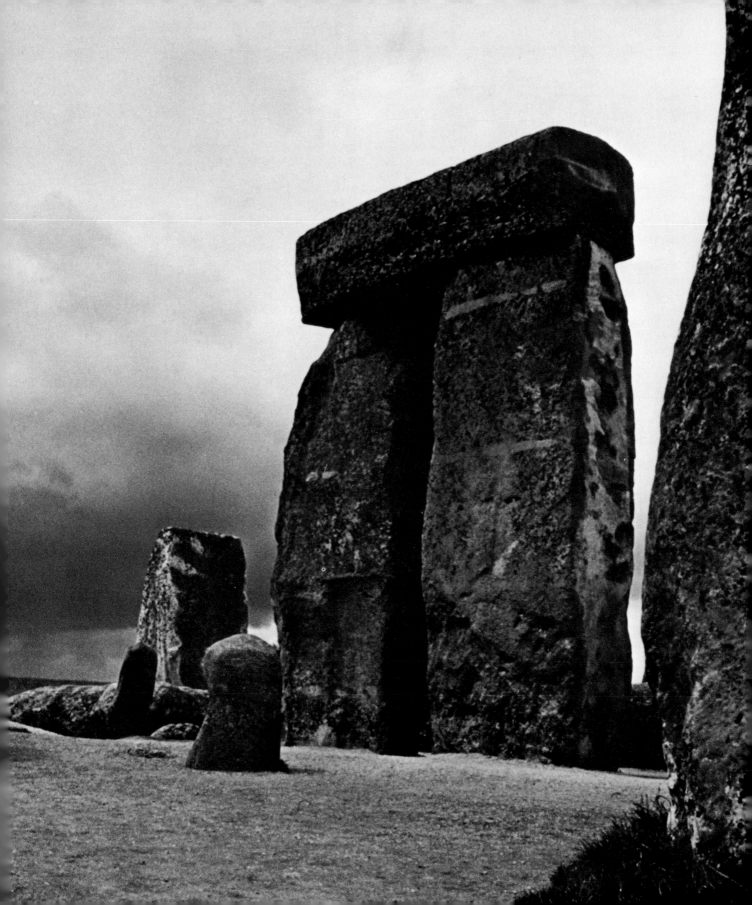

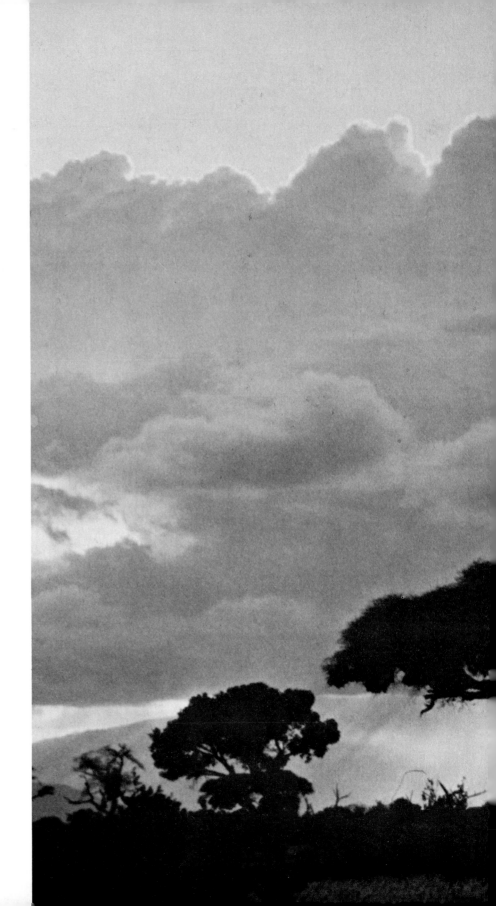

While photographing wildlife at Kenya's Tsavo National Park, a thunderstorm suddenly started up, but I was able to take this dramatic picture before the rain came pouring down. I used a single-reflex camera with a light yellow filter.

46

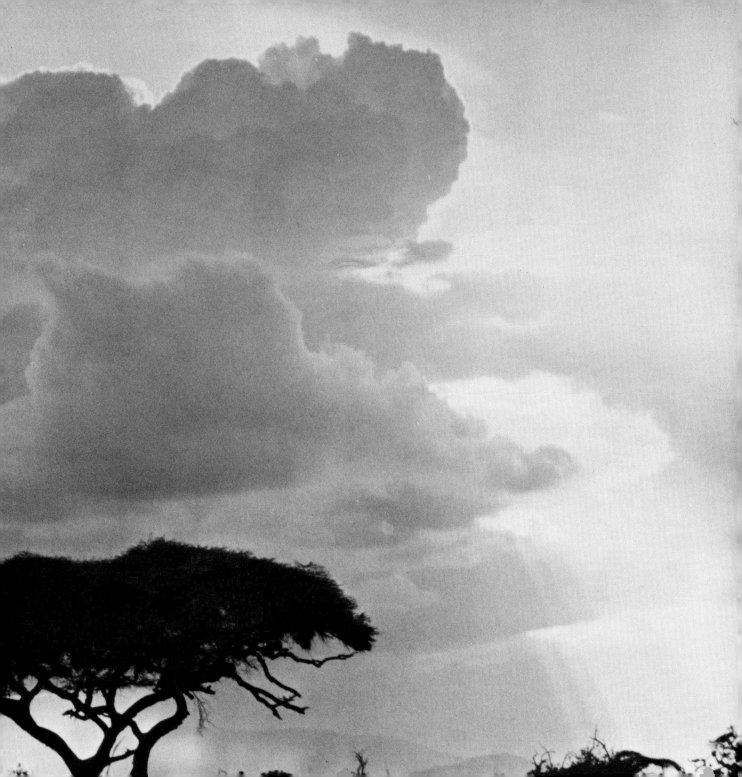

LIGHTING

Basically everything that can be seen by the naked eye, from the light of the early dawn to moonlight, can be photographed. I much prefer either early-morning light (the two hours after sunrise) or the late afternoon (the two hours before sunset), when the warmer light of the sun gives a more romantic and appealing effect. The long shadows cast at these times can also add visual interest to the photograph.

The direction of the light in relation to the camera makes an enormous difference. Most pictures are taken with the light either behind the camera or to one side of it. Strong side lighting will emphasize the texture of an object. An altogether different effect is obtained through back lighting: when the light source is behind the subject, its form stands out in dark outline as a silhouette.

If I have to photograph people outdoors, I generally prefer to shoot when the sunlight is diffused by a high overcast, because this gives a soft, pleasing light with good modulation of tones. Or else I look for an appropriate spot in the shade. Direct sunlight produces strong shadows, which are too harsh and "contrasty" for flattering portraits. Not only can the sun cause your subject to squint, but when it is high overhead, the eyes are in shadow and will come out too dark. If there is no alternative, it is advisable to use either an electronic flash or flood light to illuminate the shadow area around the eyes.

Many people who decide to use a flash stand too far away from their subject. I was amused one Christmas time when I passed a man taking a flash picture of the large Christmas tree at Rockefeller Center in New York from a distance of about sixty feet. Trying to be helpful, I said, "You're too far away—the flash won't have any effect. I am afraid your picture will come out black." He looked at me suspiciously. "What do *you* know about photography?" he said and went confidently on his way.

Indoor lighting is often a combination of daylight and artificial light. With black-and-white film this presents no problem, but with color film it affects the rendition of color. Incandescent light will produce a yellowish cast on daylight film, while daylight will produce a blue cast on tungsten film. Your choice of film should therefore be the

Even in the 1940s black-and-white films were fast enough to photograph stage performances like this Kabuki play at the Imperial Theatre in Tokyo without the use of additional light. I used a Rolleiflex 2¼ × 2¼ camera and a small tripod. The picture took in a larger area of the stage than I wanted, so when the print was made I cropped it the way it is shown here.

48

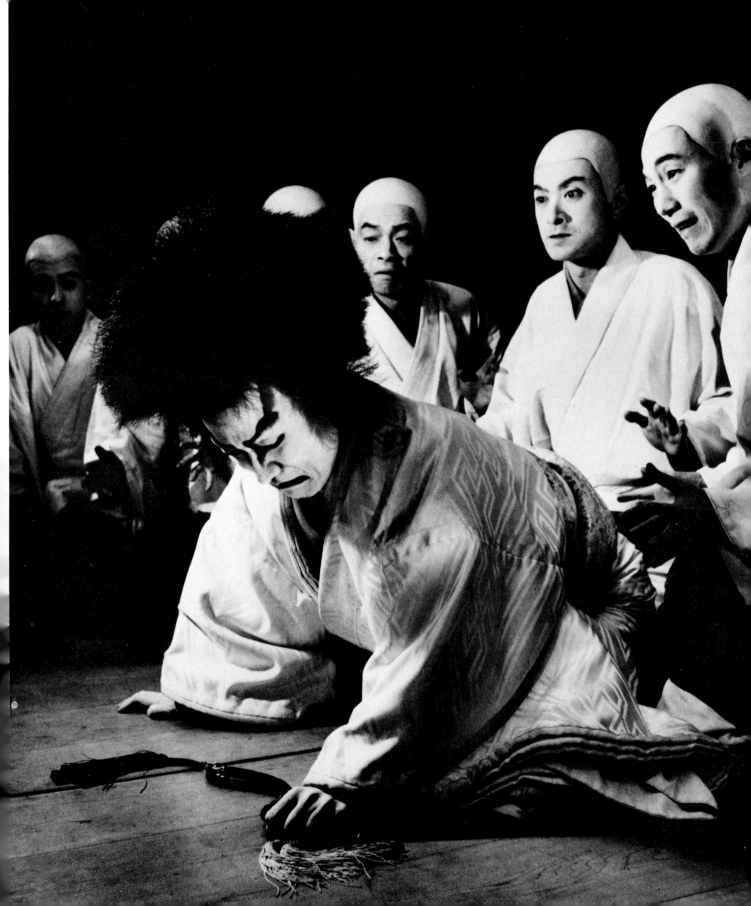

one that is balanced for the *predominant* light source in the room. I prefer natural-looking light and therefore use additional lighting sparingly, to fill in the dark areas without overpowering the available day light.

In photographs taken outdoors at night it is often the bright lights contrasted against the dark background that provide the dramatic effect. One must, however, be careful not to take photos when a few dots of light appear against a solid black background. The best time for night pictures is within half an hour after sunset, when the sky is still light enough to silhouette the subject. When one is unsure of the correct exposure for a scene, bracketing above and below the initial exposure is good insurance that one correct exposure will result.

Changes in intensity of lighting must be accounted for in photographing live stage performances. A spot meter is the ideal instrument to have when you're trying to photograph an actor who is spotlighted against a dark background. In a situation like this, if you follow the reading of a regular light meter, which averages the entire scene, the spotlighted subject will be overexposed. Once again, if you are unsure of the correct exposure you should bracket your shots.

These two pictures were taken during performances with a range-finder camera (which operates quietly, thus minimizing the possible distraction). The only light available was the stage illumination. I was allowed to photograph from the prompter's box at the front of the stage, and used a 90-mm lens and Super XX film; today I would use the faster Tri-X.

The scene at left from Tchaikovsky's Queen of Spades, *was photographed from the announcer's booth at the back of the theater. I shot the original on color film with a 400-mm lens and visoflex housing mounted on a Leica camera. Opposite is the soprano Joan Sutherland during her debut at the Metropolitan Opera in Donizetti's* Lucia di Lammermoor.

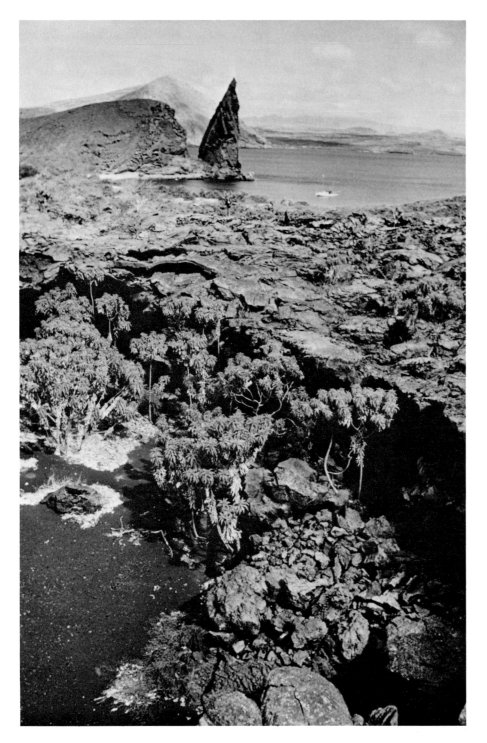

These two pictures demonstrate the completely different effect obtained with front lighting (left) and back lighting (right). The general view of St. Bartholomew in the Galápagos was taken from the highest point of this lava-covered island at around eight-thirty a.m. with the sun behind me. The silhouetted close-up of the cone-shaped rock was taken just before sunset with the sun directly behind the rock. I will never forget this particular sunset. Clouds of mosquitoes suddenly rose from nowhere and descended on us. Although we took off immediately by boat, we were still almost eaten alive. I used a Leica with a 35-mm lens for the morning scene, and I took the other from a closer position with a 90-mm lens.

OVERLEAF: *I photographed this scene of cockle diggers in the Llanrhidian Marshes in Wales from many angles, and this picture, which I shot straight into the sun, turned out to be the most interesting. Many dramatic back-lighting shots are possible, but one should make sure that the light source is not shining directly into the lens and causing unwanted flare. This photograph was taken with a range-finder camera and a 35-mm lens.*

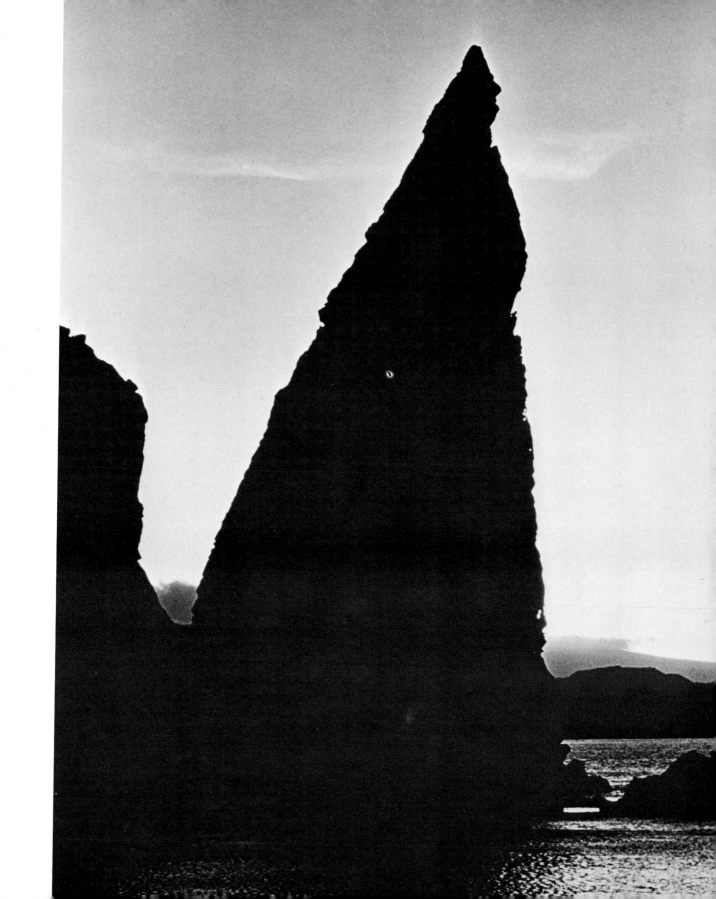

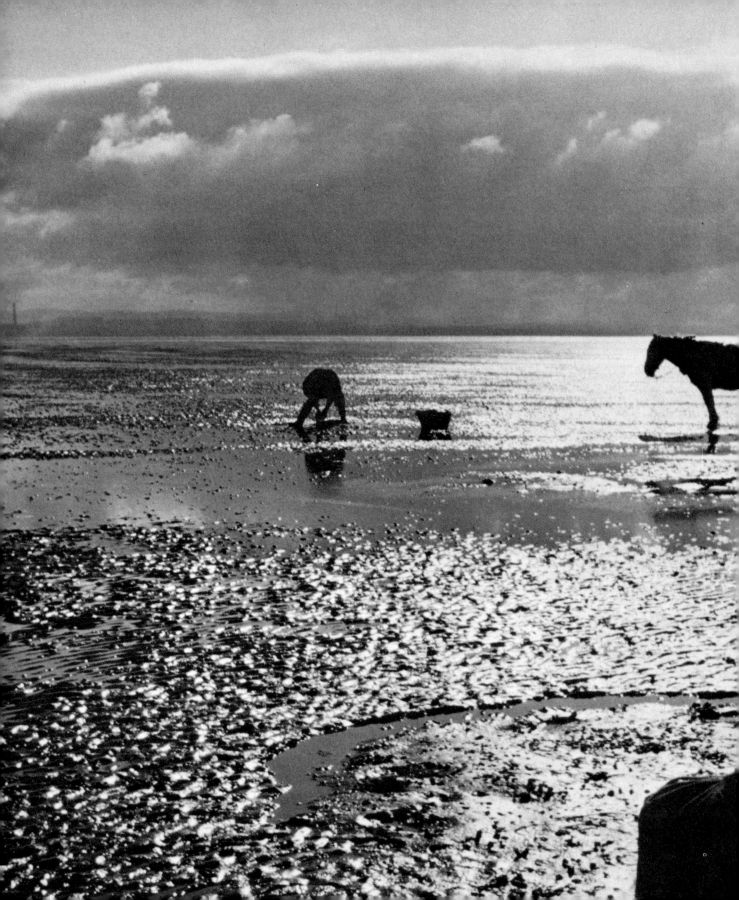

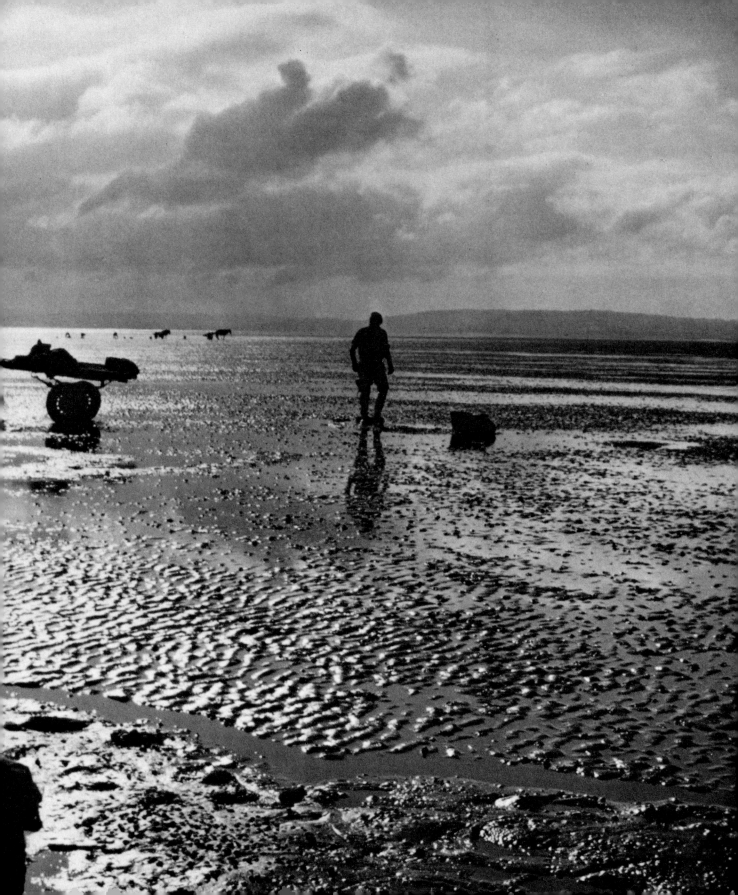

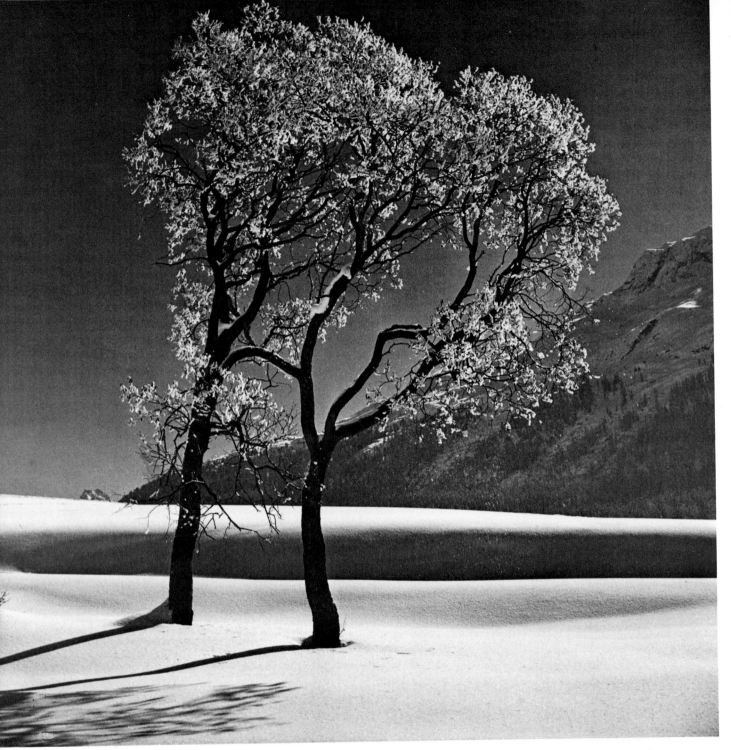

These two pictures demonstrate the importance of light and shadow. The same tree was photographed with a 2¼ × 2¼ Rolleiflex on a bright winter's day at different times and from slightly different angles. The picture at right—which is by far the more effective—was taken with the sun directly behind the tree, the other at about a 45-degree angle from the sun's rays.

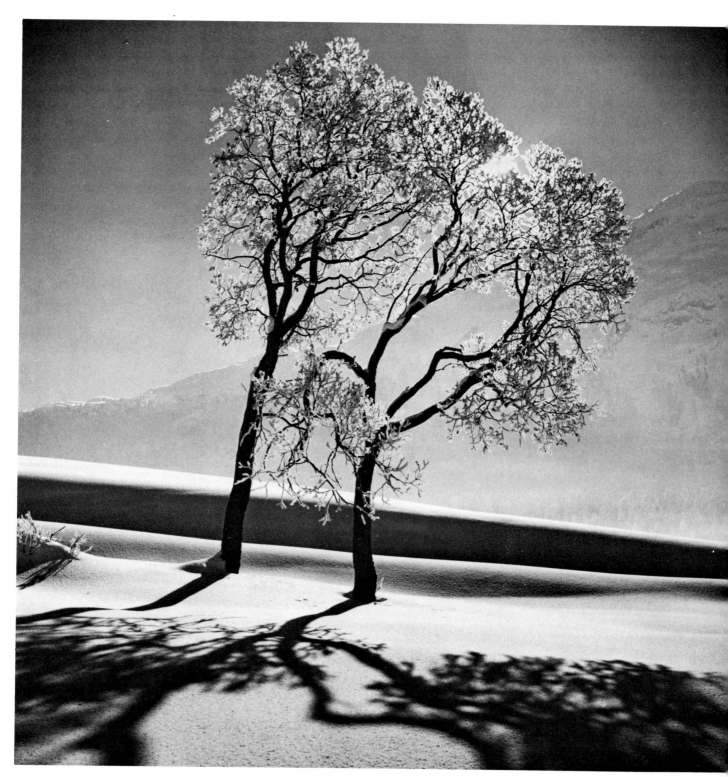

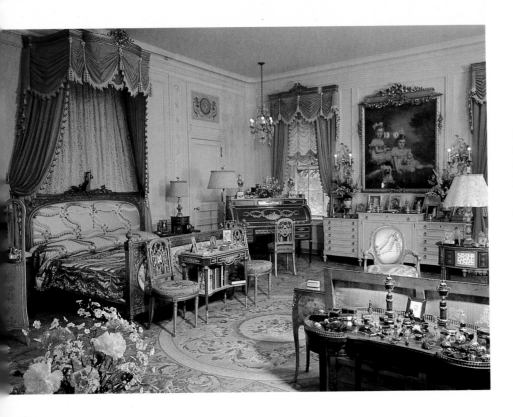

Some interiors are light enough during the daytime to be photographed in color without the use of additional light. For these three, however, artificial light was necessary. At left, in the bedroom of the late Marjorie Merriweather Post, I used daylight color film in a 35-mm camera with a wide-angle lens. The major light sources were two electronic flash units with white umbrellas which diffused the light and softened the shadows. Light from the electronic flash balances the incoming window light, making the overall effect of the picture most pleasing.

The table setting (opposite), also from the Post home, is one of the most lavish I have ever seen. Two electronic flash units were used as the main light source, giving the correct color balance for daylight film. As in the bedroom, white umbrellas were used to diffuse the light, thereby producing natural-looking reflections from the glass and metal surfaces.

This atmospheric picture taken in the Black Swan pub in Yorkshire, England (left), required time and patience. After first asking the people if I might intrude on their privacy, I had to create an overall balance of illumination with the two 500-watt photo floods that I had brought with me so that the room and the flames under the spit would be correctly exposed. I used a 28-mm lens on a Leica with tungsten film to produce the warm and intimate feeling that I associated with the scene. The camera was mounted on a tripod because the low level of light required a 1/4-second exposure.

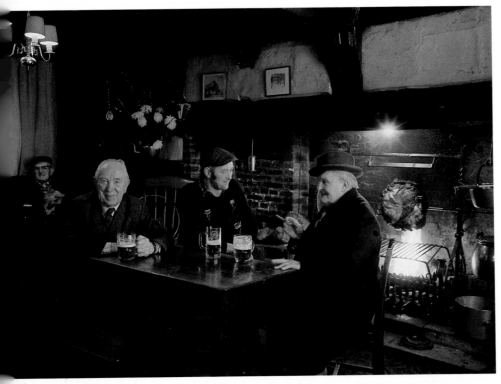

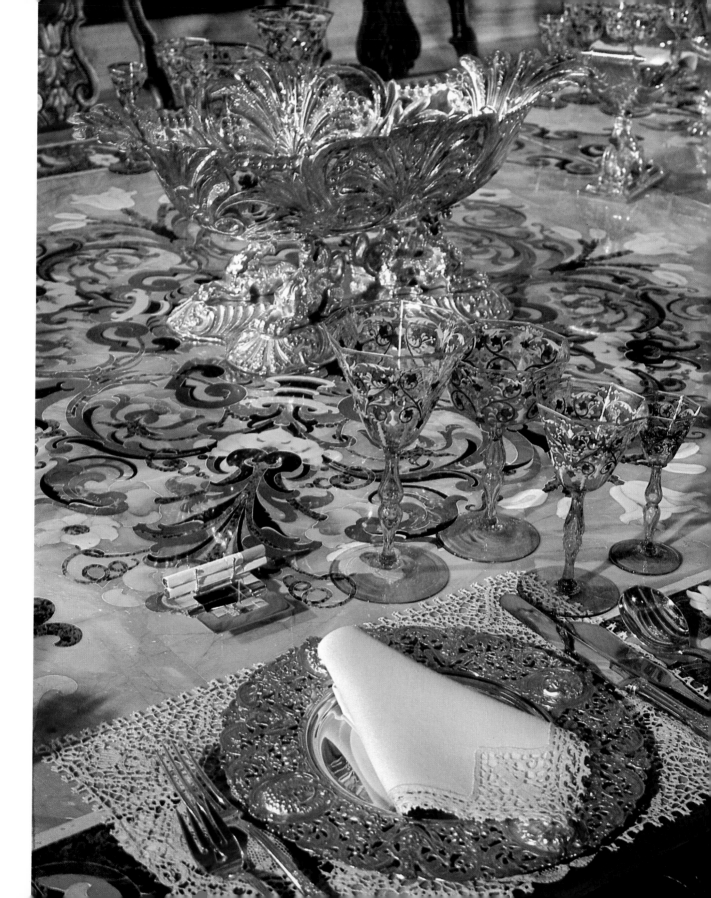

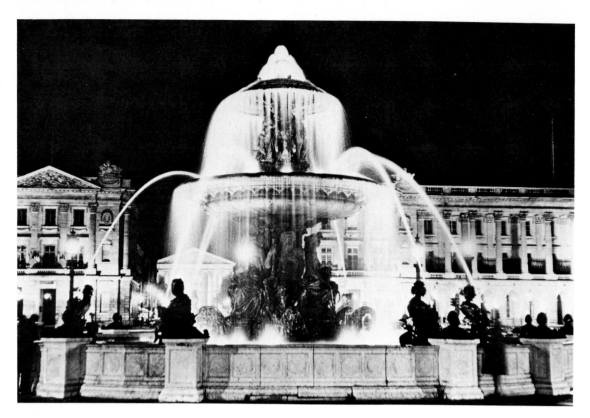

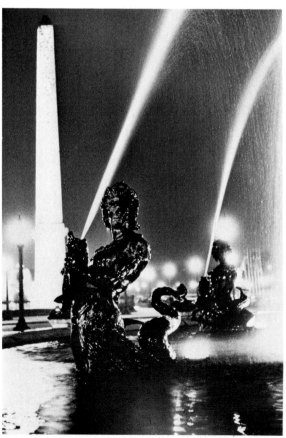

One of the many photogenic spots for night photography is the Place de la Concorde in Paris. Nothing but available light is needed if you bring along a steady tripod. Behind the fountain in the distance is the Madeleine. At left and opposite are close-ups of some of the sculptures. I made several different exposures of a few seconds using both color and black-and-white film in two separate cameras with a 35-mm lens on each. For night shots it is particularly wise to bracket your exposures.

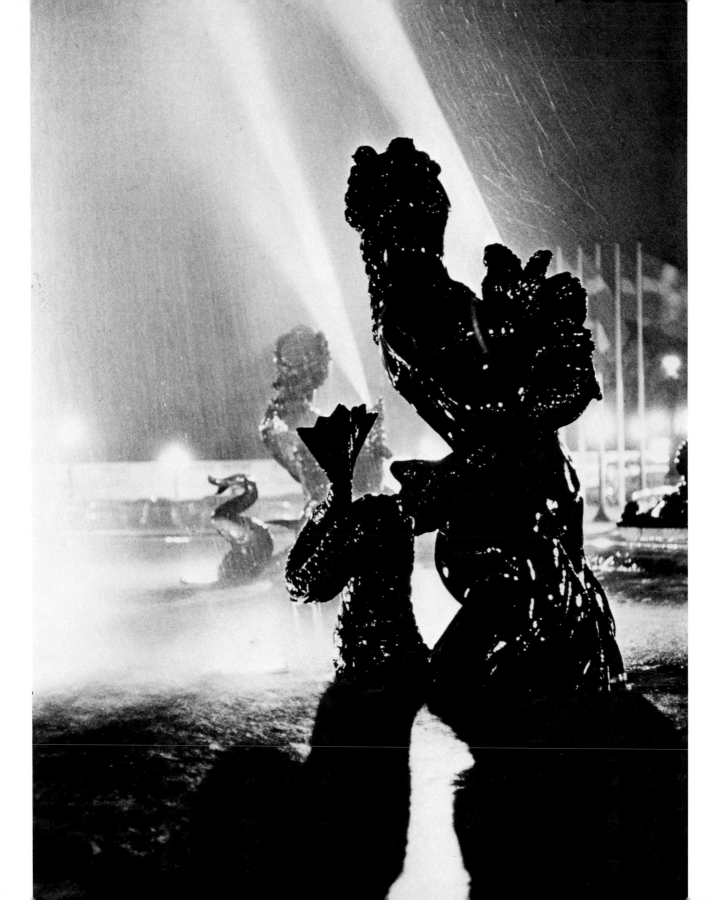

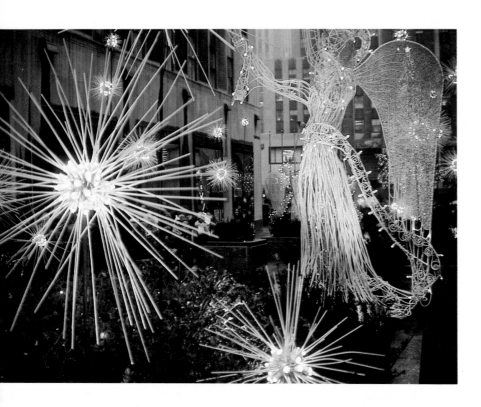

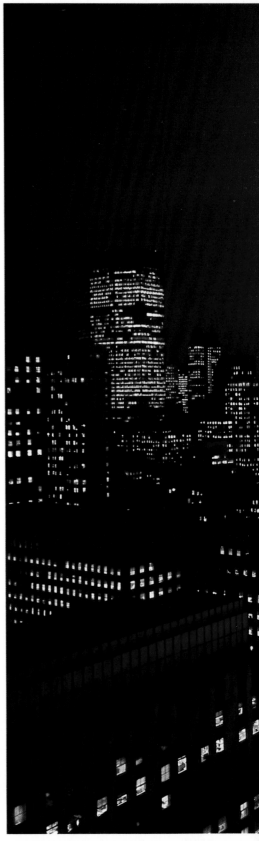

Christmas decorations can make interesting subjects for night photography. I photographed the angels, above, in Rockefeller Center late one December afternoon using daylight Kodachrome film in my Nikon with a 35-mm lens.

The picture at right, showing New York's famous skyline at night, was taken with daylight film from the twenty-eighth floor of the Time-Life Building shortly after sunset. I used a Leica with a 21-mm lens. The camera was placed on the window sill, in lieu of a tripod, for the bracketed exposures, which ranged from four to ten seconds.

62

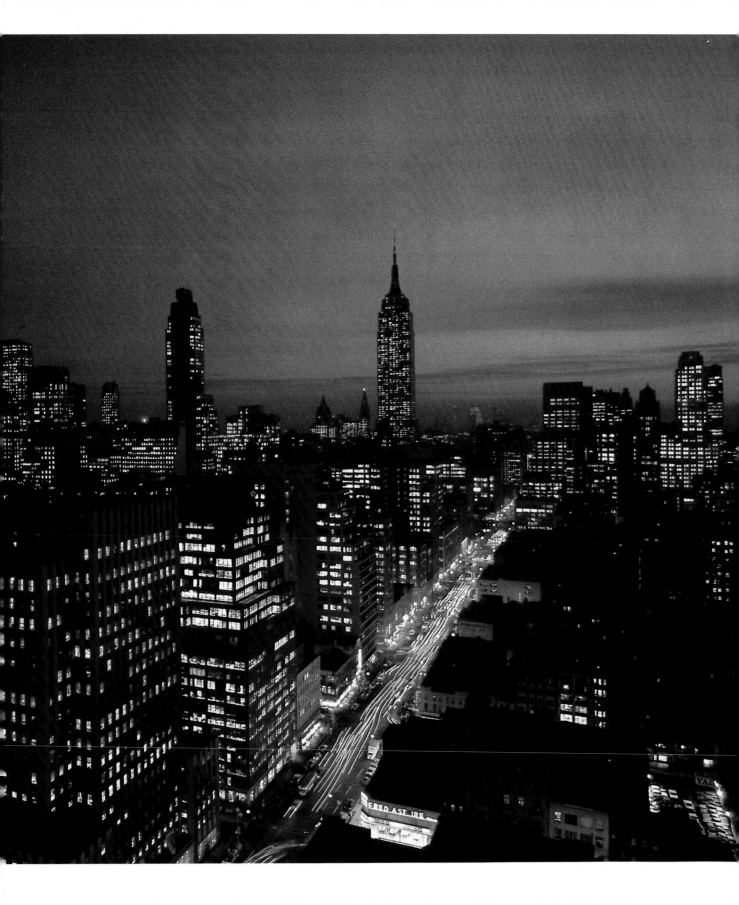

PORTRAITS

Portraits fall into two basic categories, the so-called candid or informal shot and the posed formal portrait. There are commercial studios that specialize in the latter and often use view cameras and special lighting equipment. But the informal approach is the more popular.

I have always enjoyed photographing people. If a formal portrait is to be made, I try to meet the person before the actual picture-taking session so that I can get acquainted with the subject and establish some rapport with him or her. I also like to allow plenty of time to analyze the available light conditions, backgrounds, and the position of furniture and windows. If the arrangement can be improved by moving things around, I make it a point to ask permission to do so first, even though I know the answer is bound to be "Of course." Courtesy pays off in more ways than one. In a friendly and relaxed atmosphere everything always moves along more smoothly from beginning to end.

For portrait work I bring with me two cameras (one as a back-up), four lenses—50, 90, 105, and 180 mm—a steady tripod, and two small lamps with stands. I try to use whatever available light there is, and position the subject accordingly. Available light gives the most natural-looking results, but lamps can be useful, sometimes essential, for filling in or lightening shadow areas.

The background is extremely important in portrait photography. Any distracting elements, such as an awkward chair or a tall lamp situated directly behind the subject, must be removed.

For formal portraits I usually mount the camera on a tripod so that I can talk to the person I'm photographing without continually raising the camera to my eye, a practice that often makes a sitter nervous. I also find it much easier to work when I am alone with a subject. Bystanders at these sessions have a way of distracting the sitter, making the whole operation much more difficult.

Informal portraits are usually easier to take, especially under conditions where additional lighting is unnecessary. On these occasions—on assignment, for instance—one usually doesn't have the chance to meet the subject beforehand. I take with me 35-, 50-, and 90-mm

For this dramatic portrait I carefully positioned the British portrait painter Augustus John in front of one of his paintings. His piercing eyes, staring directly at the camera, provide the focal point of the picture. Hands can often be used to enhance the composition of a portrait. Here, one hand positioned naturally in front of the chin adds visual interest to the overall arrangement. I used a 135-mm lens on a tripod-mounted Leica. Two photofloods were used in addition to daylight coming in through a window. The soft focus of the background, achieved through the use of a large aperture, helped create a three-dimensional effect in this portrait.

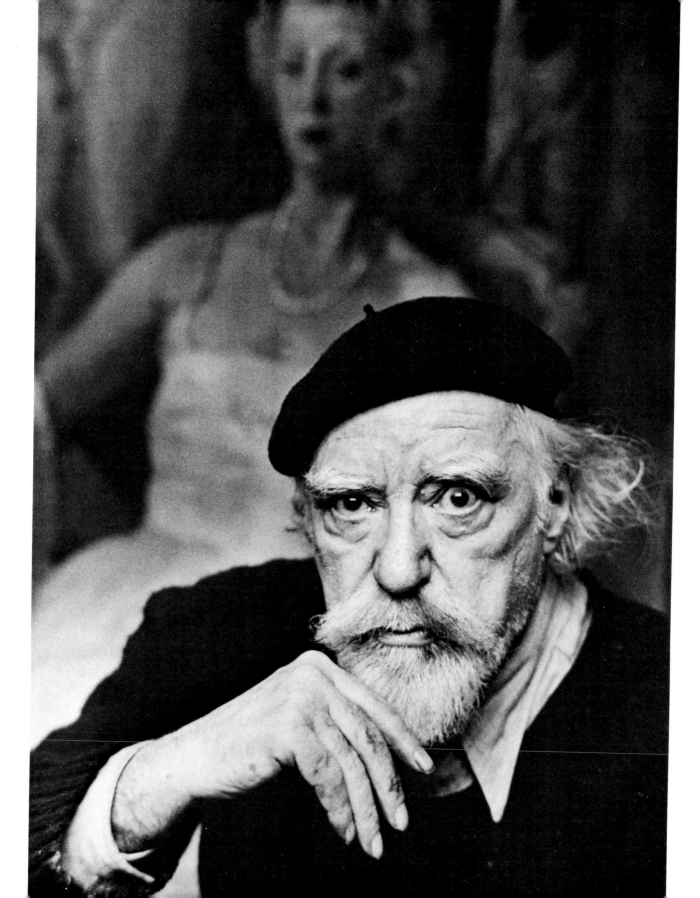

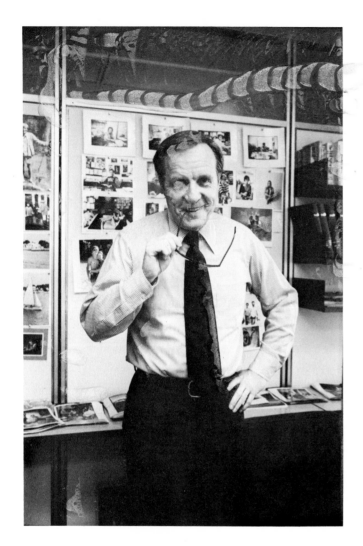 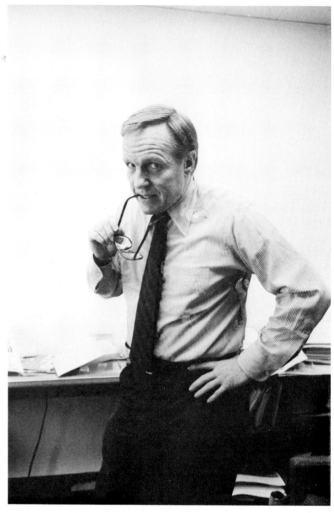

lenses, and often don't bother with a tripod. I try at once to establish the right atmosphere and do everything to make the subject feel at ease in front of the camera.

When being photographed, people are apt to seem a little tense or self-conscious at first. Consequently, one should be prepared to waste a few frames at the beginning of the session and keep photographing until the initial inhibition breaks down and the subject becomes at ease.

If it is you who feels shy about photographing someone, instead of the other way around, my advice is just to be bold and do it. It's not so difficult, and increasing self-confidence comes through experience.

Backgrounds can make or break a photograph. The picture above, left, showing Richard B. Stolley, managing editor of People *magazine, was taken quickly in his office, just to get a record shot. However, not particularly liking the background, I asked him to pose in front of a plain background for the less cluttered picture above, right.*

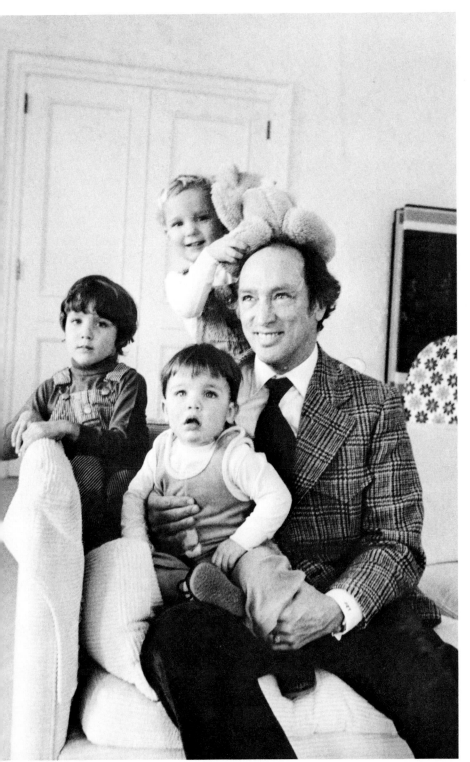

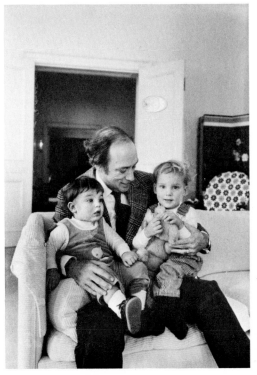

Two photographs of Canada's Prime Minister Pierre Elliott Trudeau and his children. Here again the background was distracting because of the open door, which comes out in the picture as a black void competing with the subjects for attention. While I was asking Mr. Trudeau to change his position, a third child arrived and I took the second picture. Both photographs were taken with a Leica and 35-mm lens using only natural light that came through the windows.

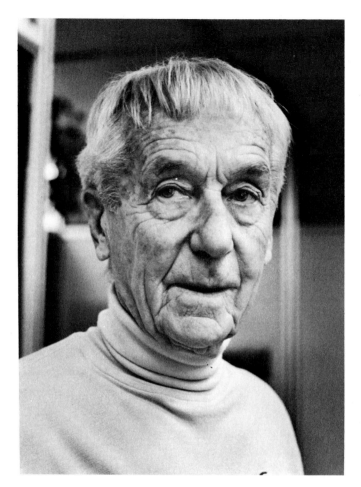

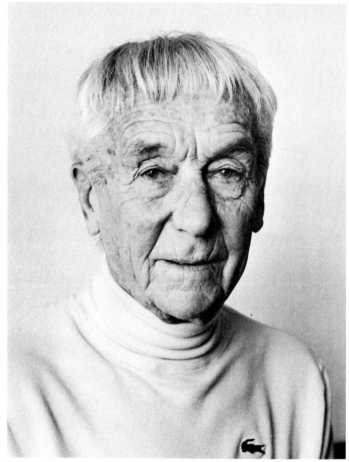

The two pictures of the French photographer Jacques Henri Lartigue were taken about a minute apart, the one on the left with an existing fluorescent light above his head which created a pleasing, rounded portrait, the one at right using only daylight coming through the window. Both were taken with a Leica and 35 mm lens.

Portraits in silhouette can also be effective. Opposite is René Levesque, Premier of Quebec. He had just lit one of the fifty or sixty cigarettes he smokes daily, and I asked him if he would pose by the window so I could include a nice view of Government House and the flag in the background. The three or four pictures I made took about a minute. If the picture were not to be entirely in silhouette I would have needed to use artificial light or else increase the exposure so much that the outdoor scene would have been completely overexposed. I don't think that either version would have been as effective. As it was, using a Leica with a 35-mm lens, I based my exposure on the outdoor light.

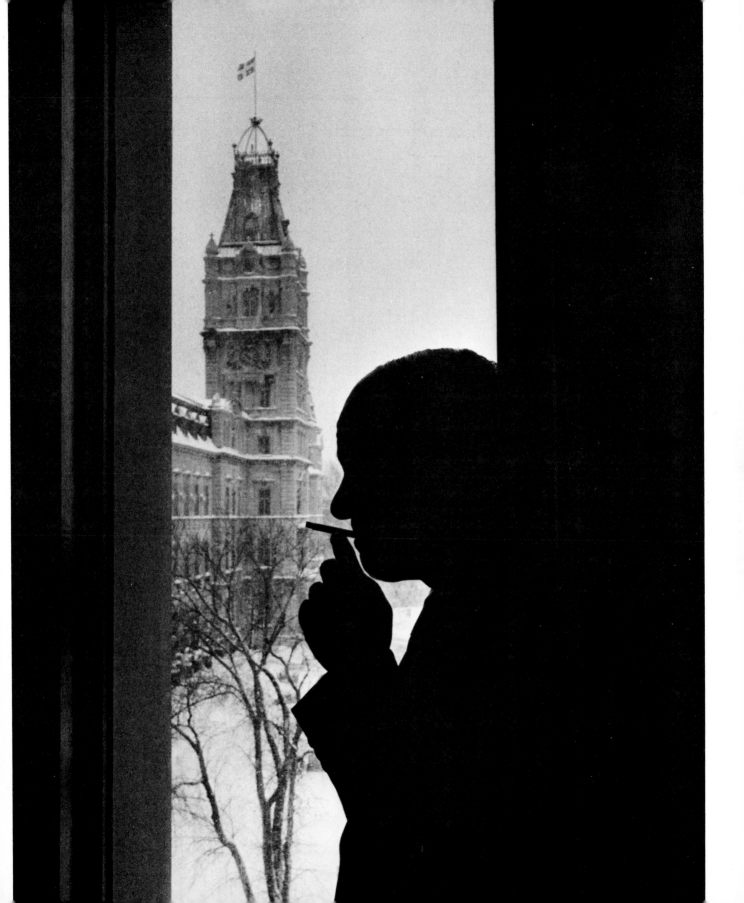

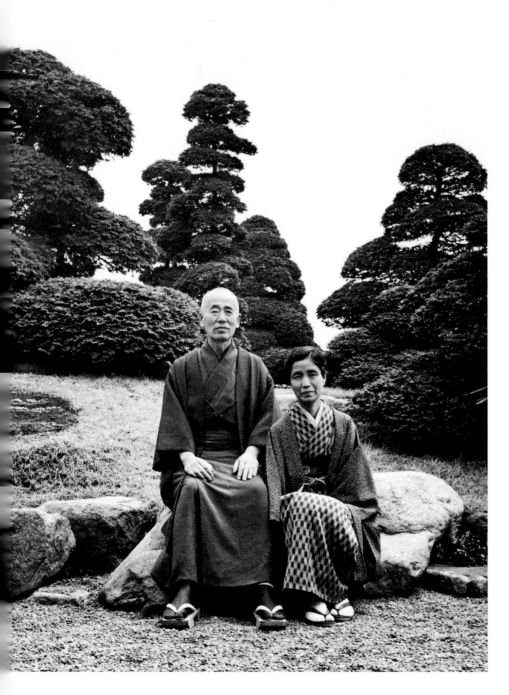

At left is a famous Japanese bonsai expert and his wife. The magnitude and quiet beauty of the pine trees and rhododendron bushes seemed to me the perfect background as the couple sat for their portrait on a rock in their garden. I felt it important to pose the man directly in front of the tall tree. I seldom pose anyone in the center of a picture, but in this case the position of the wife at his side made the composition very beautiful, to my eyes at least.

The portrait opposite of the late Emperor Haile Selassie was taken in 1935 at the Imperial Palace in Addis Ababa. I photographed him with a Leica equipped with 90-mm lens.

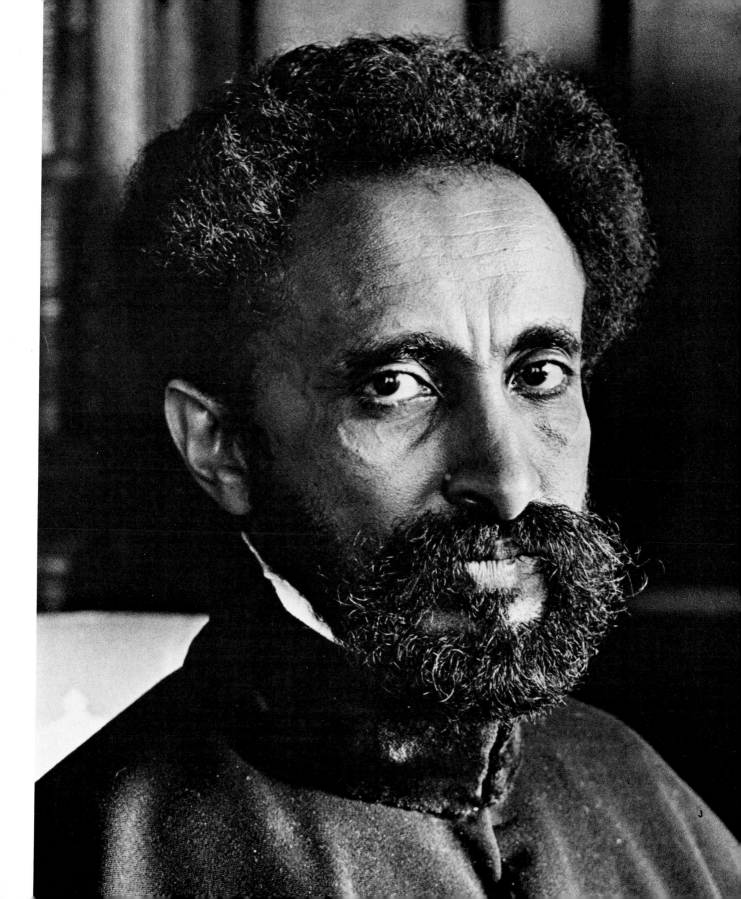

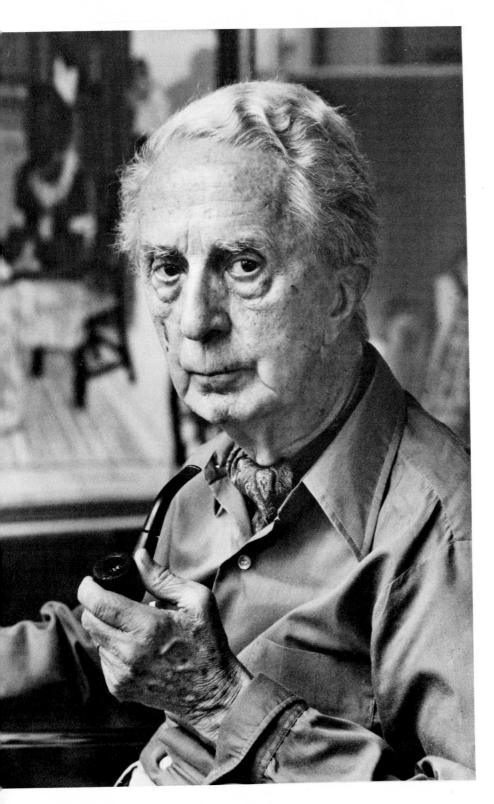

Two portraits of artists in their studios: at left is Norman Rockwell in front of his painting, "The Mission House"; and opposite is Thomas Hart Benton and his self-portrait. The camera was mounted on a tripod for both pictures while I talked with the subjects and got them to relax in front of the camera. Daylight was the only light source used for each portrait.

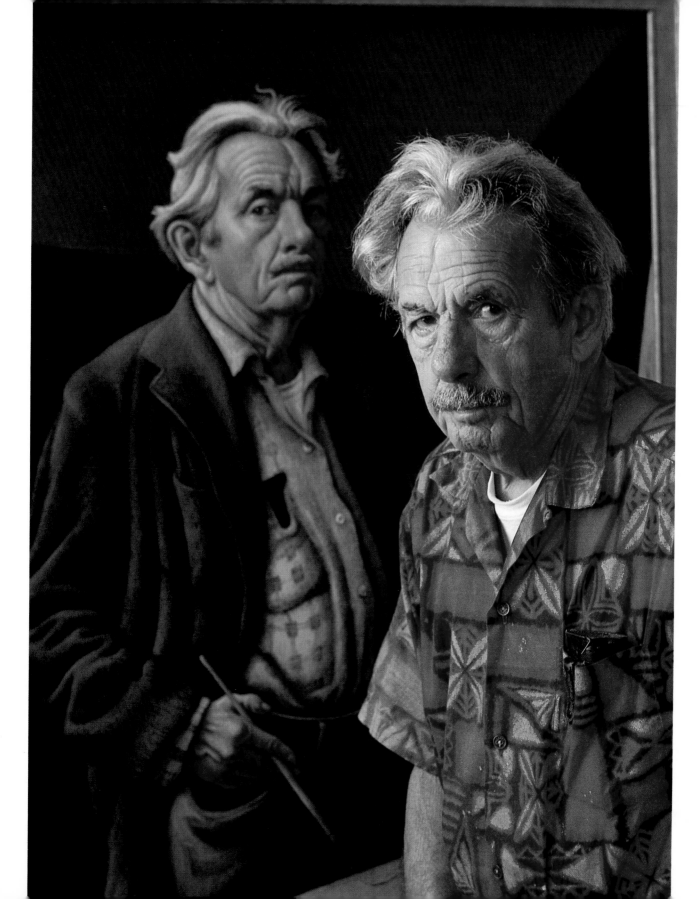

I have always liked this picture of Bertrand Russell, which I took years ago in England. As I had brought no lighting equipment with me, I had to make do with the available light in a rather dark room. Early in my career I learned the importance of not being in awe of the famous people I was photographing. Instead, I approach my subjects in a friendly way, talk sensibly about some current event or a subject that I happen to know interests them, a hobby perhaps, on which I have done a little brushing up prior to the meeting. Bertrand Russell was most gracious, and in the dim light, using a Leica and 90-mm lens, I managed to get some dramatic portraits by exposing for highlights and letting the shadow areas go black.

74

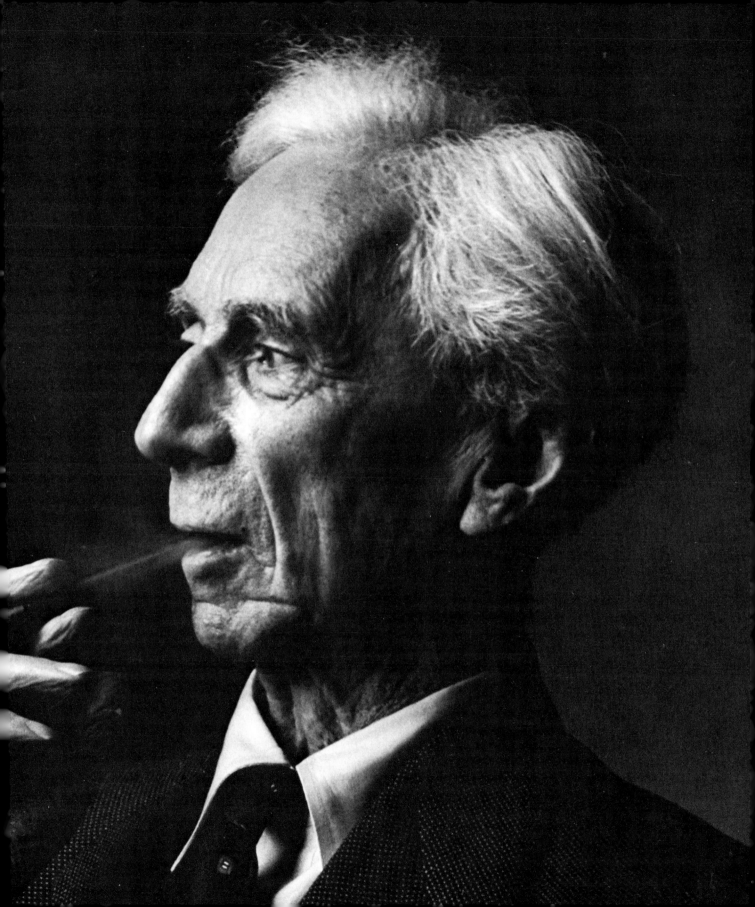

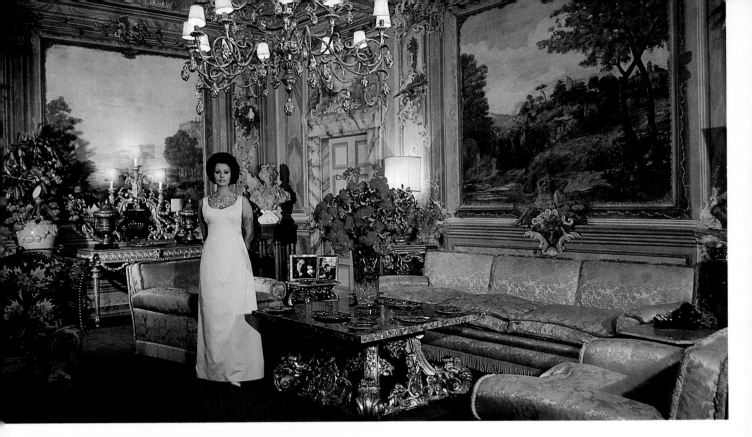

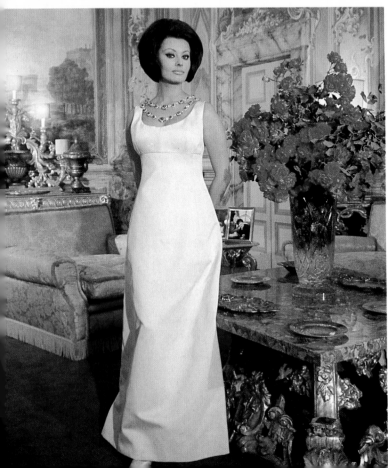

These three pictures were taken at Villa Ponti, the home of Sophia Loren and her husband Carlo Ponti in Marino, Italy. Four photo floods were used for the two pictures on this page and two for the portrait. The picture above was made with a single-reflex camera with a 28-mm lens, in order to include a wide view of the living room; the full-length portrait (left) was taken with a 50-mm lens. For the head-and-shoulder portrait of Sophia wearing a priceless necklace of diamonds and rubies, I used a 105-mm lens. For the two pictures on this page, a relatively small aperture provided enough depth of field to keep both the foreground and background in focus. For the portrait at right I wanted only the subject in focus and achieved this with a large aperture which caused both the foreground and background to become blurry.

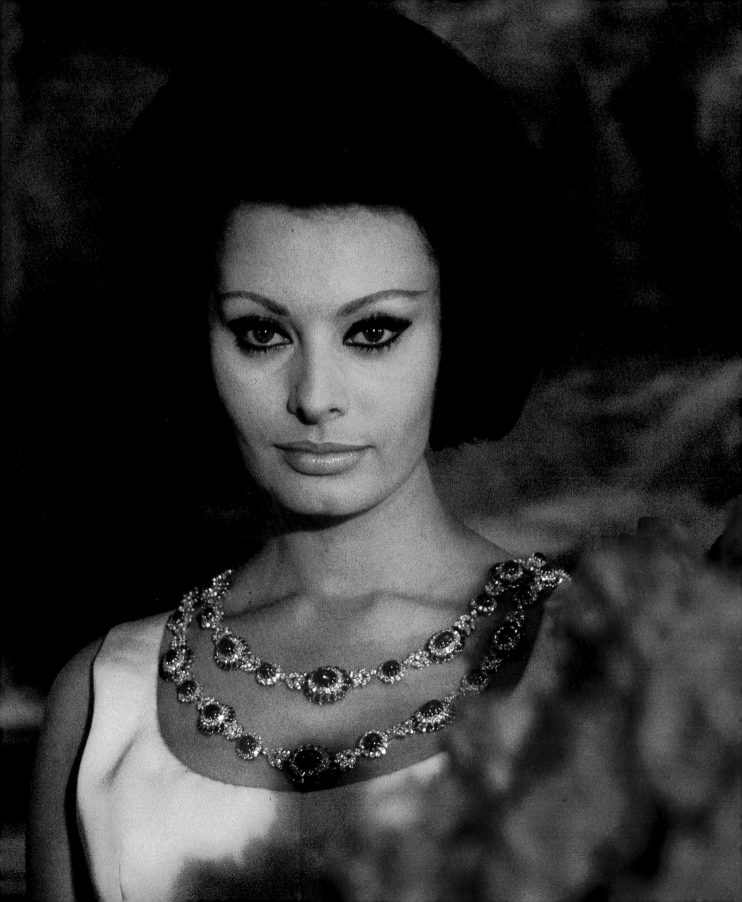

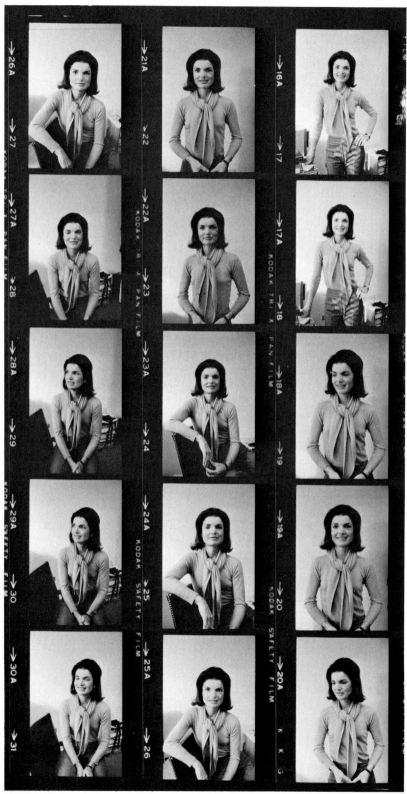

This portrait of Jacqueline Onassis was not planned ahead of time. While she was editing the book In the Russian Style I happened to pass by her office and, having my Leica, asked her whether she would pose for me. She consented, and all these pictures were taken hand-held (with a 35-mm lens) in less than three minutes. There was light from a fluorescent fixture overhead which, together with the daylight coming through a window, produced a pleasing modulation of tone. Here, as always, I felt it was important to keep a conversation going while photographing as fast as possible. From the contact sheets I chose to enlarge frame 16A for two reasons: the expression on her face and the inclusion of her hands, which are not cropped by the edge of the frame.

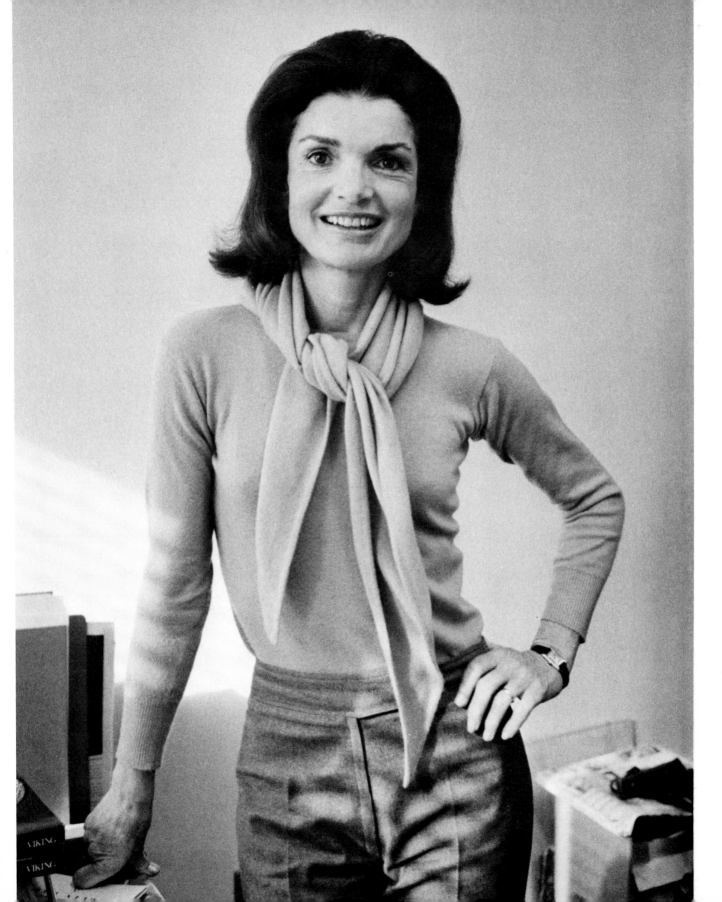

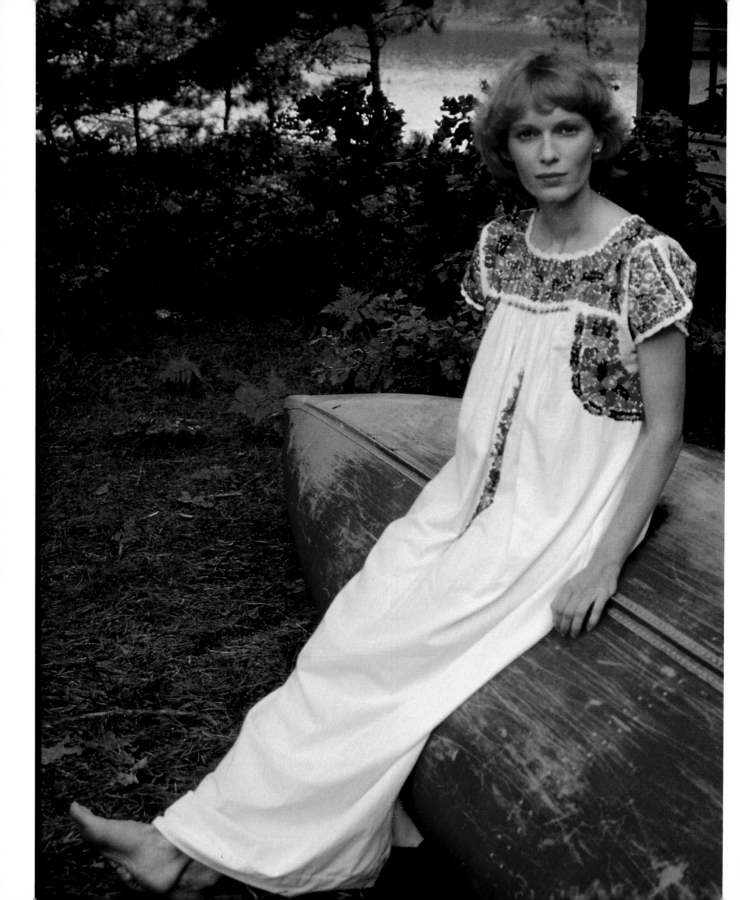

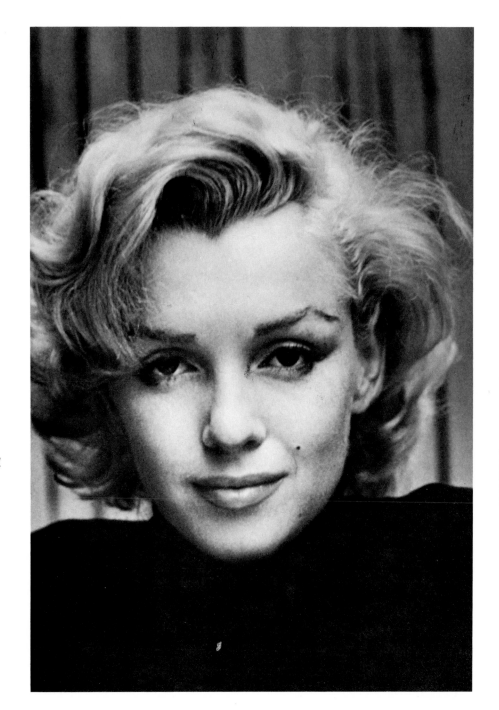

The full-length portrait of Mia Farrow, at left, was taken under a slightly overcast sky, creating a soft overall lighting. The white dress and her position out in the open produced a sharp contrast against the shaded background. A 35-mm lens on a Nikon camera was used with Kodachrome film.

I photographed Marilyn Monroe many years ago on the little patio of her Hollywood house and in a very short time, using a 90-mm lens on a rangefinder camera and no tripod. The important factor here, as usual when taking portraits, was to keep the conversation going so the facial expression never became static.

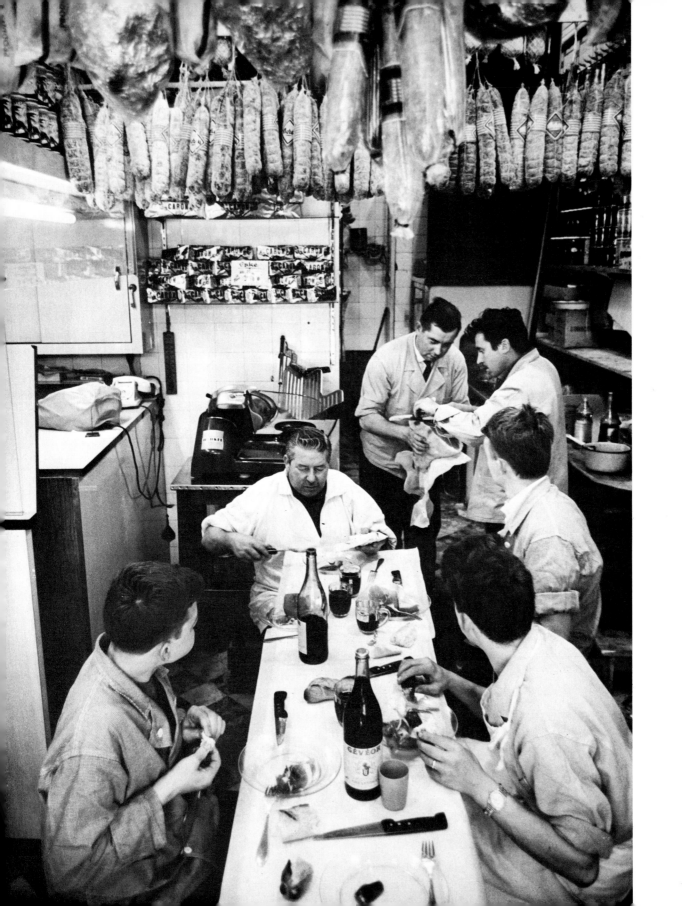

While photographing a French butcher at lunch with his family and friends (left), I wanted to include the sausages hanging from the ceiling as well as the table set with bread and wine. A ladder leaning against a row of shelves at one end of the room enabled me to climb high enough to include all the other atmospheric details as well. I was using a Leica and 28 mm lens.

The informal group below was also taken in Paris. A concierge was spending a Sunday afternoon in the yard with his family and friends. The smiles on their faces came about after I had managed to chase away a yapping dog that had taken a dislike to my camera—and me. So it was that a near disaster turned out in the end to be a great picture. This photograph was taken with a Leica and 35 mm lens.

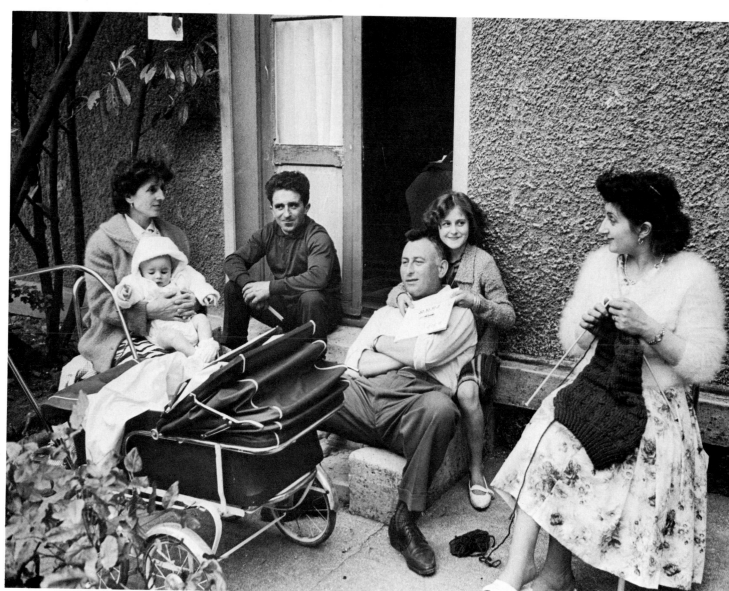

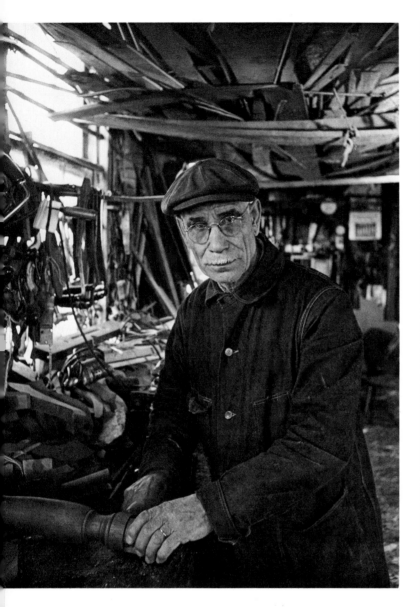

Portraits can tell a lot about the subject if the natural surroundings are included, as in both these pictures. The professions of each of the men is immediately made clear by the backgrounds. Both were taken in available light only, using a Leica with a 35-mm lens which was stopped down to give adequate depth of field. For the carpenter's picture I used a tripod and exposed for 1/4 second. The lobsterman's shack had better light from small windows and two open doors—which meant the camera could be hand held.

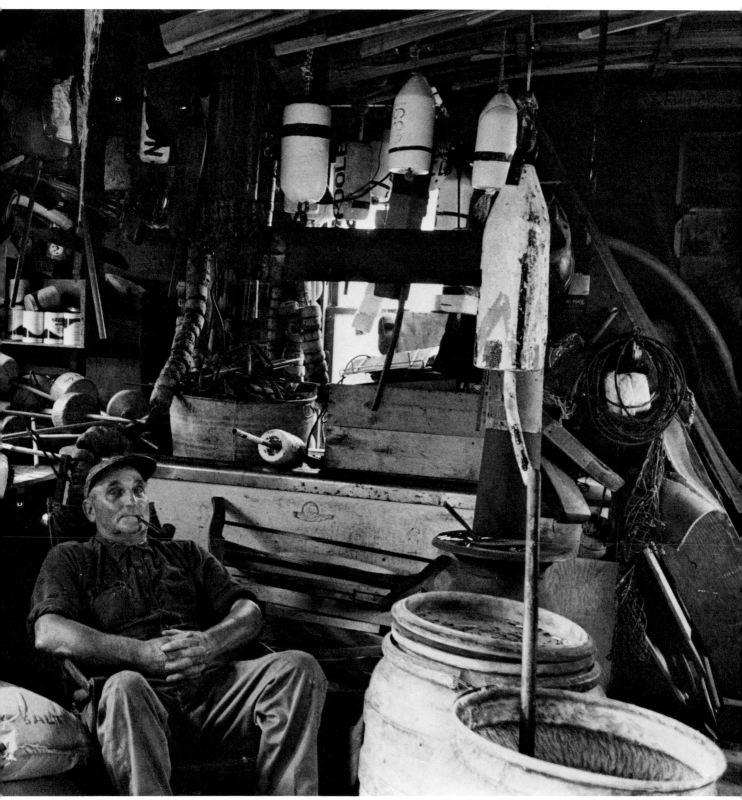

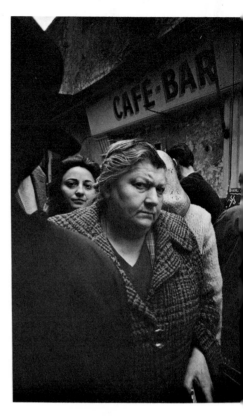

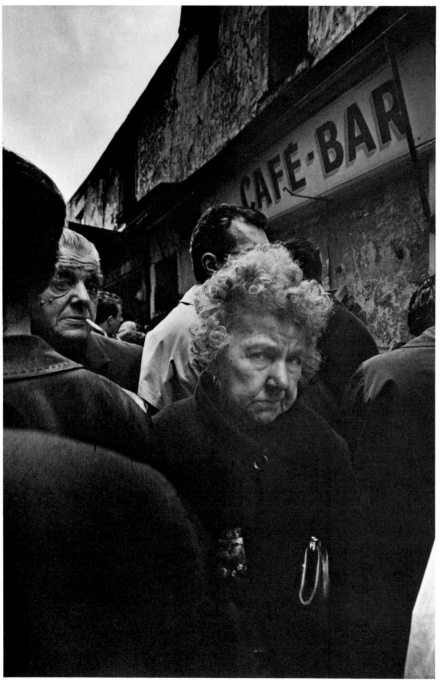

It is always a challenge to take pictures of people unobtrusively. For the photographs on this page I waited in front of a café-bar in Paris with the camera hung around my neck on a short strap. When I saw an expression I wanted, I just pressed the shutter release without raising the camera to my eye as I did not want to draw attention to myself. I use a wide-angle lens for this technique because it gives great depth of field and, since I cannot compose in the viewfinder, its wide angle of coverage allows me to crop unnecessary details in the final print.

The flower vendor, opposite, was one of many people I photographed to illustrate an essay on the Parisians. While walking along a street looking for candid photographs, I often carry the camera in my hand rather than around my neck where it may attract more attention.

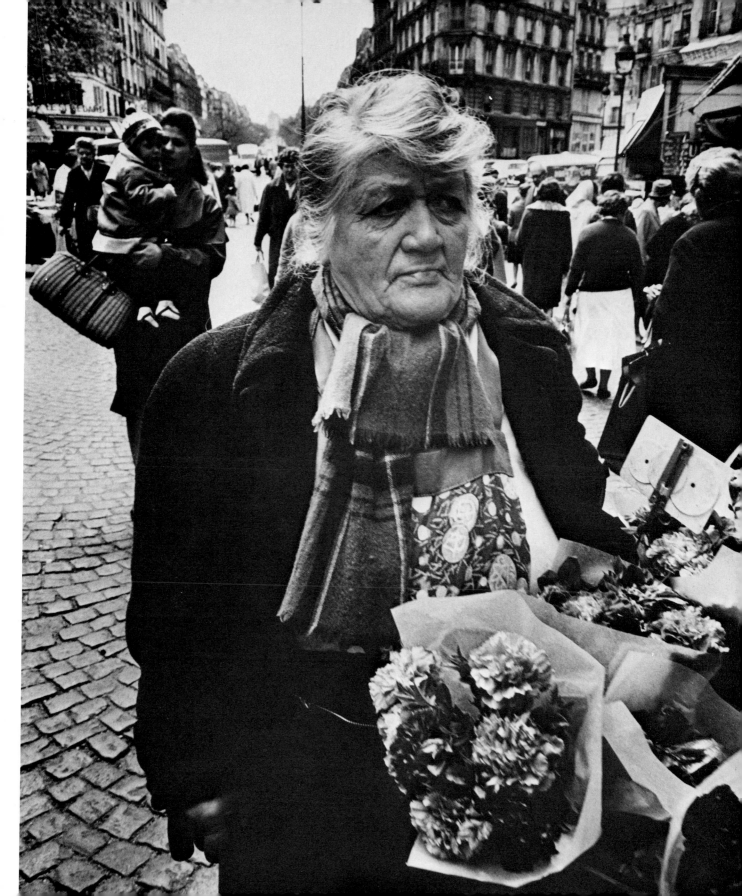

Strolling along the Champs Élysées, I came upon this happy-looking Parisian seated at a little table in a typical outdoor café. She had just finished her drink and was addressing her schnauzer in the most affectionate terms. What makes the picture so appealing, of course, is the woman's expression. The instant I saw it I brought the camera to my eye and shot quickly. When shooting grab shots such as these, I have the exposure and focus preset so that I can get the picture in the minimum amount of time.

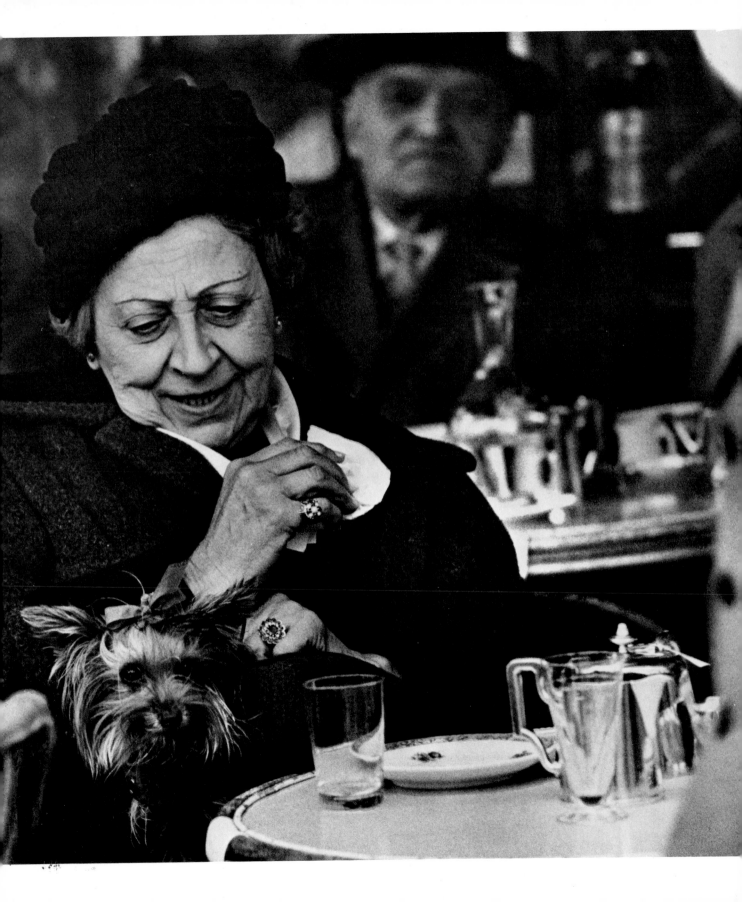

CHILDREN

One of the fascinating things about children is the unexpected things they do. Taking pictures of them, however, is not as easy as many people would think.

Different age groups react differently in front of the camera. With babies, I would say that at least half of them start to cry at once when they see a photographer point a strange instrument, the camera, at them. If you can't get a good response on your own, ask the mother to help. Sometimes she can. Once I asked a mother to lie on a couch and hold the crying baby on her stomach. It worked wonders. The crying stopped almost at once, and the child forgot about me completely. I then moved in close, eliminating the mother from the range of the camera, and got some wonderful close-ups.

With older children, it's usually better when the parents are not present during the photo session. They seem totally incapable of restraining themselves from combing the child's hair, straightening clothes, or whatever; all of which makes the child self-conscious and inhibited. Under these conditions it's impossible to get a really good picture.

The key word for handling children of any age is *patience*. Don't talk down to them; try to become one of them. Laugh at their kind of joke, play with their toy or pet. It is important that they trust you and not be afraid. I find that if I can get the children interested in something they like to do, they become less aware of the camera and, consequently, the better the photographs turn out to be. With this in mind, keep equipment to the very minimum. By concentrating on expressions and different camera angles you can get a variety of images with one camera and only one lens.

I came upon these children outdoors toward the end of their recess period at a Chinese Mission School in San Francisco. They were lining up, holding their books in front of them, on their way back to the classroom. This unposed picture, taken in the early thirties, was used in the first issue of Life *and remains one of my favorites. A 35-mm rangefinder camera with a 35-mm lens was used.*

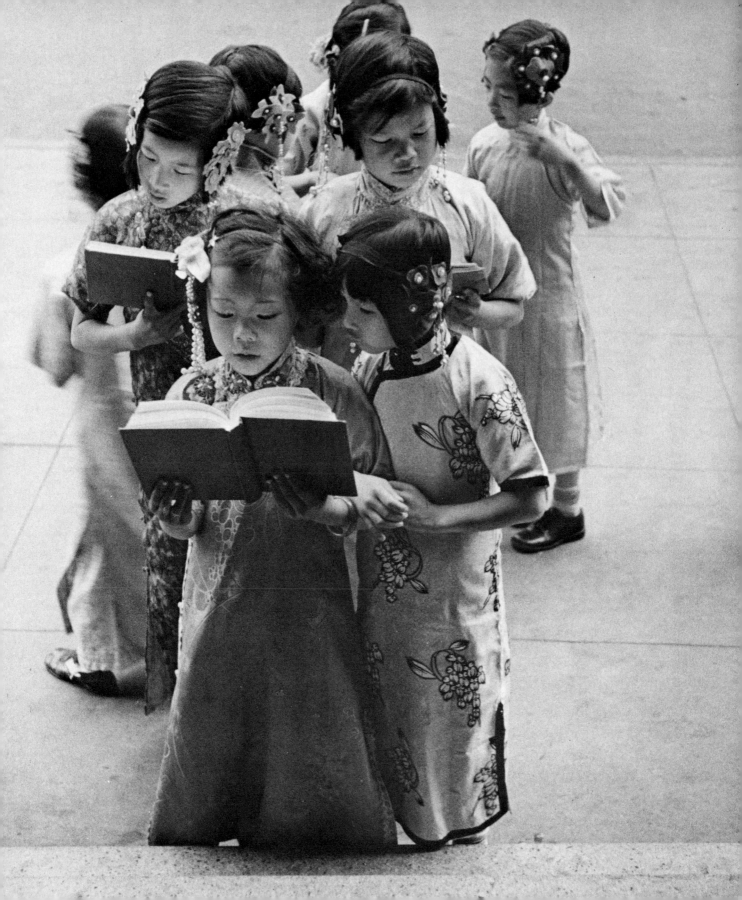

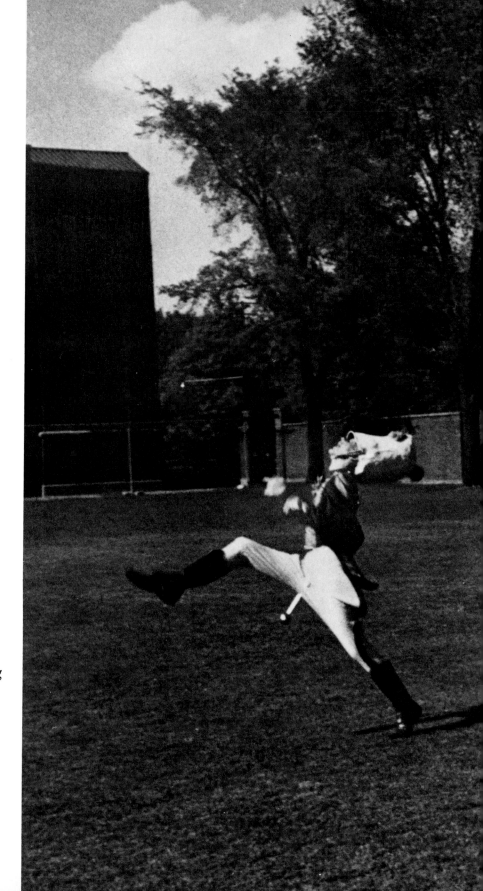

I have been asked time and time again whether this famous picture was staged. It wasn't. While doing a photo essay on the brass band of the University of Michigan in Ann Arbor, early one morning I saw the drum major strutting along while rehearsing for the forthcoming football season. When I ran toward him with my camera, children of faculty members spotted me and naturally wanted to be photographed too, and as they started to follow the leader this memorable little scene developed of its own accord. A Leica with a 35-mm lens was used.

92

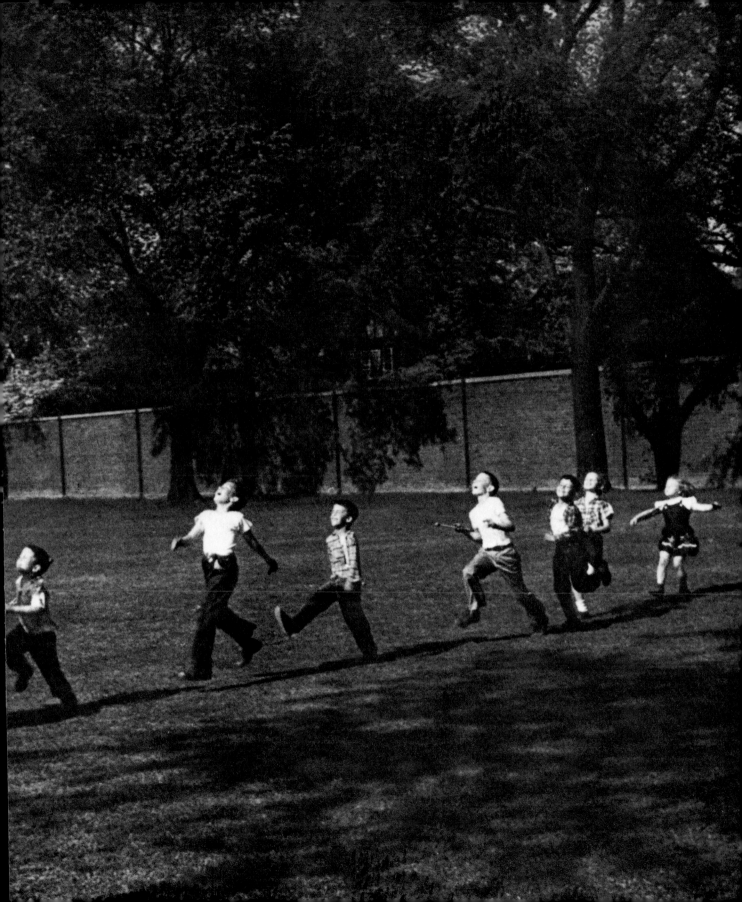

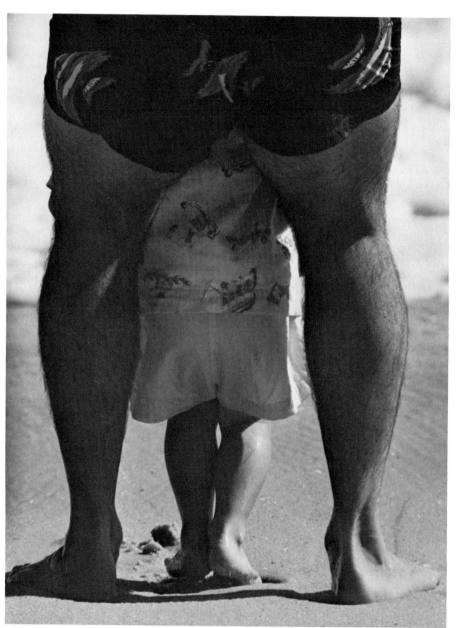

One beautiful Sunday morning on the beach I set up a sturdy tripod and attached a camera with a 400-mm telephoto lens and looked around for "prey." Soon I spotted a father with his child at the water's edge and was able to catch this amusing little sequence as the splash of the wave came rushing up the sand. The advantage of a telephoto lens is, of course, that it's so much easier to take pictures of people without their knowing, and thereby obtain completely natural results.

94

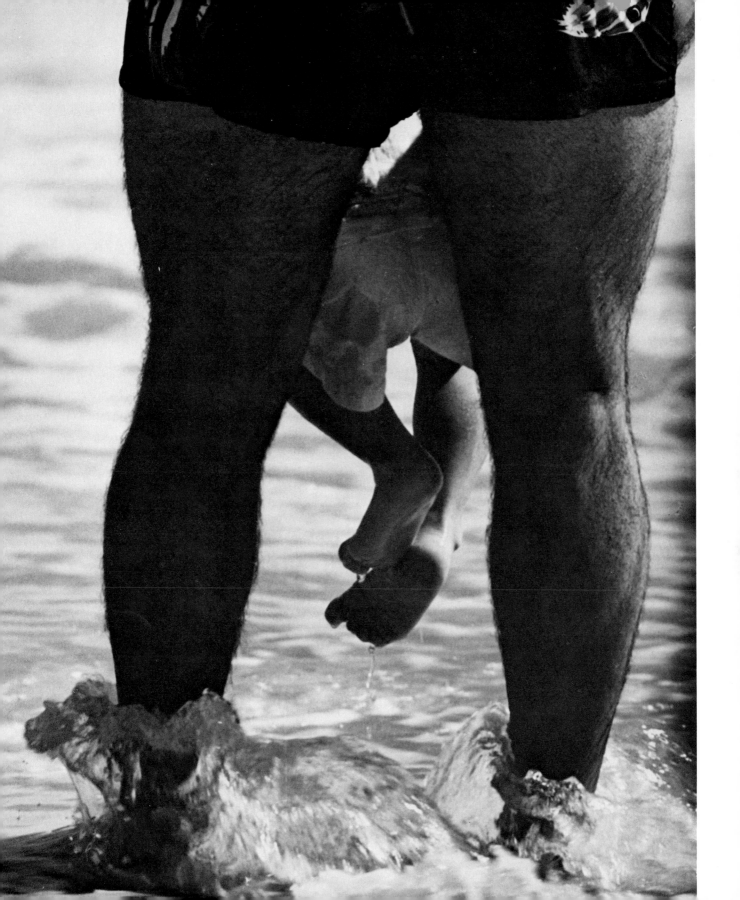

Playgrounds are among the best spots for getting good candid pictures of children. While preoccupied with games they are less likely to be aware of being photographed. Here, in Paris's Luxembourg Gardens, the children are completely involved with a mini-merry-go-round. I took this happy picture with a rangefinder camera and a 35-mm lens.

The little boy was looking at Richard Nixon and his entourage while the president-to-be was still campaigning. As a Life photographer who covered news events I had learned to be very fast and agile. The impulse to shoot is an instant reflex from the brain to the fingertip, bypassing the thinking stage. Often when you start to do just that—think— it is too late, because thinking causes a tiny fraction of delay. I was looking for just this type of picture and had to run with the passing caravan to get it.

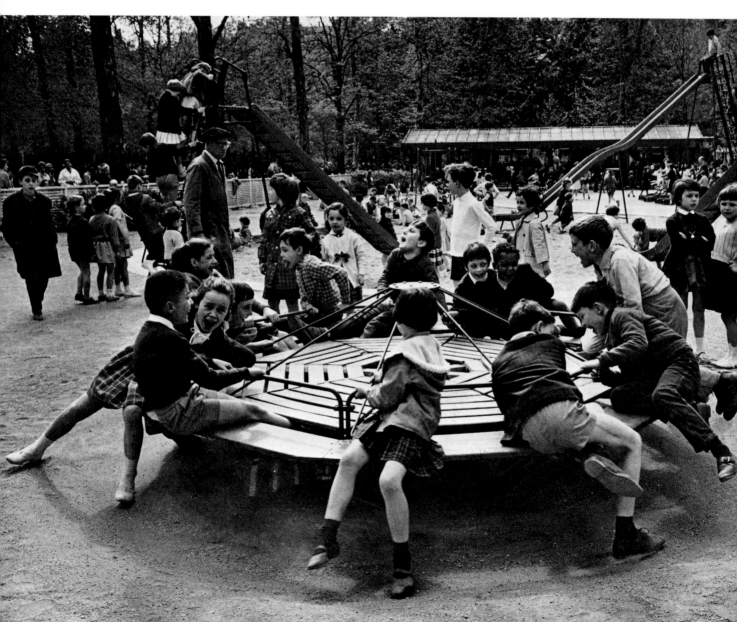

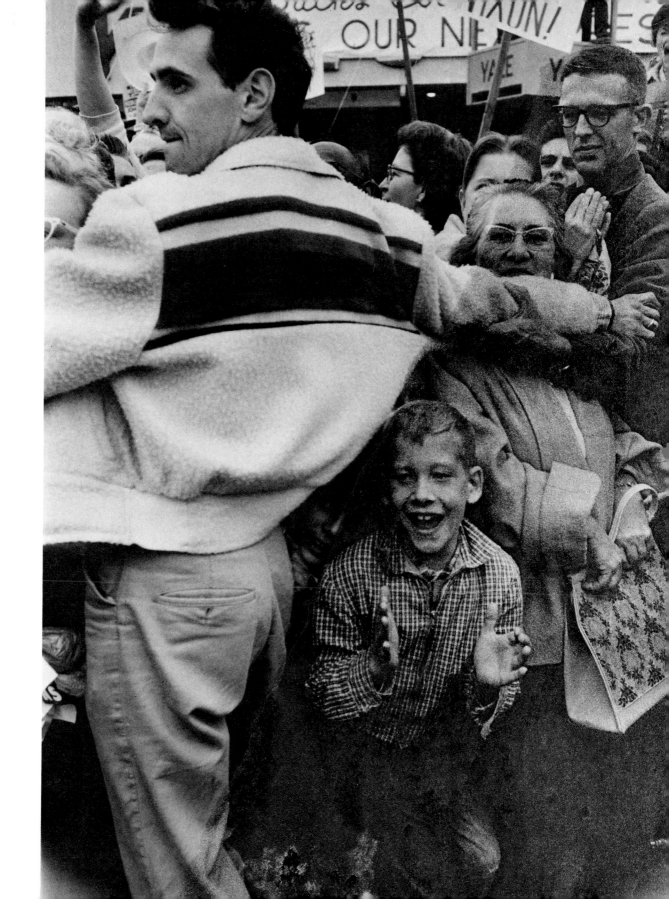

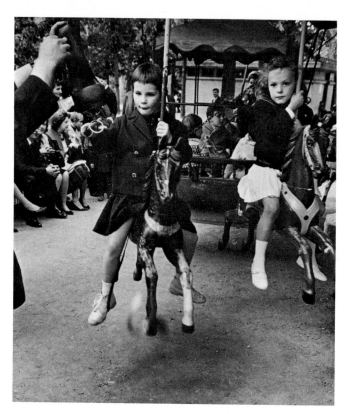

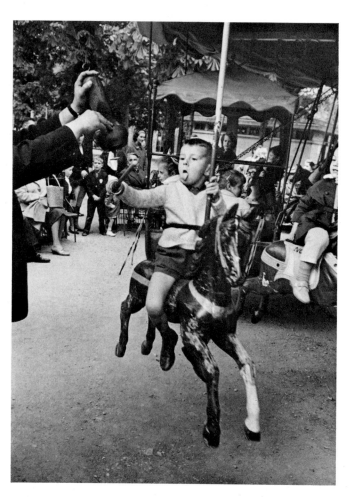

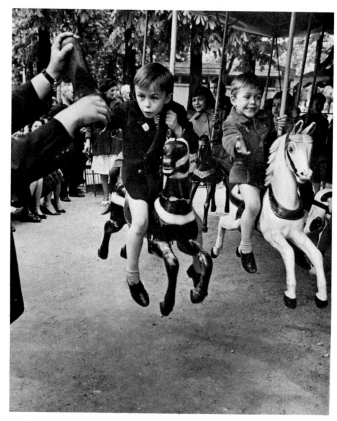

These pictures were all taken from the same spot with a 50-mm lens on a Leica camera. As the carousel went round and round the children tried to put a stick through a ring held by an attendant whose hands are seen in the foreground. My object here was to record the various expressions of children doing the same thing.

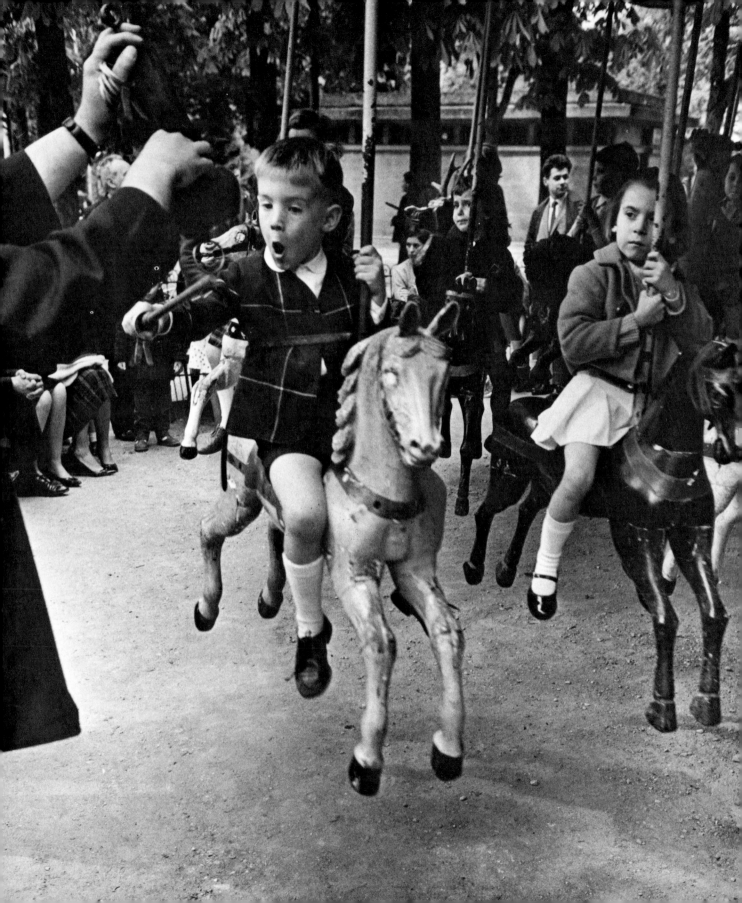

This looks like an easy enough photograph to take, but it took a long time for me to find the right vantage point. The children were watching a puppet show about Saint George and the Dragon, and, amused by their expressions, I tried out five or six different positions before I finally decided to sneak in and sit on the ground right in front of the little stage. I made it just in time to capture the excitement of the young audience as the dragon was finally slain. I used a range-finder camera and 35-mm lens.

100

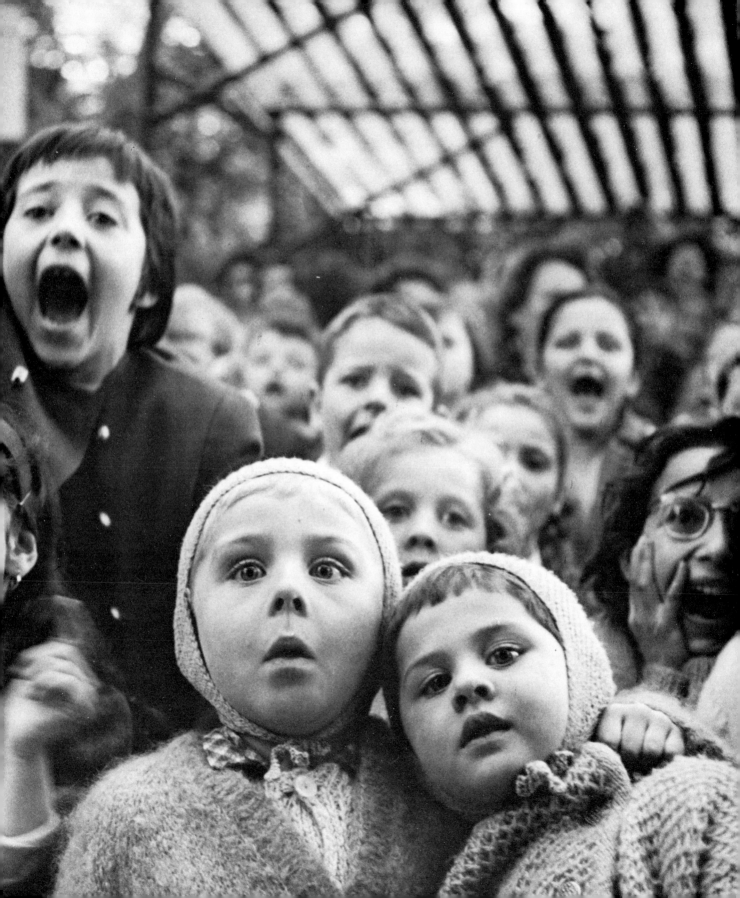

ANIMALS

I have photographed many different types of animals and birds, most of them in the wild. Of the two, birds are by far the more difficult to take.

Wildlife photography demands the greatest amount of patience. Since there is no way you can ask wild animals to do what you want, you must be familiar with their natural habits and work around them. I was once in the Florida Everglades waiting to photograph some interesting birds in flight. My camera and 400-mm lens were mounted on a tripod. First I had to wait about four hours for a bird to appear. Then I focused the camera and took one not very interesting picture of the great white heron. The shot I wanted to get was of the bird as it started to fly away; instead it sat there for almost two hours. I became hypnotized as I waited with the cable release in my hand. Suddenly the heron did take off and I was able to get a picture, but only one. Fortunately, it was a good picture, so my expedition was not in vain.

Anyone serious about wildlife photography will need a long telephoto lens with a focal length of between 200 and 500 millimeters. Such a lens allows you to get a good-sized image of the subject from a respectable distance.

For pictures of wildlife one need not, of course, travel farther than the local zoo. As more and more zoos are abandoning the iron-cage concept and setting up natural habitats, quite natural-looking photographs can be made without a lot of elaborate equipment.

Animal behavior is unpredictable, and frequent failures should be expected, but this makes an outstanding photograph all the more rewarding. With pets the task is somewhat easier, but only if the pet is yours or a friend's, and wouldn't take off and hide under the bed as soon as it sees a stranger. This is more true of cats than dogs. In any case, keep the camera and yourself, too, as inconspicuous as possible.

Outside of zoos there are fewer and fewer places in the world where you can find animals like this beautiful creature. I photographed the young lion from the open window of an automobile in Kenya's Nairobi National Park. It was not as difficult a task as you might imagine because you can drive quite close to the animals, and by using a telephoto lens, like the 300-mm used here on a Nikon, you can get a large image of the subject from a safe distance.

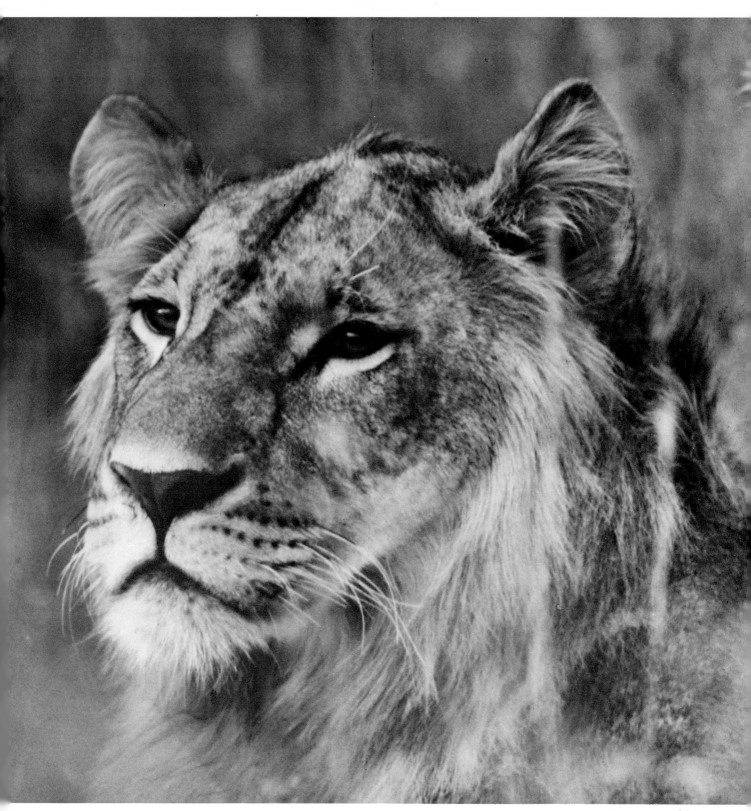

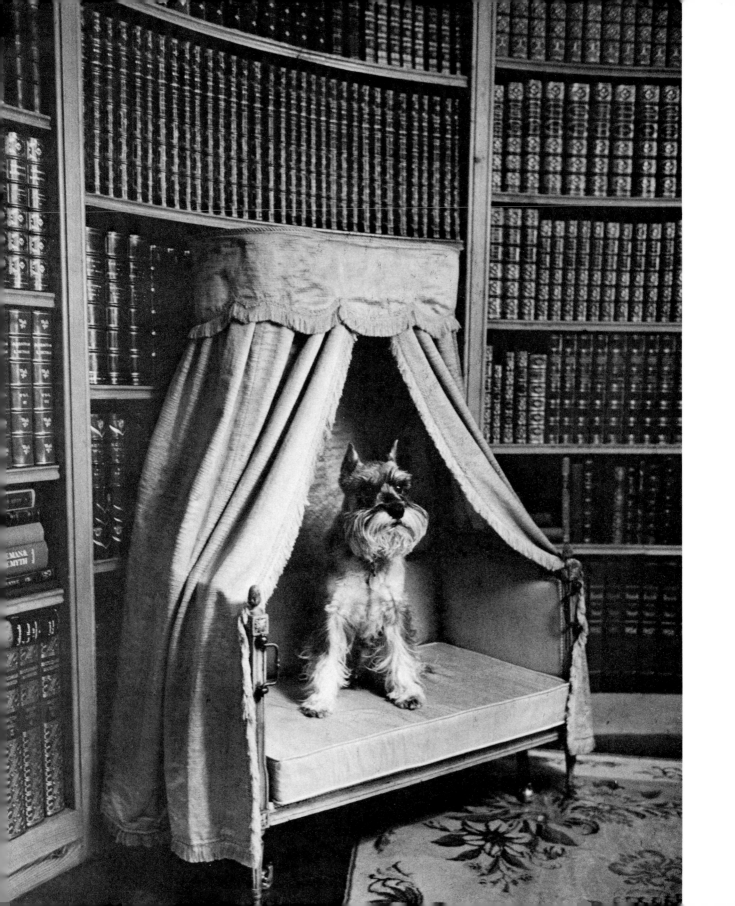

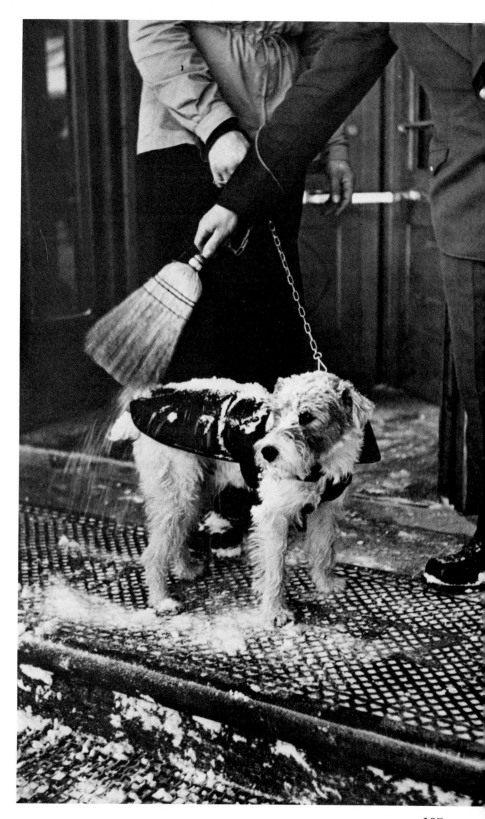

Two pictures of "society dogs." The schnauzer at left was the prize possession of a wealthy American dowager who fed her pet the choicest steaks on silver platters and furnished him with a two-hundred-fifty-year-old canopy bed that once belonged to Albert, King of the Belgians. It is the bed, of course, together with the expression on the dog's face, that makes the picture.

A slightly resentful Scottish terrier after being taken for a walk in the snow by his master's servant is left to be brushed off by the doorman at the Palace Hotel in St. Moritz. I was glad to come upon this scene just in time to catch this ritual in progress. A moment later and the picture wouldn't have been worth taking. The more you photograph, the more your camera becomes a part of you so that when you see something interesting, you don't have to stop and think, you simply stop and shoot.

One morning in a city park I saw these dogs being exercised by a member of a dog-walking service. After taking several pictures from a distance, I knelt down and got the above result—with a Leica and 35 mm lens—just at the right moment. The dogs looked bigger and more impressive from this angle than from above.

Looks, as can be seen below, are often deceptive. The rather comically vicious expression on the bulldog's face amused me so much that I risked stopping to take the quickest picture I possibly could. Contrary to my expectations, however, the dog turned out to be not only obliging, but one of the sweetest creatures I ever photographed. No telephoto lens was used, but an old 2¼ x 2¼ Rolleiflex.

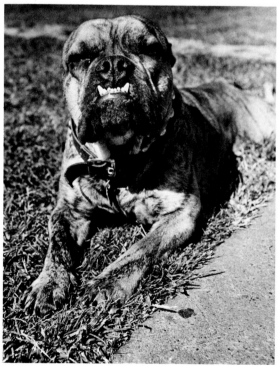

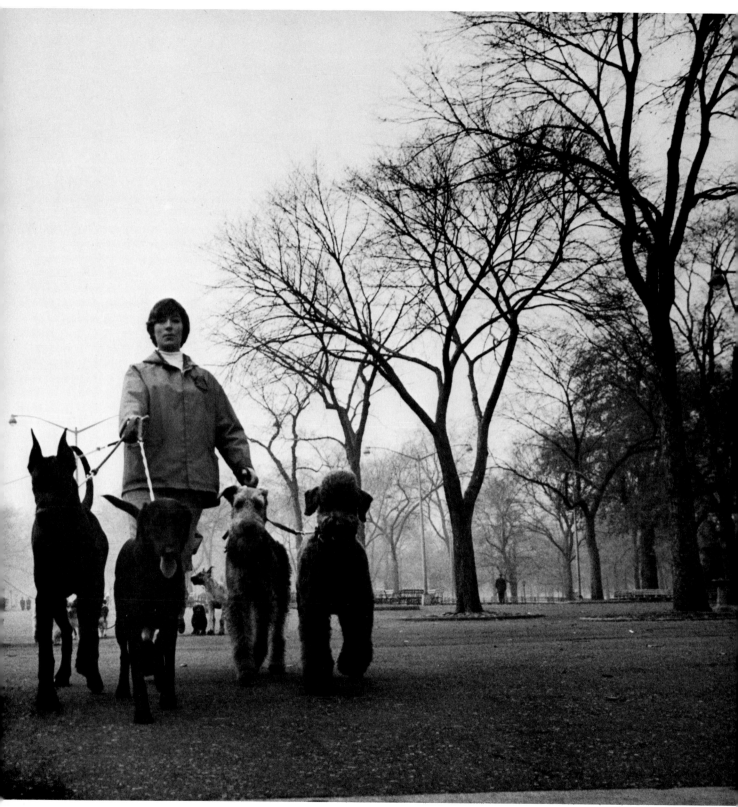

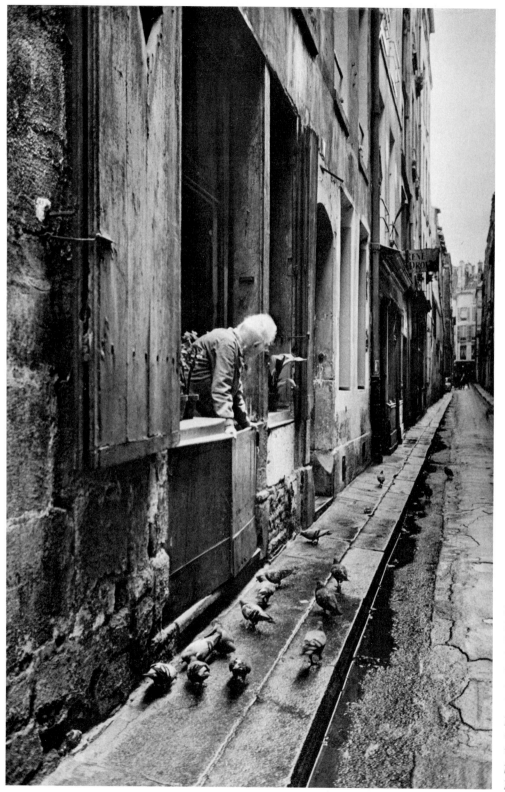

Early one morning while walking down one of the narrow streets of Paris's Left Bank with my rangefinder camera in hand, I came upon this white-haired lady who had just thrown some seeds out of her window for the pigeons. As I took the photo she was looking to the left, wondering why the pigeons were strutting away instead of eating. Her presence gives the picture human interest, without which it would mean very little.

This picture, too, isn't so much an animal study as a picture made unusual by the presence of cats. One of the exciting things about photography is coming upon the unexpected and being able to record it in a split second. This is particularly true where people and animals are concerned. Moments after I made this exposure, the cats jumped down and disappeared.

The main emphasis here is on the eyes of animals. The pitch-black Persian cat was sitting on the floor, calm and relaxed after being fed its meal for the day. At first it paid little attention to me, so I got down on the floor, flat on my belly, and just managed to get this head-on view before she began to wonder what I was up to.

The face of the young langur, opposite, was taken on a hot afternoon in Sri Lanka. As I knew I would have to wait for a long time to get what I wanted, I set up a tripod, moving my arms and hands very slowly so the monkey wouldn't get nervous and unruly. In order to get the detail in the dark face, I exposed for that area and allowed the lighter hair of the animal to be overexposed so the face was framed like a halo. A single-reflex camera and a 400-mm lens was used.

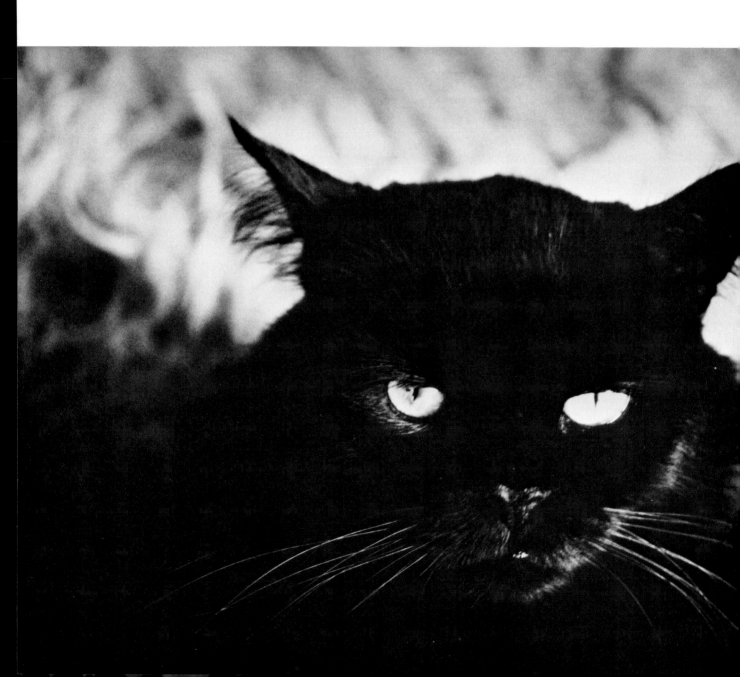

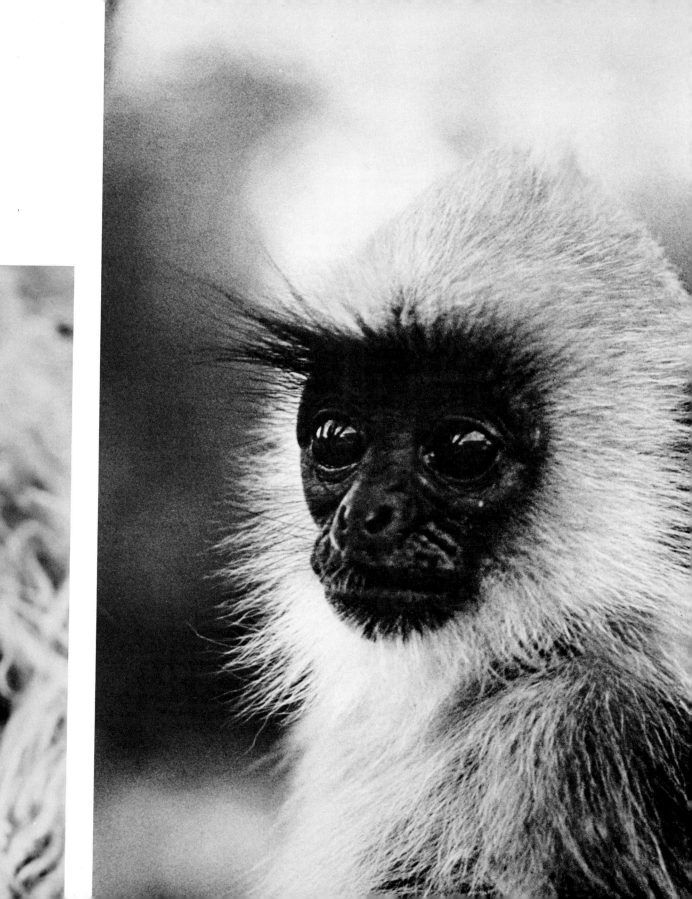

I shall never forget taking this picture at the 175,000-acre Bevin Ranch in Texas. I was warned, while photographing, not to move out too far, otherwise one of the bulls might charge at me. Being a "fanatic" with a camera, I naturally disregarded the advice and gave the cowboy a signal to chase the herd past me. Meanwhile the leading bull had already begun to race ahead and saw me standing in front of him—almost hypnotized. In that flash of a second I remembered having read somewhere that if you are attacked by a bull, you should look him in the eye and not step aside until he is a foot or two away, then do so quickly. Luckily, that was what I did. The first thing the Life editors asked when I got back to New York was whether I had photographed the bull charging right at me. I hadn't. But I did manage to photograph him seconds after he passed me. I used a 35-mm lens with a shutter speed of 1/1000 of a second, which stopped the action.

112

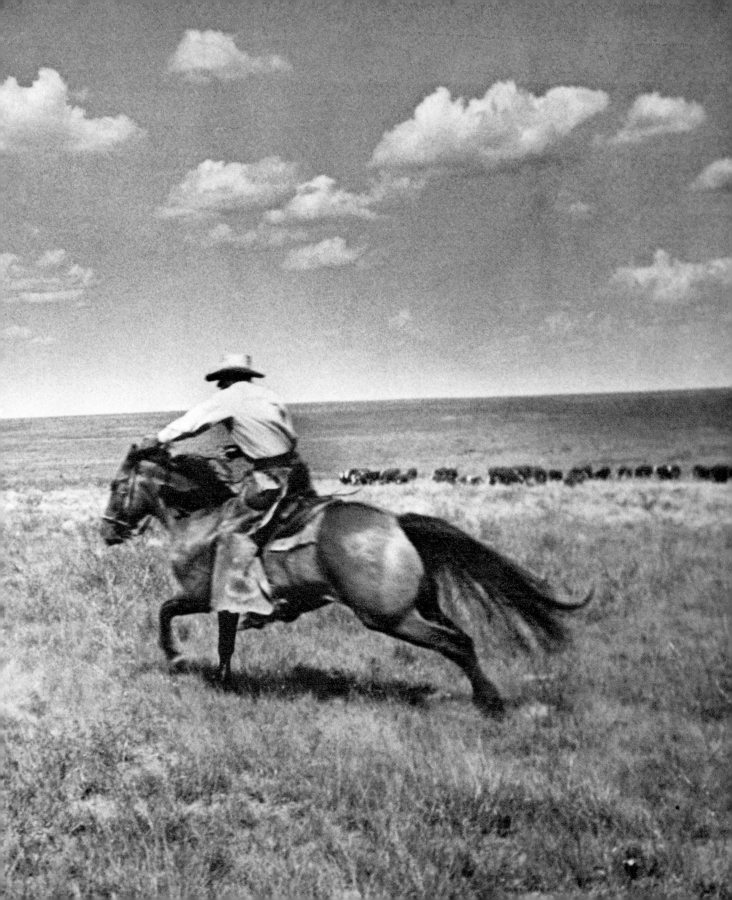

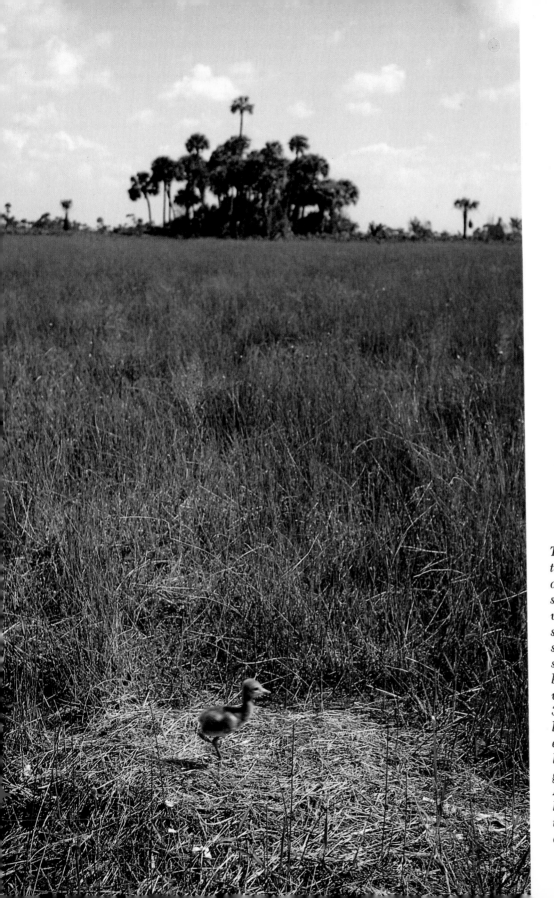

The advantage of carrying a telephoto lens for landscape or nature pictures is demonstrated here. Both pictures were taken from the same spot. Without frightening the sandhill crane it was impossible to get closer to the little bird than I did at left, for which picture I used a 35-mm lens. To see what the bird really looked like, however, I substituted a 90-mm lens for the 35-mm and got the result shown at right. A skylight filter was used for both pictures, which were taken shortly before nine o'clock on a sunny morning.

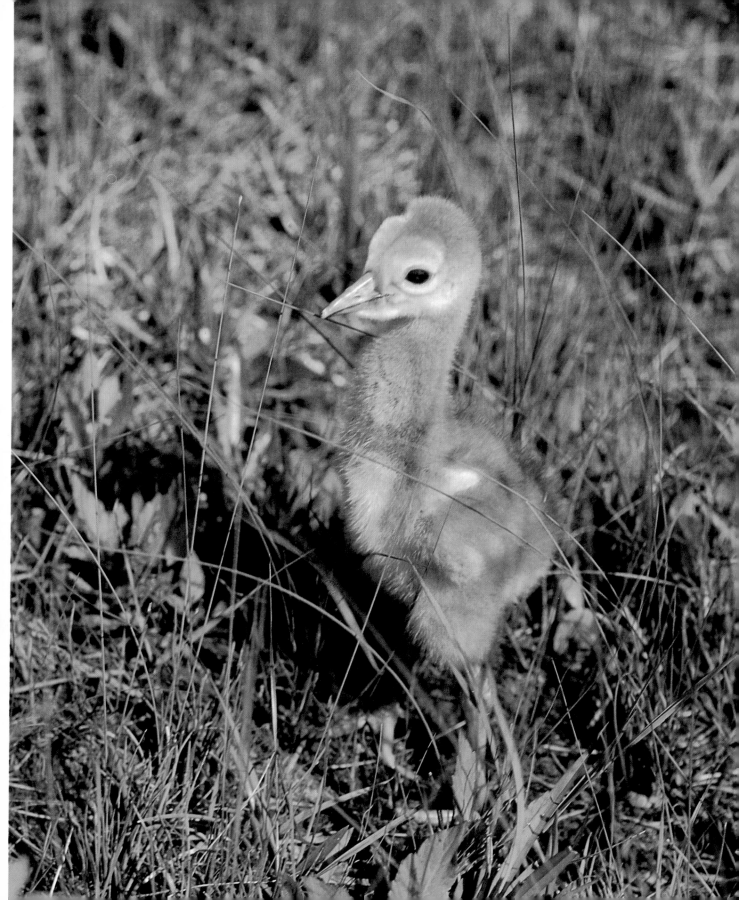

The most important thing in wildlife photography is patience, patience, and more patience. This is particularly true where birds are concerned. The two little herons below, however, were too young to fly, so once I spotted them and trained my telephoto lens on the nest, the picture was made quickly. On the other hand, I had to wait nearly seven hours with a Leica and 400-mm lens mounted on a tripod before I got the photograph of the flying heron at right. The shutter speed was set at 1/125 of a second, which allowed the wing tips to blur slightly, giving the feeling of movement. A faster shutter speed would have frozen the action more and would have made the picture appear too static.

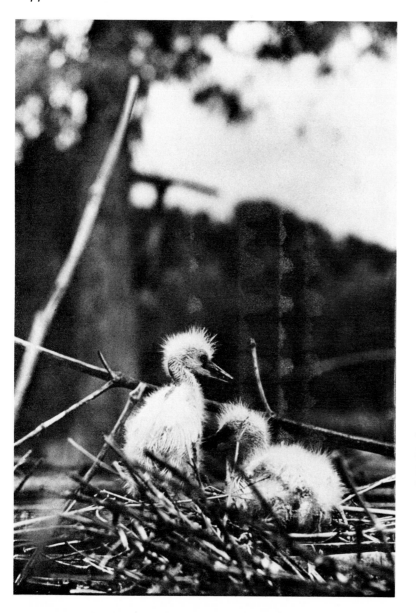

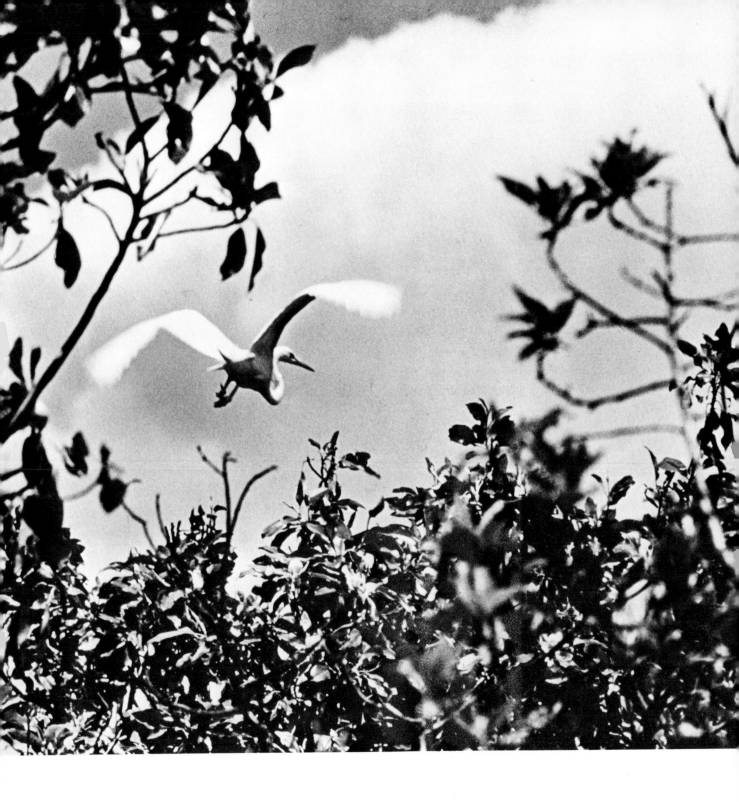

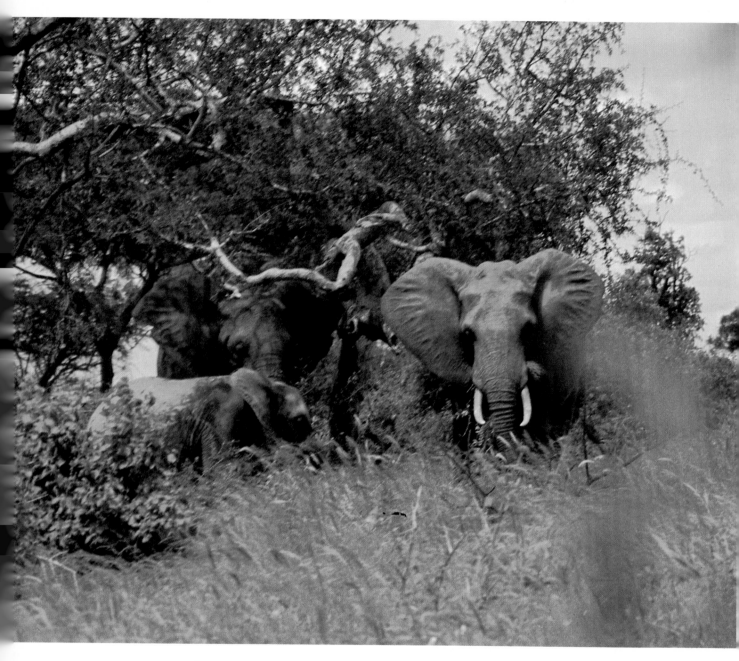

I came upon these brownish-looking elephants in Tsavo National Park in Kenya, where, after rather boldly leaving my Land Rover and making my way through the bush and thorny vegetation, I saw them throwing red dust at each other. At the click of my Leica one of them spotted me and started to rush toward me. I obviously managed to get back to the jeep in time. A note to prospective elephant photographers: if an elephant spreads its ears, raises its trunk, and begins to move toward you—run.

These three giraffes were photographed with a 200-mm lens from a car window in Krueger National Park, South Africa. This is one of the most difficult wildlife preserves for a photographer because it is so overgrown with greenery that the animals can vanish quickly. In Kenya or Tanzania, on the other hand, the landscape is so wide open you can see for miles and miles.

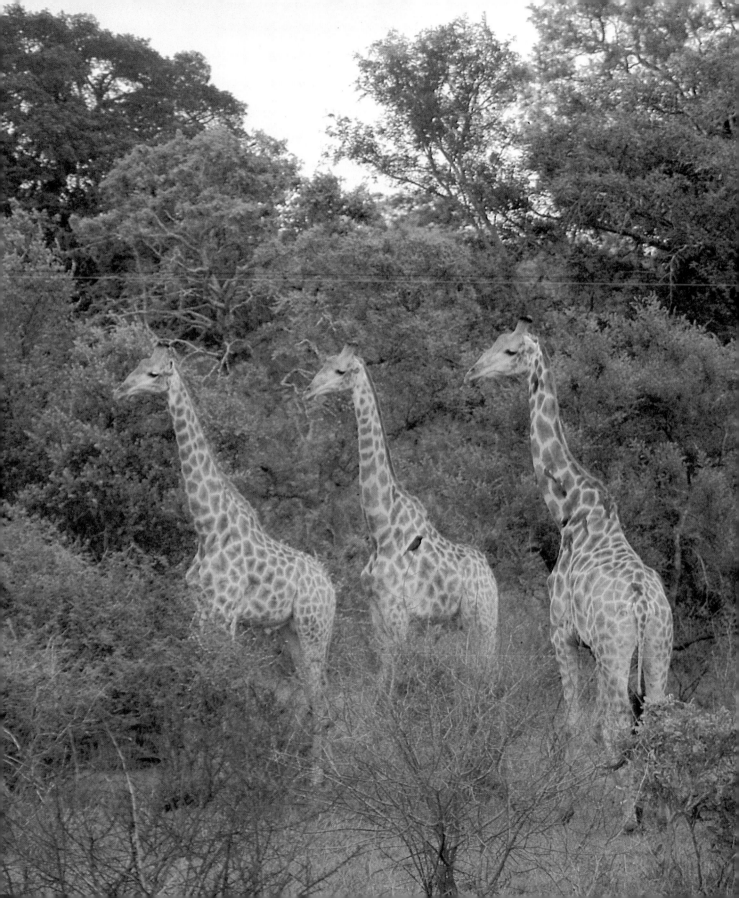

NATURE

Whether on a beach or in the woods, one will find a wealth of shapes, patterns, and colors from which to choose: the jewel-like quality of a flower, leaf, or seashell. In short, keep your eyes open and explore.

One can make successful nature photographs with virtually any lens. There is plenty of time to search out the best camera angles and to carefully compose the picture. I generally limit myself to one lens, such as the 50 mm, because I am then free to concentrate on the subject, not on equipment.

An SLR with a macro lens is ideal for extreme close-ups and opens up a whole new realm of photographic possibilities. With this type of lens I am able to focus from infinity right down to a distance of four inches. Minute details of a flower or leaf can be captured on film and shared with others. Similar magnifications can be obtained more economically through the use of close-up lenses that attach to the front of the lens like a filter. Extension tubes provide better resolution than close-up lenses but require an increase in exposure.

By studying nature you can learn so much about color and design that your own sense of pattern and composition is bound to develop and, in time, help you take better pictures.

The patterns of nature—and so many millions of them are to be found in flowers and trees and foliage—can become a photographic hobby in itself. I always liked the patterns of caterpillar-eaten leaves, but never could I find a leaf that was otherwise intact. Either the stem was too short or the rim of the leaf was damaged, or something else was faulty. Then suddenly one day I came upon this example. I took it home and, with a dab of rubber cement, fastened the leaf to the window and photographed it against natural daylight with a macro lens mounted on a single-reflex camera.

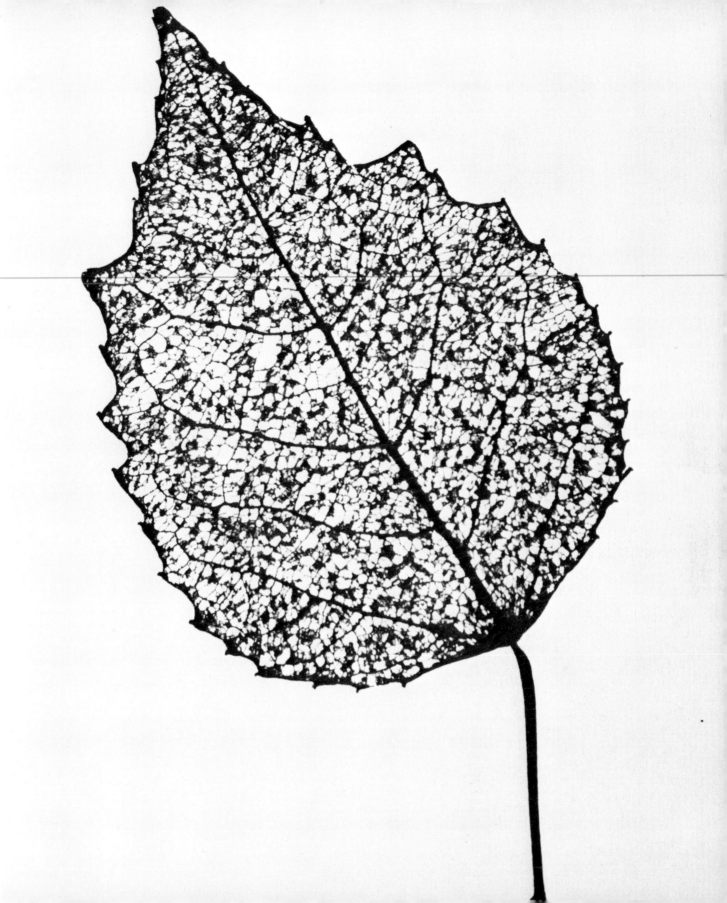

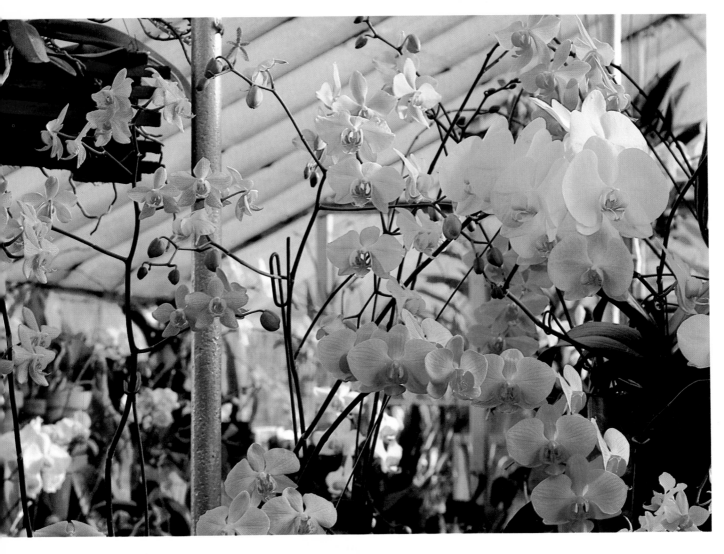

Both pictures of the moth orchid (*Phalaenopsis*) were taken in a greenhouse around noon in February, which is when this particular orchid is in full bloom. The overall shot was taken with a 35-mm lens on a hand-held camera. For the close-up, a steady tripod was an absolute necessity. I had to turn off all the fans and even control my breathing in order not to disturb the utter stillness of air in the greenhouse. Any movement of the flower during the more than ten-second exposure would have resulted in a blurred picture. A 90-mm lens is attached to a bellows mounted on a Leicaflex. I used a small aperture in order to get the maximum depth of field, which is often important in extreme close-ups. I timed the exposure with a stopwatch in one hand while using the other to control the shutter with a cable **release**.

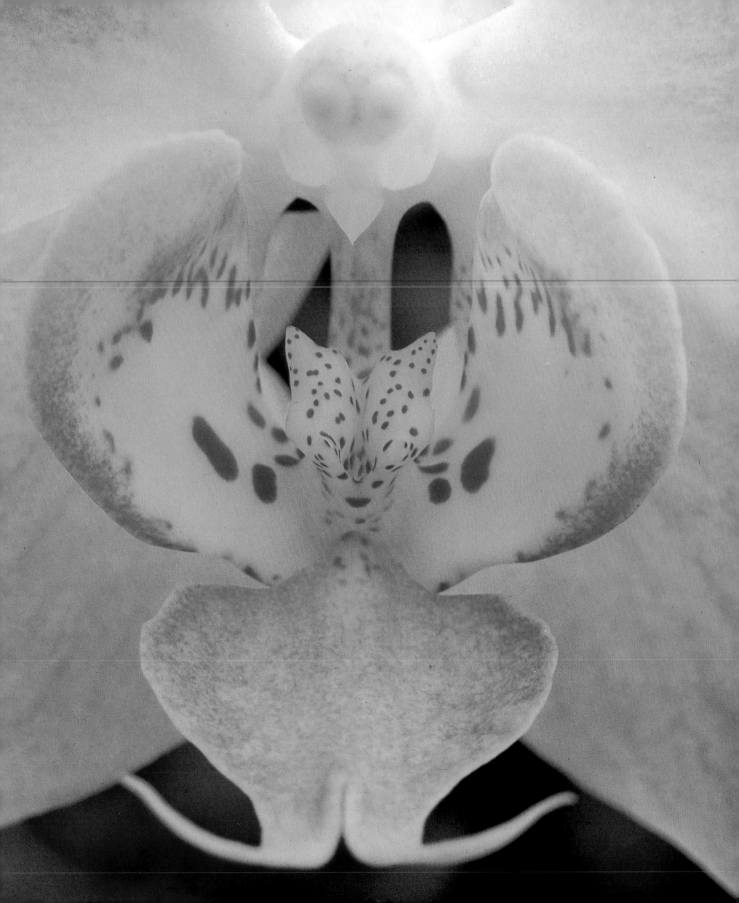

Both photographs of treetops silhouetted against the sky are part of a series I made in the tropical rain forest of Surinam. I used a 28-mm lens which gave a wide-angle view, emphasizing the height of the trees, which were photographed from a somewhat unusual vantage point.

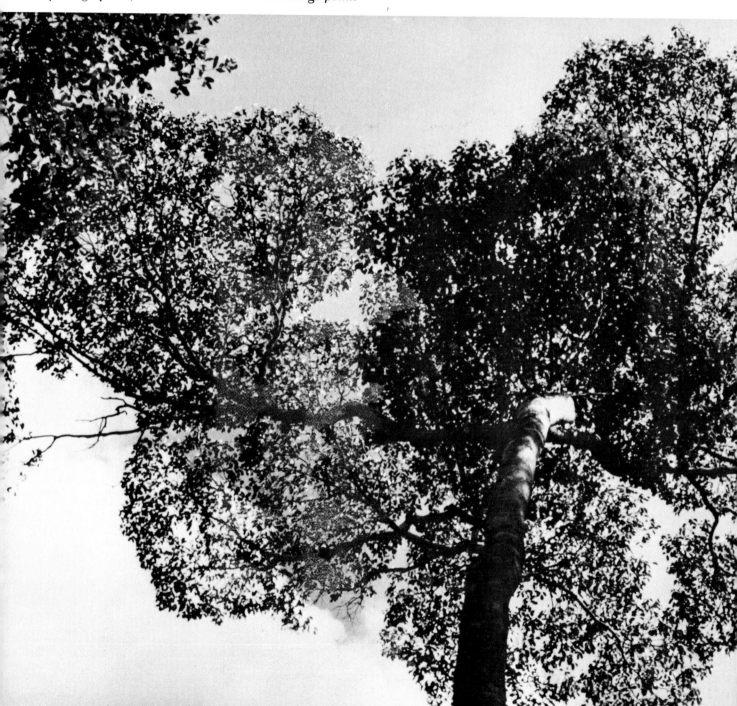

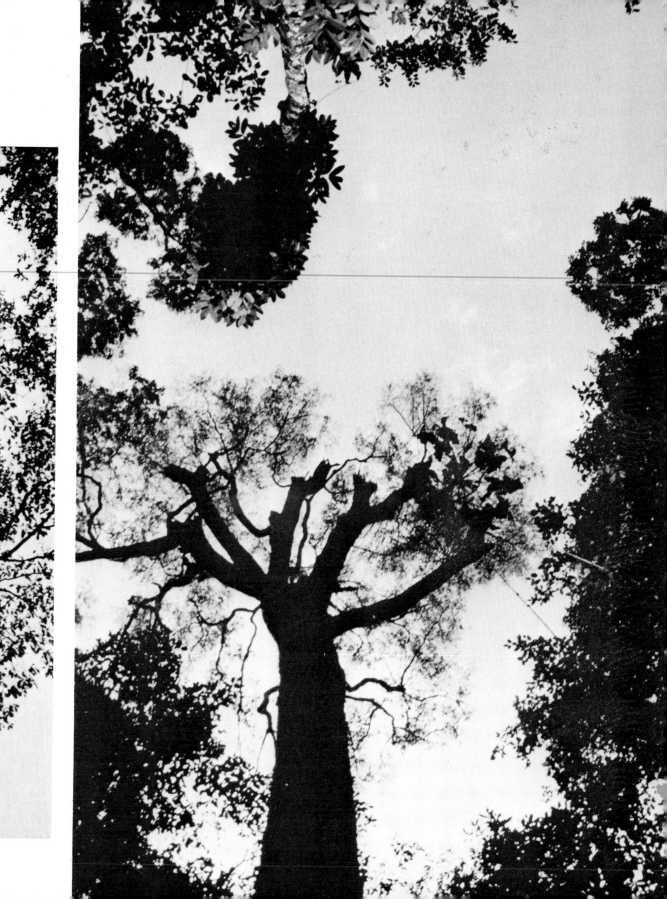

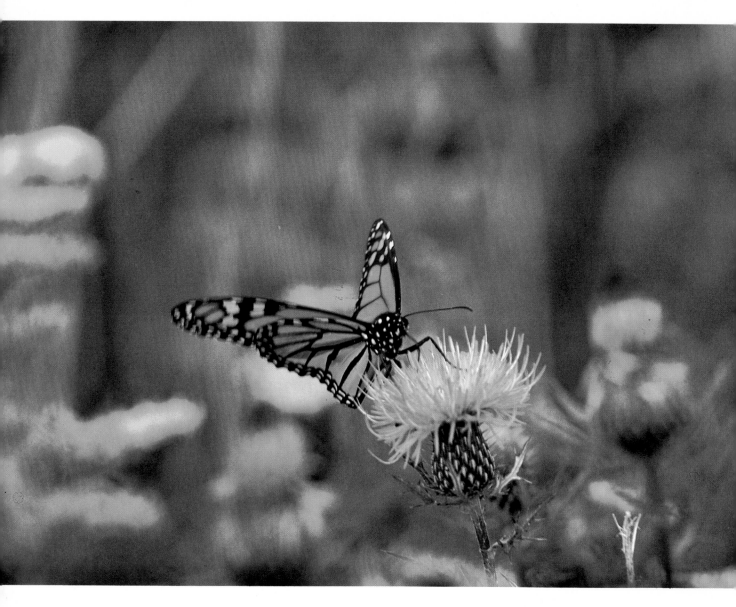

In late August and early September the flower of a thistle is a great attraction to Monarch butterflies prior to their long journey south before the cold weather begins. I waited near this thistle until a Monarch finally alighted on the flower and started his feast by pushing his proboscis into the nectar. This photograph was taken from a relatively close position with a 200-mm telephoto lens. By using a large aperture I was able to emphasize the subject, which is in focus, and have the background an out-of-focus blur. The 1/250-second exposure was fast enough to freeze any motion of the subject.

I have always had a passion for cosmos and have photographed versions of this flower with all kinds of lenses, filters, and prisms. For the picture opposite, which is purposely soft and hazy, I used a 500-mm mirror telephoto lens on my single-reflex camera supported by a tripod. The mirror lens has a fixed aperture, so I positioned the camera close to the flower and allowed the background to be blurred.

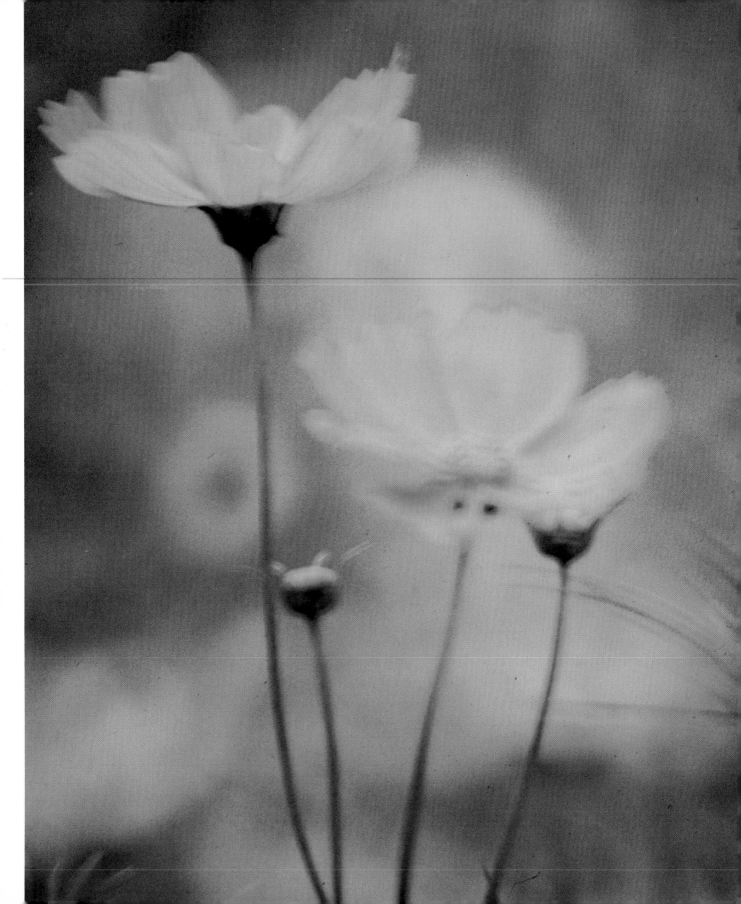

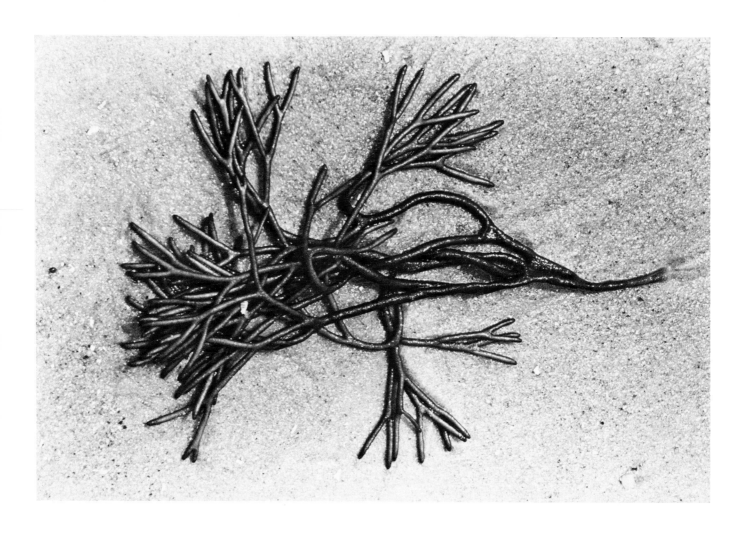

Beaches yield all sorts of interesting things to be collected or photographed: for instance, driftwood, seaweed, and shells. For outdoor still life, as here, I seldom try to rearrange anything, as nature has a way of doing things best. More important is to find the angle from which the object that interests you composes itself best. Both photographs here were made hand-held with a 55-mm Micro-Nikkor lens and Nikon camera.

OVERLEAF: Seaweed may not strike one as an interesting photographic subject, but for me it is. The subtle colors and delicate texture of the example shown here make this one of my favorite beach details. It was taken under a light overcast sky shortly after the tide had receded.

128

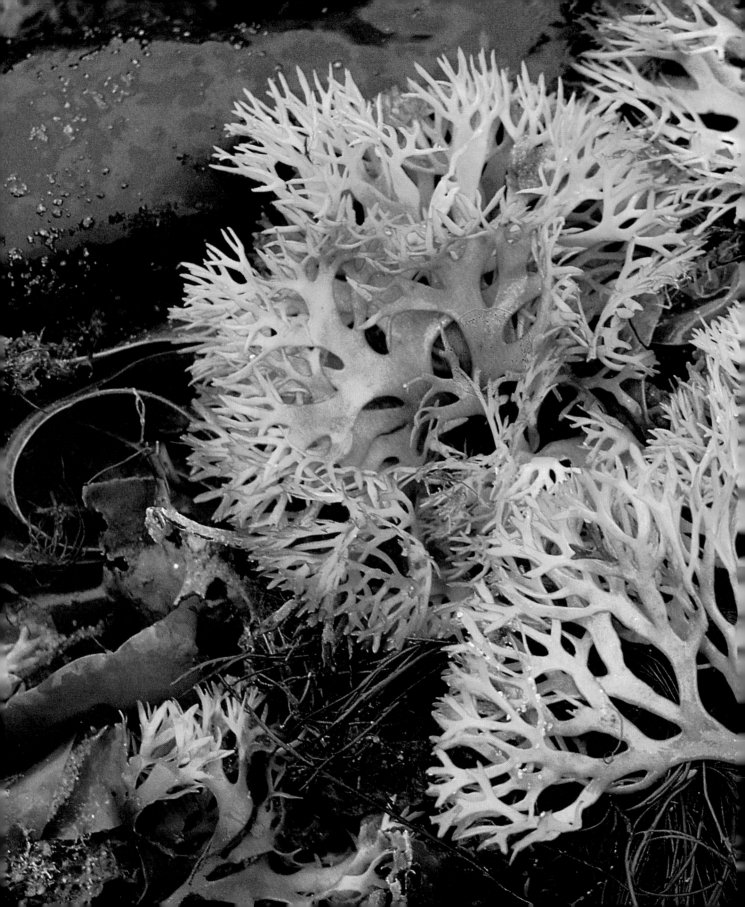

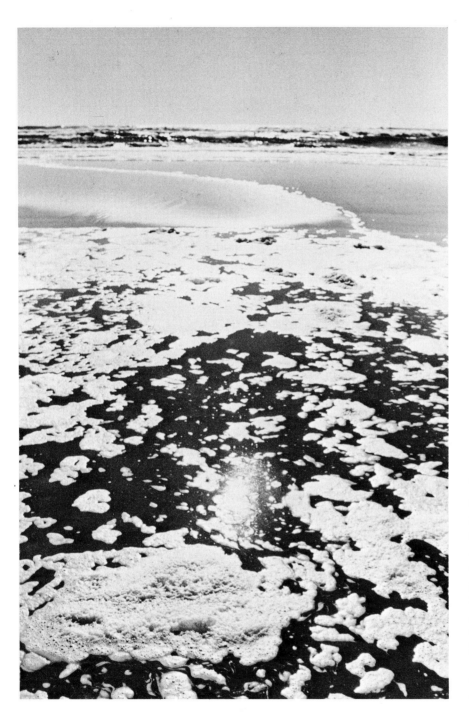

When walking along the beach I usually carry a 55-mm Micro-Nikkor lens, hoping for a situation that doesn't often happen—like this one. It was after a heavy storm, and the ocean waves created wonderful foam patterns many miles long. Out of the dozens of pictures I took, I chose one general view and a close-up of the scene, both of which are among my favorite compositions. The general view was taken with a wide-angle lens and the one opposite with the 55-mm Micro-Nikkor lens.

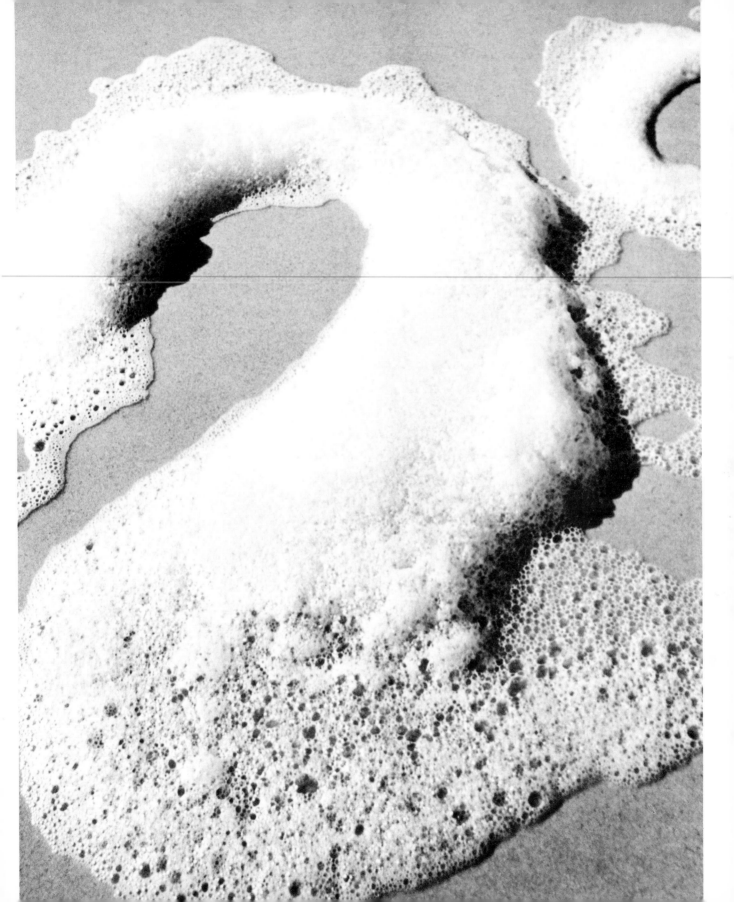

TRAVEL

People tend to take most of their pictures while on vacation. It's quite natural to want visual reminders of all the interesting places one has visited. Holiday photography, in addition to making a record of a trip, usually affords an excellent opportunity for improving technique, developing the eye for better composition, and experimenting with equipment.

My advice is to travel as light as you can. If you load yourself down with a lot of equipment, you may find yourself more concerned with choosing the right lens than with taking a good picture.

Nearly every situation can be covered with three lenses: a normal lens for general coverage, a wide-angle lens when you are working in confined spaces, and a telephoto for shots when it's impossible to get right up to the main subject. A tripod or monopod is helpful for dimly lit interiors like churches or houses, and for night photography. If your mission is to shoot wild animals from a distance, you will need a long telephoto lens (200 to 500 mm).

One mistake I see people make everywhere I go happens when the photographer wants a picture of his family in front of some famous landmark. Invariably one or more subjects are placed next to the monument, or whatever, while the photographer moves far enough away to fit the whole scene into the frame. The resulting photograph will usually show, at best, a barely recognizable tiny person in front of the overwhelming background. My advice is to position the subject fairly close to the camera, with head and shoulders in the frame, and the landmark, possibly out of focus, in the background.

I enjoy photographing people on my vacations, and find that the best way to catch them in their natural behavior is to be unobtrusive and to blend in with the background as much as possible. At the same time one must always be alert and try to anticipate some interesting action so you are ready for those fleeting moments that happen only once.

It doesn't make sense to be afraid of taking a lot of holiday pictures, because film and processing represent such a small proportion of your vacation budget, particularly in relation to the lasting satisfaction that photographs bring.

134

The most beautiful building I have seen anywhere is the Taj Mahal in India. I spent hours in Agra contemplating this architectural masterpiece before deciding from which point of view I might get an interesting photograph and one that I hoped would be different from the many we have all seen before. I made one series of photographs head-on at different times of day, from dawn till moonlight, and another more unusual series from behind a bougainvillea bush. For the picture here, I focused the 35-mm lens on my Leica on the building, keeping the flowers purposely unsharp—like splotches of color—in the foreground. As the sky was very blue and the film, at that time, more sensitive to that color, I used a skylight filter.

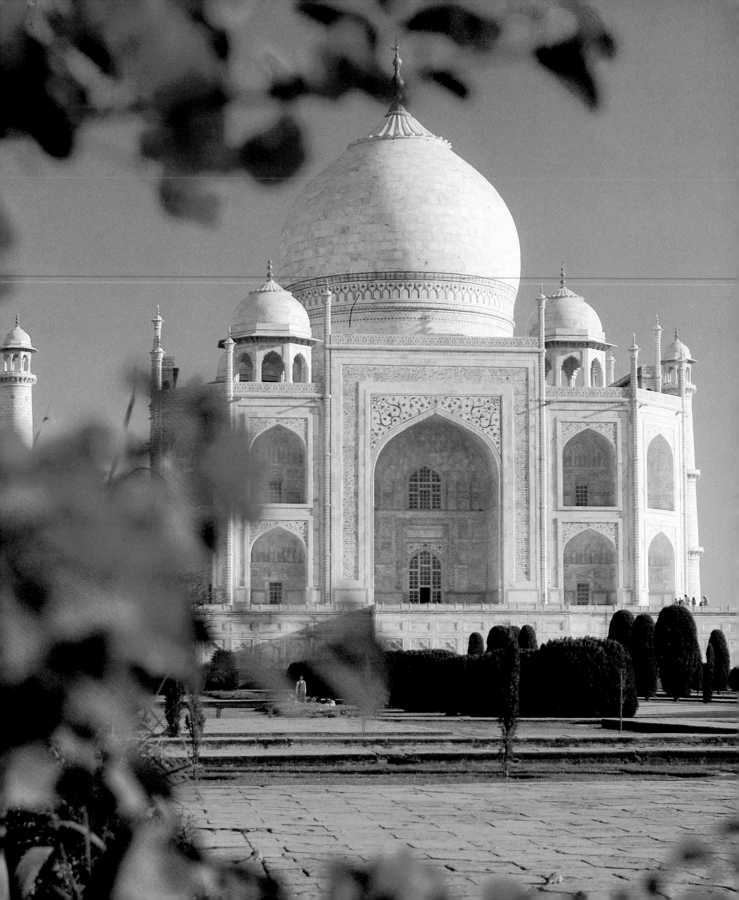

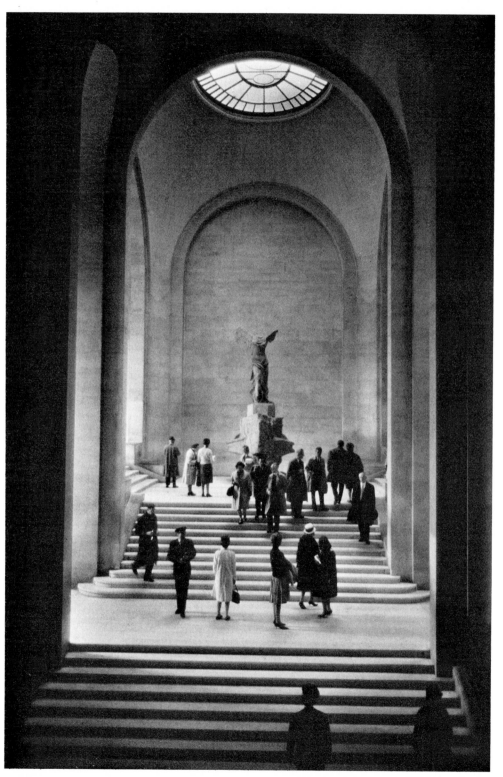

Sooner or later, everyone who travels to Paris visits the Louvre. It was my idea to take a photograph just inside the entrance where the stairs lead up to the Victory (or Nike) of Samothrace and to catch just two people on the steps. I was unable to carry out the idea because there were too many visitors, not to mention too few people of pleasing proportions. After waiting for ages, I decided to make the best of it and took this photograph, using a 35-mm lens and available light only.

I can't imagine how many photographs have been taken of this replica of Michelangelo's David and Cellini's Perseus with Medusa's head in front of Florence's Palazzo Vecchio. As usual I wanted something different, and therefore chose this point of view after a great deal of deliberation. My idea was to show how photographically effective a white marble statue and the silhouette of a dark green bronze statue can look against a subdued background. A Leica camera and 35-mm lens were used.

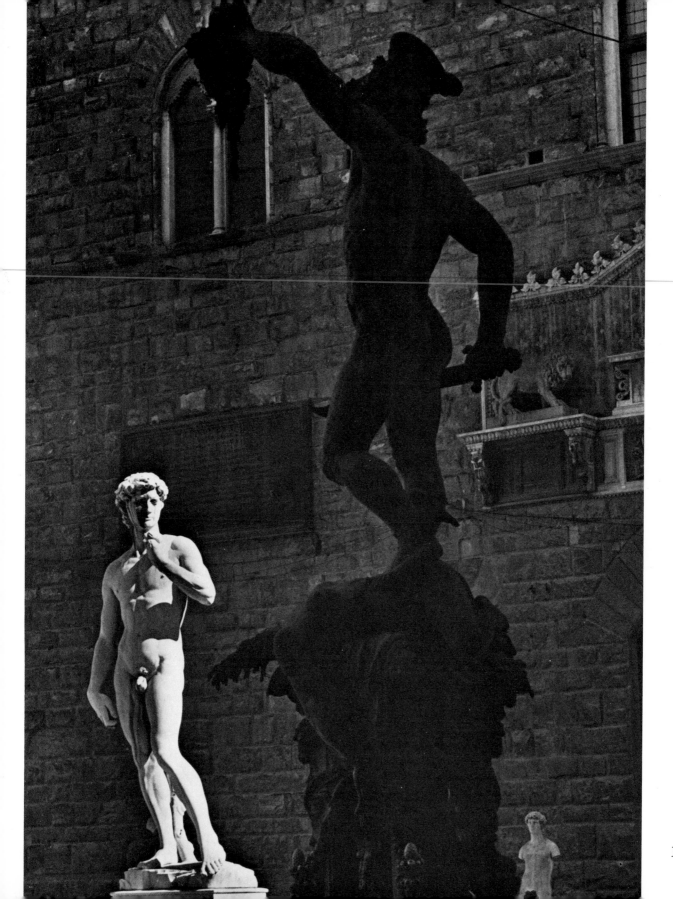

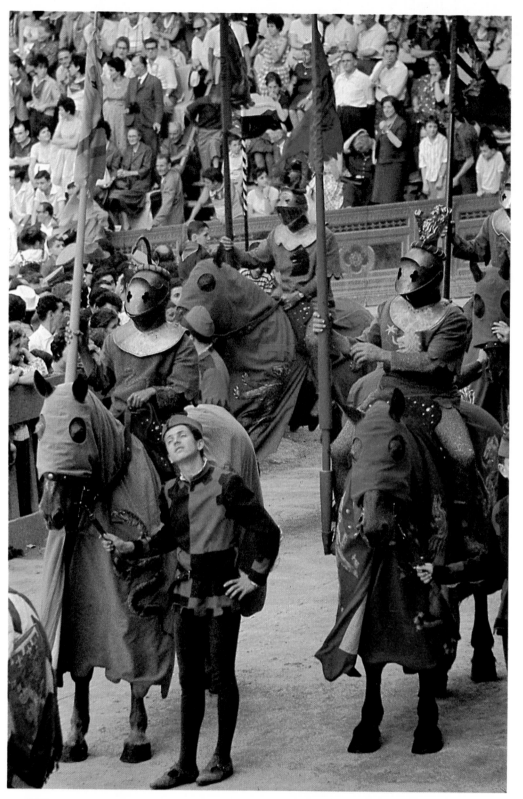

The Palio festival is held annually at Piazza del Campo in Siena, Italy. I took this colorful scene, which preceded a medieval horse race, from my seat on a low balcony.

The Leaning Tower of Pisa is another famous landmark that has been photographed time and time again. Looking around for a foreground to frame the scene, I spotted the old spun-glass windows of a nearby hospital. Permission was granted to photograph from inside the building, where I took the picture shown opposite.

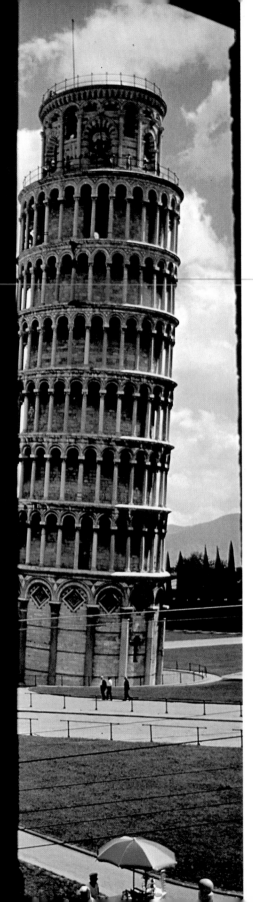

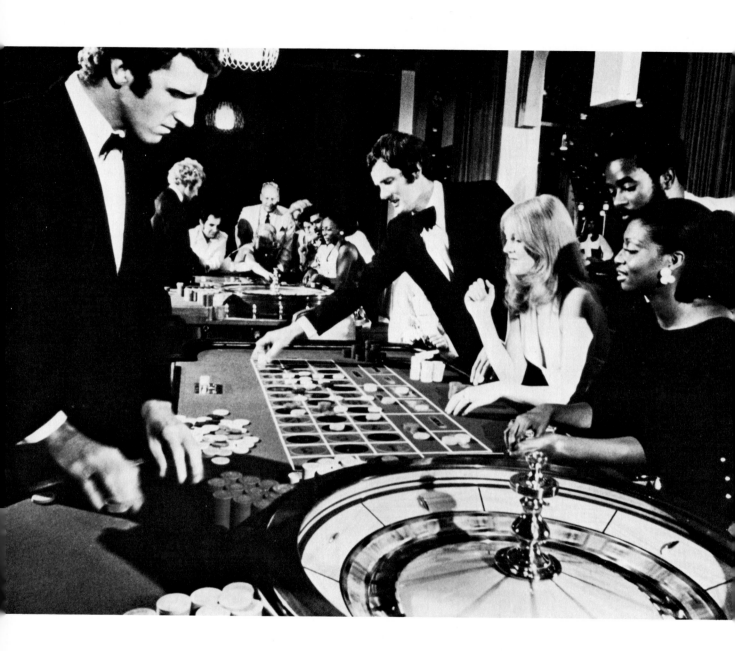

For some people gambling is one of the attractions of the Bahamas. This photograph, originally taken in color, shows a typical scene at the roulette tables of one of the casinos in Freeport.

The objects in the window of this antique shop caught my attention, so I looked for an interesting angle from which to photograph them. This view was from the inside with a 28-mm lens.

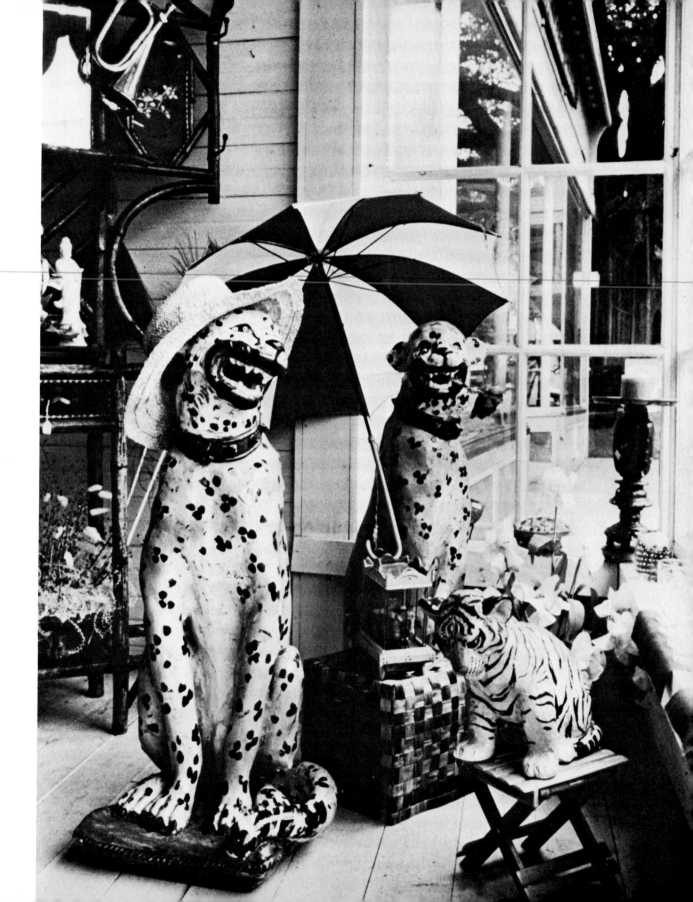

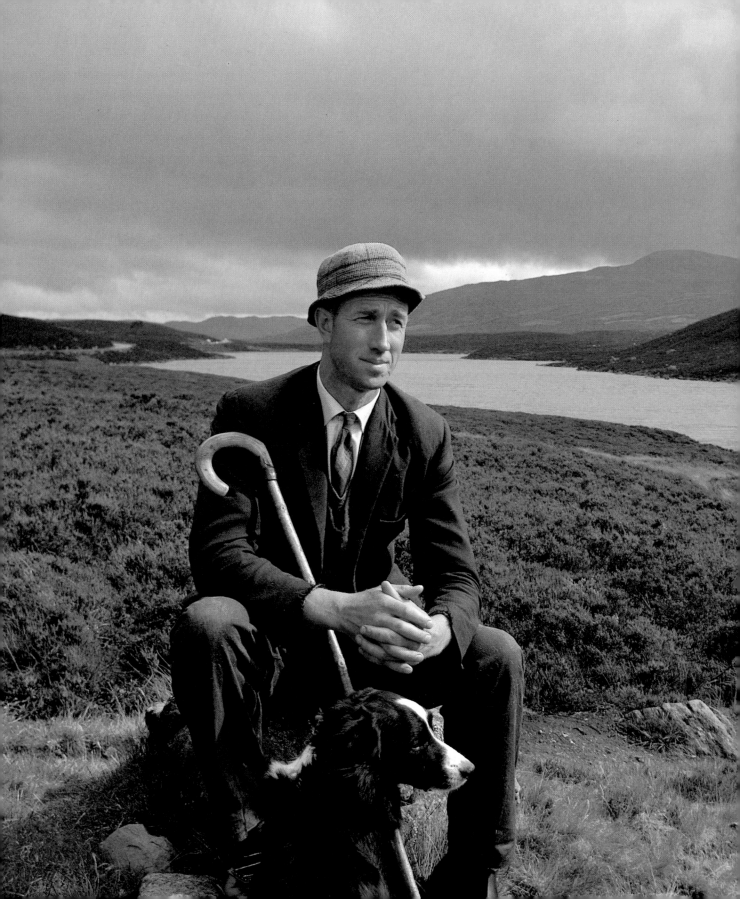

John Murdoch, a Scottish shepherd from Inverness, sat for a portrait (left) at Lammermoor *with* his constant companion, his dog. It wasn't *an* easy picture to take. First there was a search for just the right spot where he could sit naturally with no houses or power lines to disturb the scenery; then an hour or more of waiting for a moment of sunshine to lighten up his face; then another ten minutes before the dog decided to sit still, and so on. But this kind of thing is to be expected. The two pictures above, also taken with a single-reflex camera, were photographed nearby on different days.

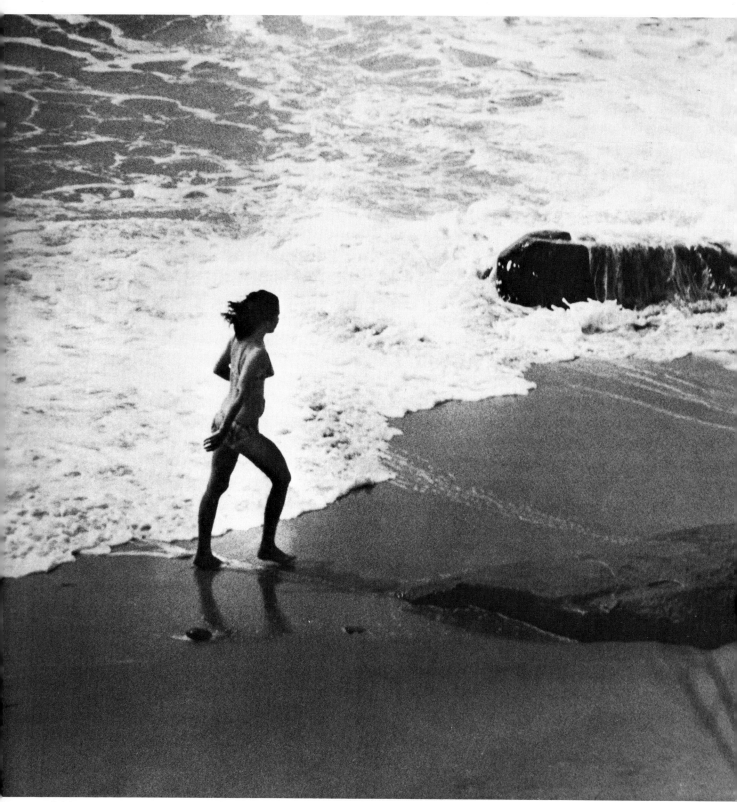

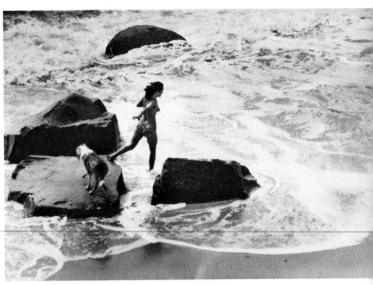

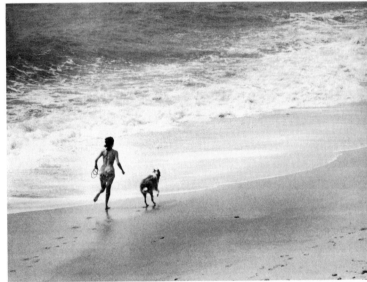

Wherever he goes, a photographer has to have his camera
and his eyes and wits about him because so often it is
the unexpected subject that provides the best picture.
One summer day I was photographing cloud formations
from a high cliff overlooking the ocean when suddenly
I saw a girl in the distance leapfrogging through the surf
with her dog. It was a lovely sight. Fortunately, I had a
200-mm lens with me and had time to attach it to the
camera and catch her in these three different positions.
All pictures were made using a light yellow filter with
a 1/1000-second exposure to freeze motion.

145

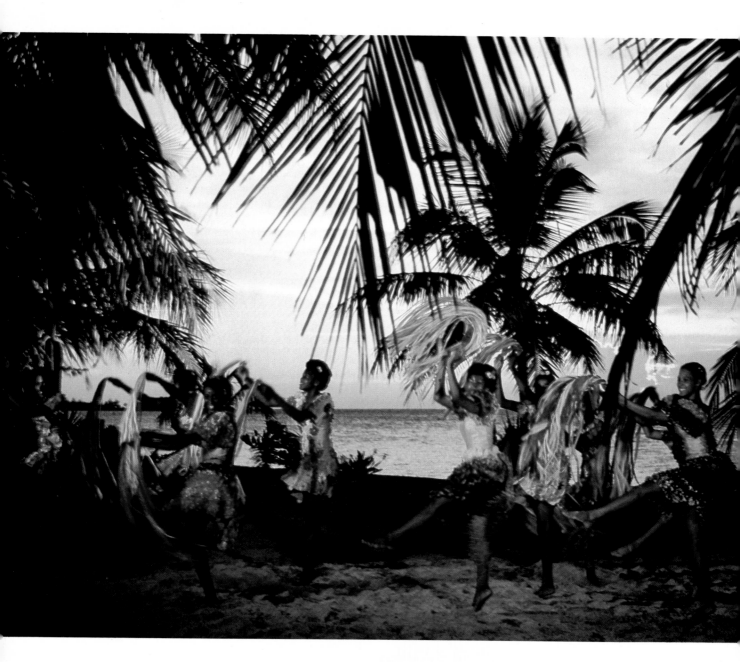

These two pictures convey the happy atmosphere during carnival celebrations in the Bahamas. Knowing that additional lighting would be needed for the early evening scene above, I took two photo flood lamps to illuminate the dancers.

The boy opposite, dancing to the beat of a steel band, was photographed at night. A movie that was being filmed of the proceedings provided me with light for this picture, which was later used as a poster. Both photographs were made with a fast shutter speed to minimize blur caused by movement of the subject.

146

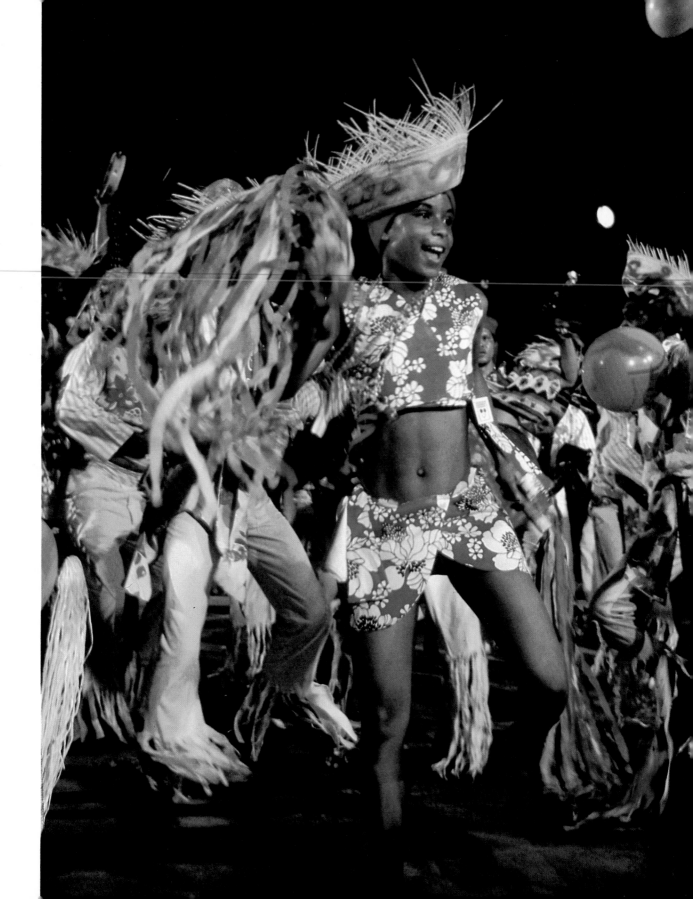

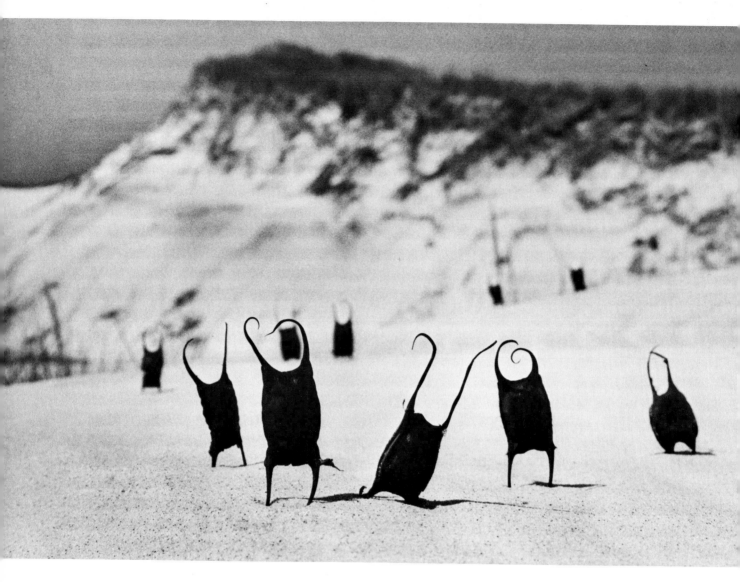

When traveling one should always be on the lookout for the unusual as well as the obvious, for quaintness and humor as well as beauty. The group of dried black eggshells of the skate fish (above) looked to me so much like people dancing that I could not resist arranging them in a continuous line winding across the beach. The effect would have been destroyed if the sand looked disturbed, so it was necessary to photograph from a low viewpoint, which also captured the little scene in correct perspective.

Over two hours went by before I was satisfied. I used a Nikon camera and 50-mm lens, plus a yellow filter to darken the sky, separating it from the white sand.

The abandoned wooden house at right looked so unusual I felt compelled to photograph it for that reason alone. The tall branches of the tree that seem to be clutching at the house and at the sky add to its haunted look. The picture was taken with a Leica and 28-mm lens.

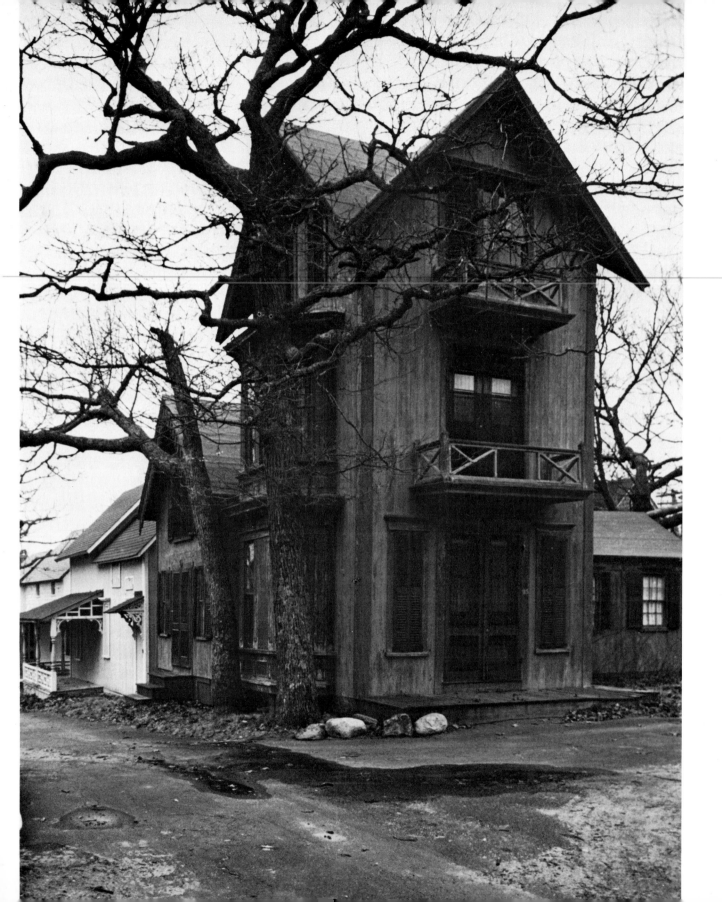

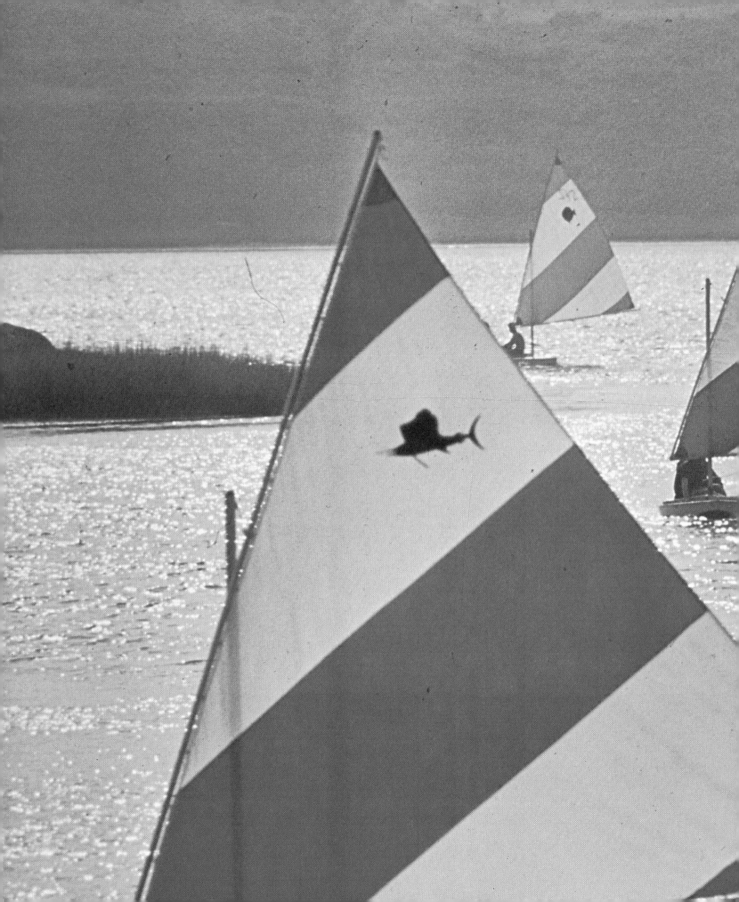

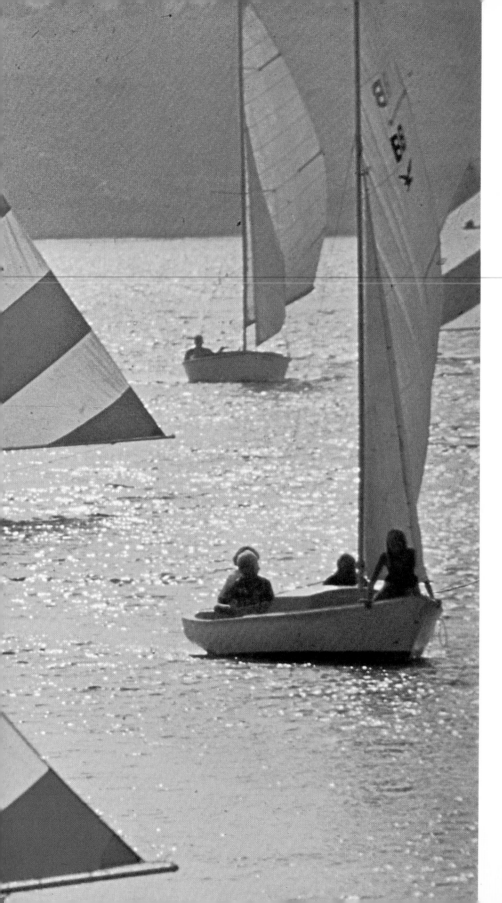

For years I tried to get a good photograph of a sailfish race, but either the background was not right, the wind was wrong, the boats were too scattered, or the sun went behind a cloud at an otherwise opportune moment. Patience again brought its reward with this late-summer photograph, which I consider one of the best holiday pictures I've ever taken. I was concentrating on the pattern of the sails against the effective backlighting and was finally able to take the photograph at about three o'clock in the afternoon. I took advantage of the optical effect of a telephoto lens (a 400-mm in this case), which tends to compress space and here enhances the composition by making the boats appear closer together than they were.

151

SPECIAL EFFECTS

The term "special effects" can cover a multitude of techniques, but here I use it in reference to experimental photographs or pictures with a gimmick. Just as I enjoy finding new subjects, I also enjoy discovering new ways of looking at familiar subjects, and, when I'm not rushed, I spend a lot of my spare time experimenting with new ideas.

Apart from the nature of the camera and film, the possibilities for experimentation are limited only by one's imagination. To help in this direction, many "special effect" gadgets have been invented, such as prisms and cross star filters, and new devices keep appearing on the market all the time. You can also experiment with equipment you already own, such as using filters designed for black-and-white photography with color film in order to produce intensified yellow, blue, or red effects. Or, for strange misty pictures or abstract compositions you can shoot through a piece of glass, or a filter that has been lightly smeared with Vaseline. Multiple exposures or shooting reflections are other possibilities. Any one of such things can be done in combination with another to produce still different effects.

A gimmick by itself does not make a picture; indeed it can often spoil an otherwise perfect shot. As in straight photography, it's important first to find an interesting subject, then to try to portray it in an interesting way. The subject should also be suitable for the special effect you wish to employ. If you have a definite theme or motif, so much the better. Many photographers have taken a passage from some literary classic and interpreted the theme and mood in a highly poetic way.

One word of caution: whatever your chosen special effect, use it sparingly in any kind of presentation you make. No matter how good it is, anything that is overdone or repeated too often loses its impact and becomes increasingly monotonous.

On the next few pages are a few experiments I have made in recent years that have pleased me. They are included in the hope that the reader may be inspired to go out and make experiments of his own and maximize the personal satisfaction gained through photography.

When I first saw this statue it struck me as a subject that might make an effective photograph if double exposed. Had I made both exposures at the setting suggested by the light meter, the resulting photograph would have been overexposed. Each exposure was therefore made with the lens stopped down 1 stop.

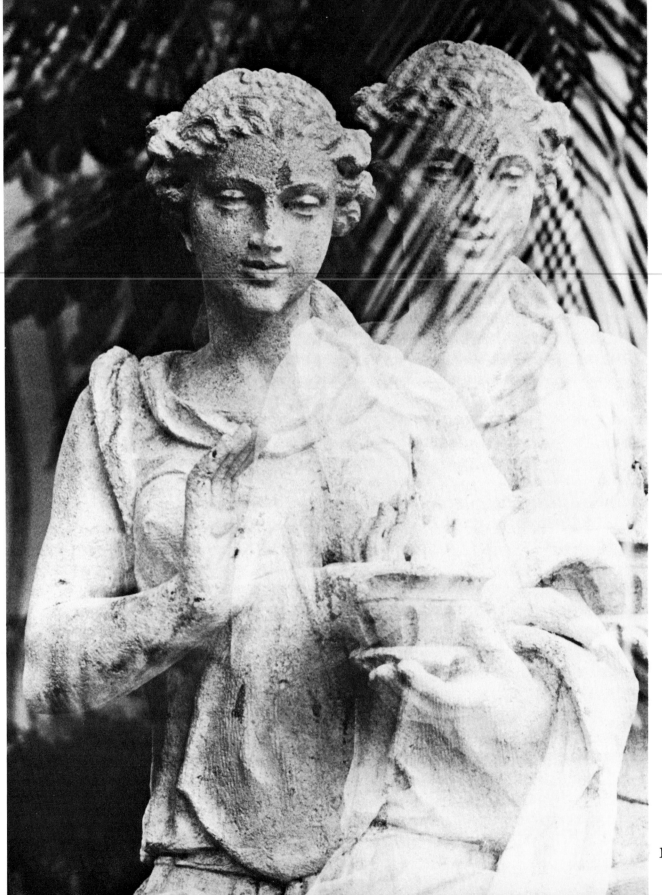

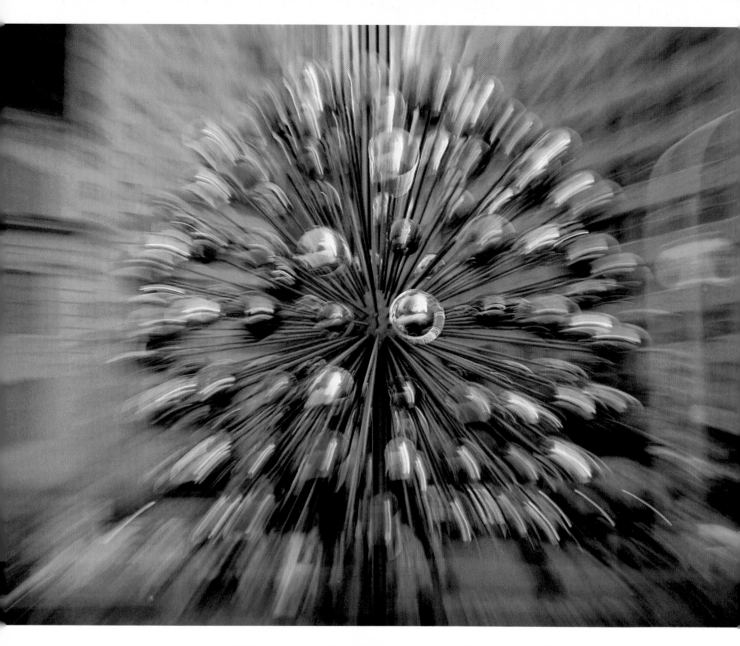

While experimenting **with a**
43–85-mm zoom lens, I was attracted
to the glass globes decorating a
fountain in front of a high-rise build-
ing and obtained this exploding
starburst effect by zooming during the
1/8-second exposure. For this tech-
nique it is essential that the camera
be held still during exposure. I have
found that I get the best results by
starting to zoom before releasing
the shutter.

Shop-window displays are fascinating subjects
to photograph. Almost endless abstract com-
positions can be made by incorporating the
reflections in the glass from the street behind
you. Very different results are obtained by
focus and the aperture which controls the
depth of field, so I use an SLR and normally
compose with the lens stopped down, varying
the focus and aperture till I see an effect that
pleases me. In this picture I felt it important
to have the mannequin in sharp focus, with
the reflected buildings slightly out of focus.

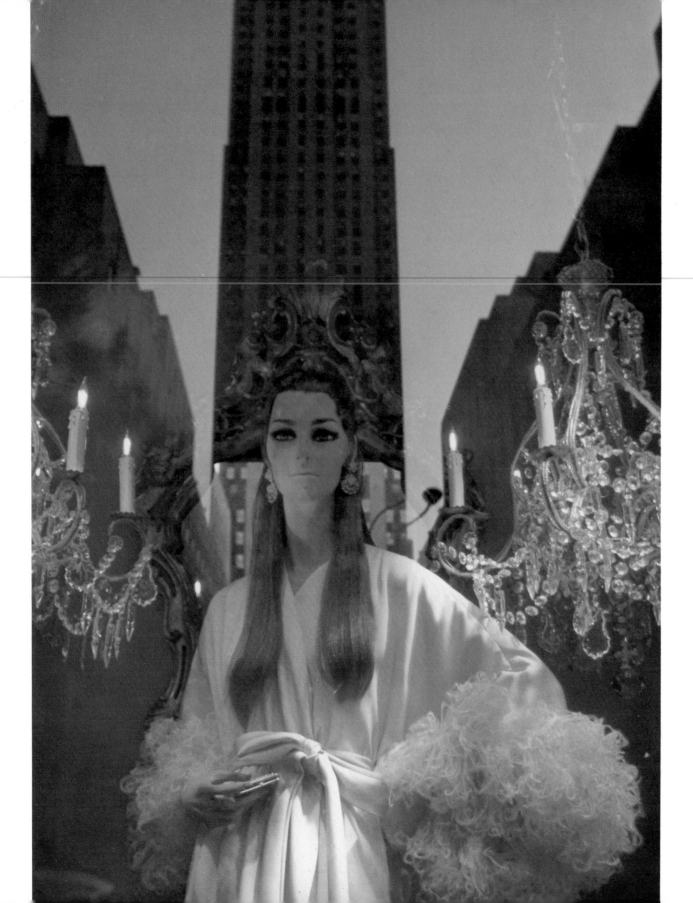

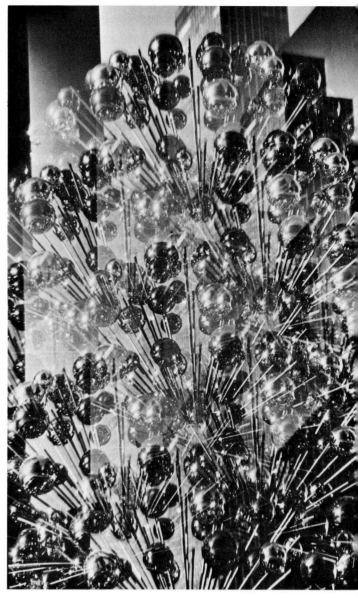

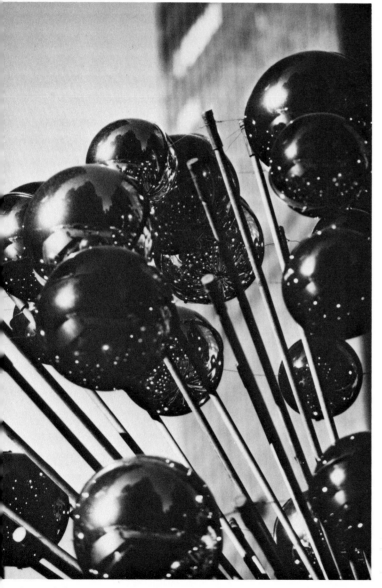

These three pictures are variations of the glass globes on the previous page. At left is a straight shot of part of the fountain, taken with a Nikon and 200-mm lens. The other two pictures are almost identical except for the lighting. The sun was shining on the globes from behind me in the illustration above, and onto the back of the globes in the illustration opposite. The difference is quite startling. For both studies I attached two 3P prisms (each of which produces three parallel images) positioned at 90 degrees to each other over a 50-mm lens.

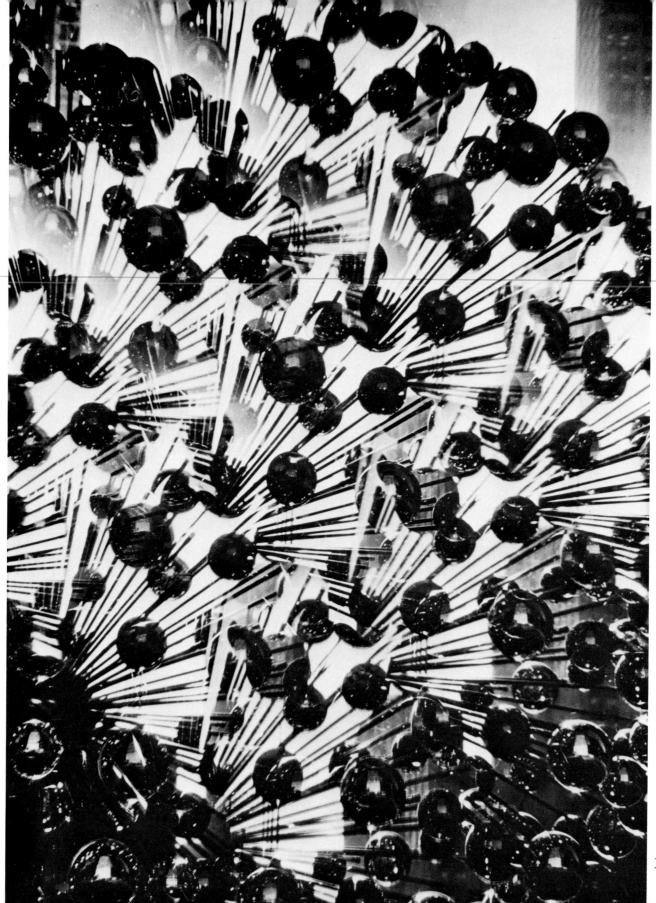

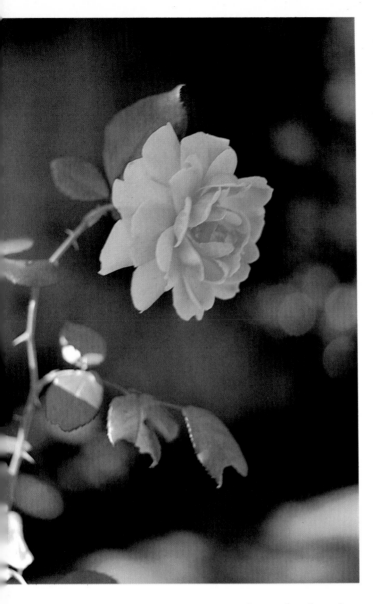

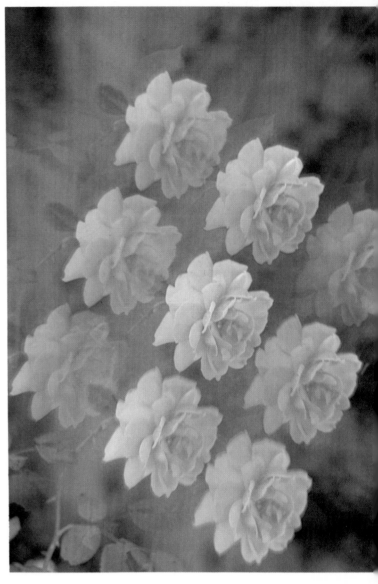

On weekends and vacations I usually carry a single-reflex camera and one or two prisms and filters while on the lookout for subjects that inspire me. It was toward evening when I came on this perfect specimen of a rose, softly lit by a ray of sunlight. I took the conventional photograph with a 50-mm lens, then attached two 3P prisms at a 90-degree angle to each other and created the nine roses in the second picture.

This unusual picture of a cosmos was taken with two 3P prisms at a 90-degree angle attached to the lens. I have found that the aperture opening has a great effect when using prisms. For this picture I focused on the darkish red flower and let the background go out of focus by using a wide aperture. I used a 50-mm lens on a Nikon, which I always prefer for prism shots because, as with reflections, it is essential that I see the effect through the picture-taking lens.

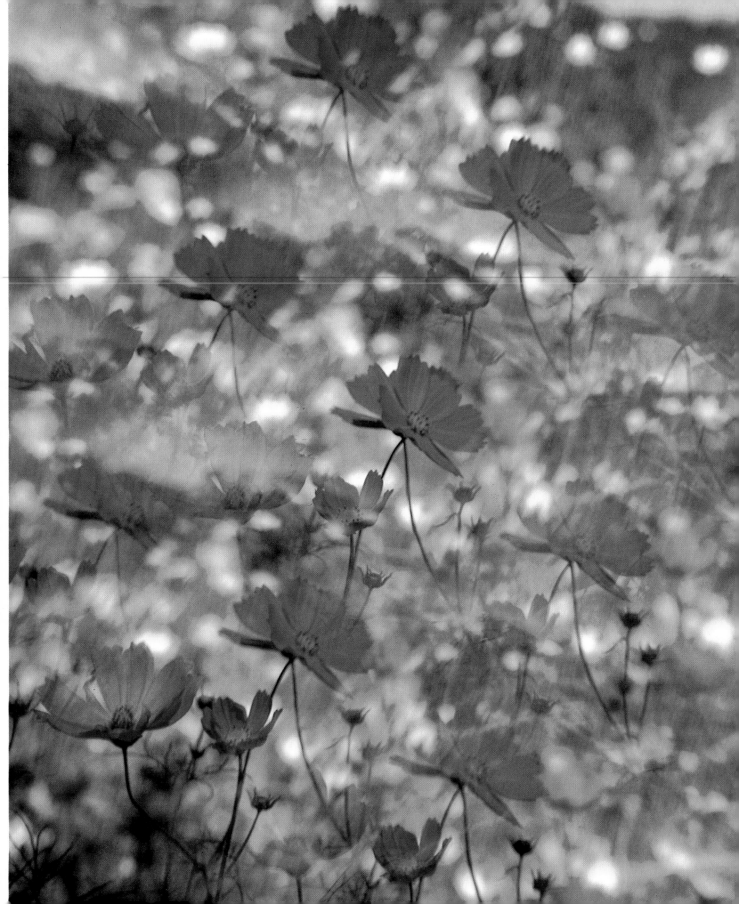

PHOTO ESSAYS

A photo essay is not necessarily a group of pictures that tell a story; it can also be a group of related images that reveal different aspects of a subject or theme. The purpose of the essay is that the images taken as a whole provide the viewer more information than any single picture can do on its own.

To make a successful photo essay the photographer must have sufficient understanding of the subject to portray more than merely its superficial qualities. This requires time as well as making a lot of exposures. Each picture in an essay should be more than just technically good; it must also show an interesting aspect of the subject and relate to the overall tone. A good photo essay should have at least one outstanding photograph, strong enough to stand on its own, which ties the whole essay together.

I feel that producing a picture essay is one of the more challenging assignments in photography. One can portray a feeling such as the serenity of life in the country, or convey one's impression of a single building or a whole city. The range of subjects is limitless.

Early in the 1930s I photographed young ballerinas at l'Opéra de Paris in a dimly lit rehearsal studio. The results were so beautiful and atmospheric that I dreamed of going back and doing a new picture essay. At last, in 1964, I did, but was greatly disappointed to find that the new rehearsal room had been equipped with fluorescent light. In my early pictures (like the one left) daylight coming through windows created beautiful patterns of light and shadow, but for this second series I had to make the most of the effects of the fluorescent light, which often tends to smooth everything out, giving flatter-looking results. In surveying the layout of the room, I found some background wall areas that were more interesting than others, especially those where the chandeliers could be lit, so I used those whenever I could. In the picture opposite, I saw a lone ballerina practicing under a large painting and waited to capture her in this pose, which complements the scene in the canvas. The pictures on these and the following two pages were taken hand-held with a rangefinder camera and 35-mm lens. Printing them on harder paper made the black-and-white photographs more "contrasty."

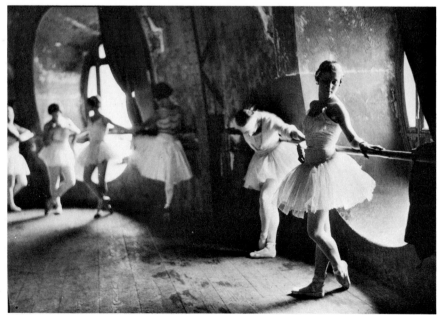

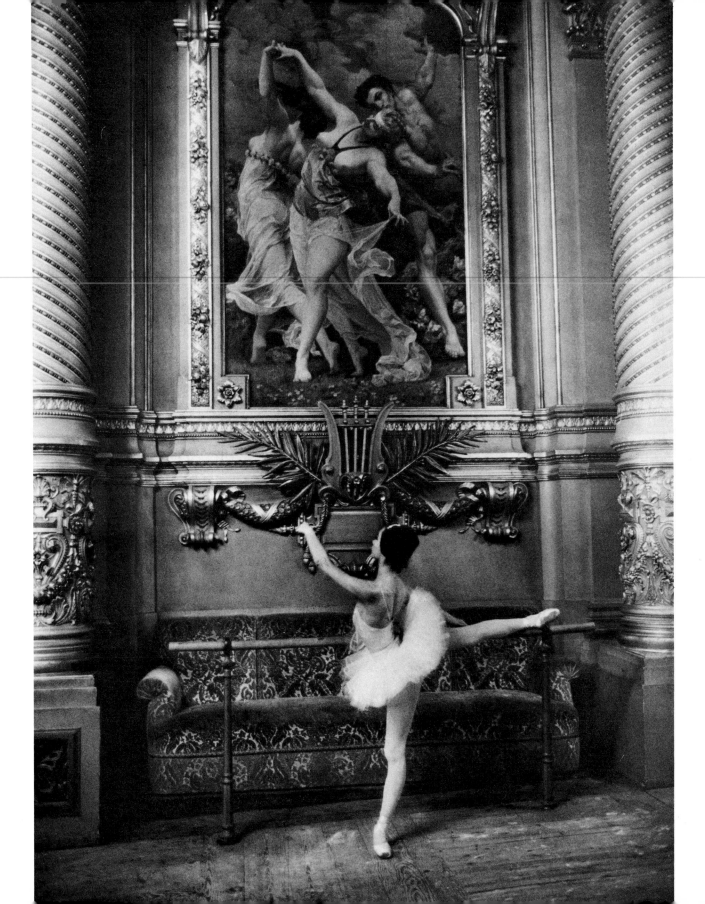

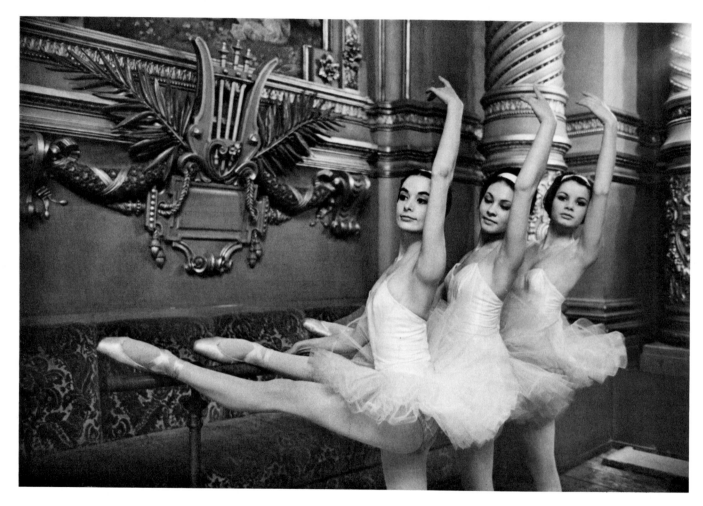

A photo essay is a group of pictures, each showing a different aspect of a specific theme. On the preceding page we see a lone ballerina. The photograph above shows a group of dancers going through their exercises, and the one opposite shows them during a break and also includes more of the atmosphere of the rehearsal room.

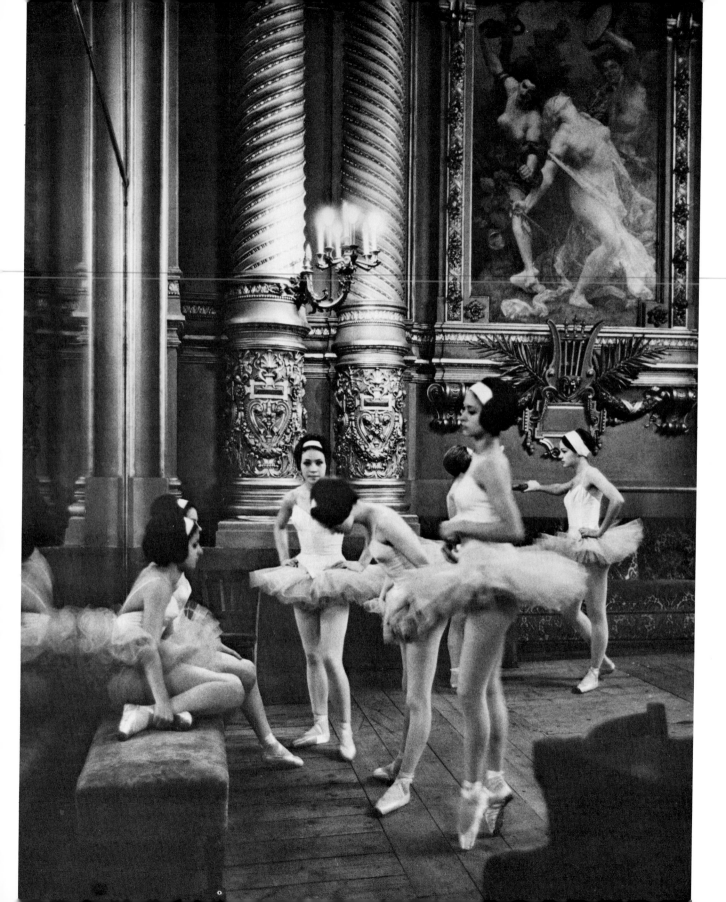

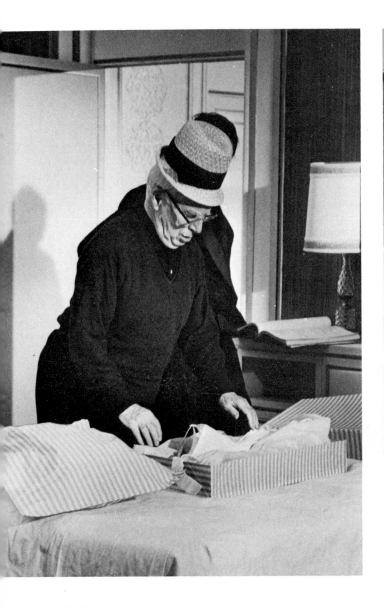
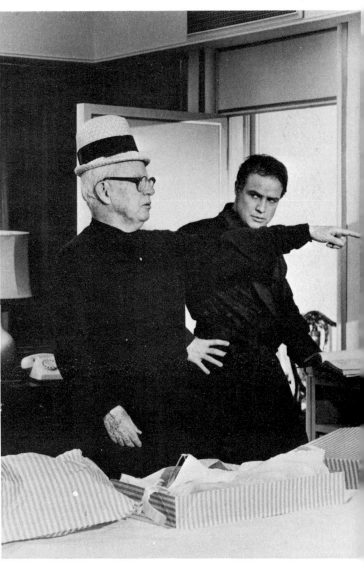

Charlie Chaplin was a master of mime. Here, as a director, he is showing Marlon Brando how to execute an amusing scene with Sophia Loren in The Countess from Hong Kong. In a photo sequence one must shoot quickly, as the most important thing is to capture the flow of events. These photos were taken in the Ealing studios near London.

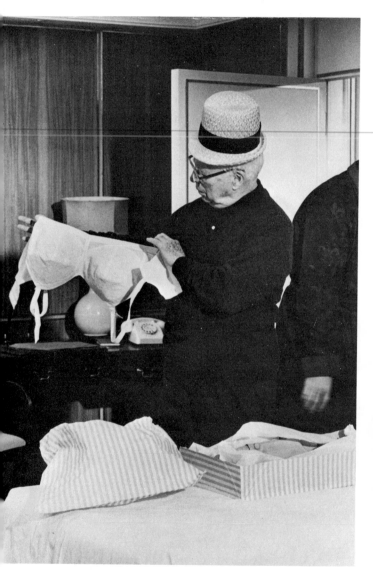
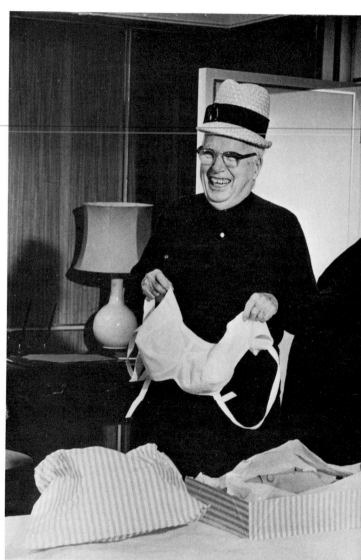

R. Allen & Co., butcher, Mayfair

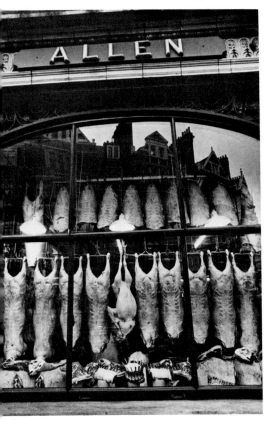

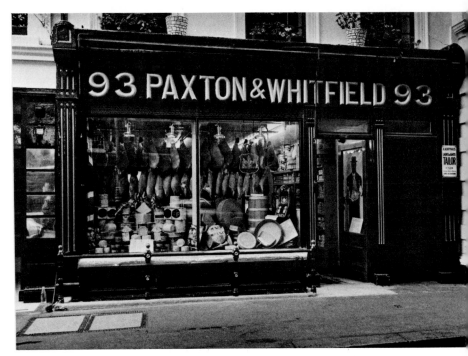

Paxton & Whitfield, cheese merchants, Jermyn Street

OPPOSITE: *John Lobb, bootmaker, St. James's Street*

These four pictures are from a series I did on stores in London that have established reputations for their excellence. Time of day was an important consideration. The picture opposite, for instance, had to be taken around eleven a.m. If it had been taken earlier the sun's image would have been reflected in the window pane, and later, the façades of the buildings opposite would have been in direct sunlight and their reflection would have been clearly visible in the pane. A 35-mm P.C. (perspective control) lens is very useful for architectural photography, and was used for most of these pictures, as it can prevent parallel lines from converging.

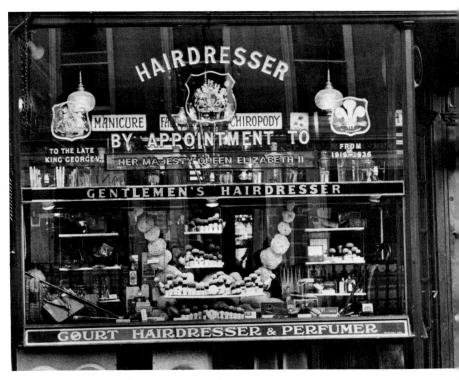

Trumper, men's hairdresser, Curzon Street

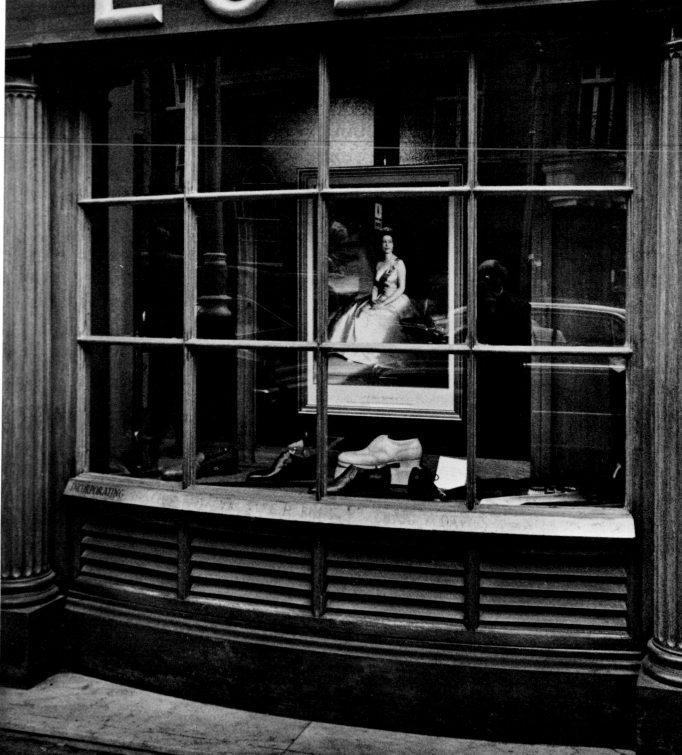

For years I have been interested in
photographing empty chairs in
natural settings. The ones shown here
were all taken at Oak Bluffs, Martha's
Vineyard, when I was not pressured
by a limited amount of time.

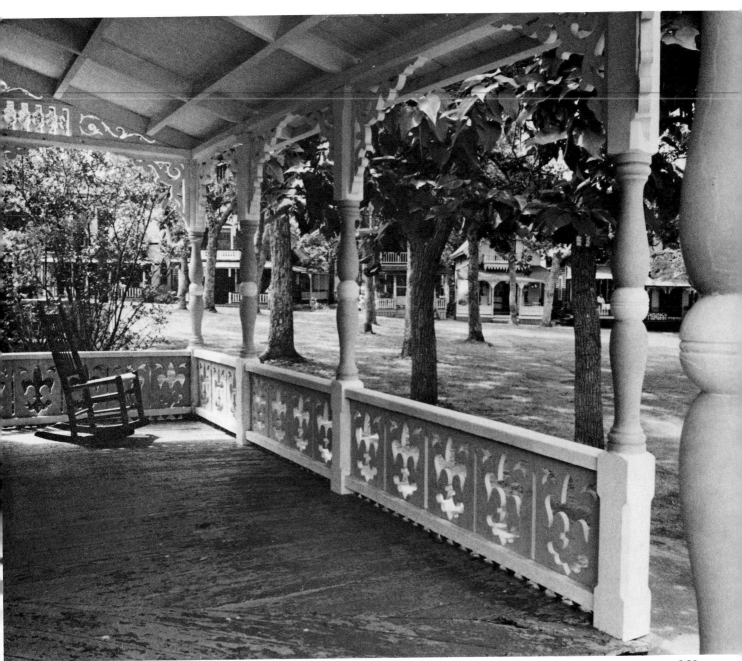

A GUIDE TO EXPOSURE

Modern cameras with built-in exposure meters make the selection of a correct exposure easy. However, understanding of the principles outlined below will enable you to exercise creative control over your photographs.

In order to get technically good results from photography, one must expose the film correctly. An overexposed picture will be too light and an underexposed one too dark.

The aperture is designated by f/ stops. The standard f numbers are: f/1, 1.4, 2, 2.8, 4, 5.6, 8, 11, 16, 22, 32, 45, and 64. Each increase in the f number reduces the size of the aperture, halving the amount of light passing through (i.e., an aperture of f/4 will allow through half the amount of light as f/2.8 and twice as much as f/5.6).

The shutter speed indicates the time in seconds, the standard times being: 1, 1/2, 1/4, 1/8, 1/15, 1/30, 1/60, 1/125, 1/250, 1/500, and 1/1000. Each setting is about twice as fast as the previous one.

The shutter speed and aperture are directly related, and various combinations of them can be used to produce the same exposure. For example, if the lighting conditions require an exposure of 1/125 second at f/8, but you want to stop or freeze the motion of a moving subject, you can obtain an equivalent by increasing the shutter speed to 1/250 second, halving the time, and opening the lens by one stop to f/5.6, doubling the intensity of the light. Conversely, if you wanted the greater depth of field obtained at f/11, you would have to compensate for the light loss by exposing for 1/60 second. All three settings— 1/60 second @ f/11, 1/125 second @ f/8, and 1/250 second @ f/5.6 —would give equivalent exposures.

If your exposure meter is out of order, you can achieve good results by following the manufacturer's instructions that come with the film. One rule of thumb worth remembering is that you can get a good exposure in bright sunlight by setting the aperture to f/16 and using the shutter speed closest to the ASA speed of the film being used (i.e., with ASA 64 film, use 1/60 second, with ASA 400 use 1/500 second, etc.).

FILTERS

I remember when filters were considered to be one of the most important of camera accessories. I now find that, with the improvements made in films over the years, I rarely use them any more. On the opposite page is a list of fairly common filters with the effects they were designed to produce.

Today the most useful filter I own is a polarizing filter, which can be used with black-and-white as well as color film. This filter is used to reduce reflections from nonmetallic surfaces such as water or glass, giving a richer saturation of color, as well as for darkening a blue sky. I also use a medium yellow filter with black-and-white film for a moderate darkening of the sky, emphasizing cloud formations. Occasionally I use a skylight filter with color film to add warmth to a beach scene by reducing the blue hue of the sky.

Filters for Color Film

Filter	Effect
Polarizing*	Eliminates or reduces reflections from nonmetallic surfaces, giving greater saturation of color, and darkens blue sky.
Skylight	Reduces blue hue and adds warmth.
Haze	Reduces the effect of ultraviolet light and can be used to protect the lens.

Filters for Black-and-White Panchromatic Film

Filter	Effect
Yellow	Darkens blue, thereby darkening the sky and emphasizing cloud patterns.
Green	Lightens foliage while slightly darkening blue sky.
Red	Darkens blue sky dramatically for extreme emphasis of cloud formations.

* May also be used with black-and-white film.

MISTAKES I HAVE MADE

The person who doesn't make any mistakes doesn't learn anything. Like every other photographer I know, professional or amateur, I have made every mistake imaginable. Below I have listed a few typical ones, which may help the reader avoid them.

Remove your lens cap before shooting (rangefinder camera). This sounds obvious, but it's a more common mistake than you'd expect. I remember photographing an Easter parade with a rangefinder camera from the roof of a building opposite St. Patrick's Cathedral. As I was looking down, a balloon vendor suddenly lost the grip on his balloons, which drifted up toward me. Excited at the prospect of an unusual photograph, I began shooting, only to find out later that I had captured nothing on film because the lens cap was covering the lens the entire time! If you use an SLR camera you will not have this problem, of course, because you view directly through the picture-taking lens.

In bright sunlight use your lens cap when you are not shooting. One bright sunny day I was waiting in the front seat of a car, with my camera on its strap around my neck. Later, after finishing the photo story I had come to do and the film was developed, to my horror I found that all my shots were fogged. The sun's image had been focused by the lens on the cloth shutter of the camera and had burned a small hole in it, allowing light to leak through onto the film.

Make sure the film is properly engaged in the take-up mechanism when you load your camera. Some years ago I took a lot of pictures of the silver anniversary of Prince Louis Ferdinand of Prussia completely unaware that the film had not been advancing at all. This is quite a common mistake if you are not careful. When loading the camera, visually check to see that the film is properly engaged by the sprockets and is inserted in the take-up spool. Close the back, advance a few frames, and release the shutter. Before advancing the film again, turn the rewind crank until you feel a firm resistance. Now advance the film. If the rewind knob turns as you advance the film, it is properly loaded.

Make sure the camera is loaded with film before you shoot. While covering the Bicentennial celebrations in Philadelphia, I took some interior shots that I was excited about and was sure would turn out well. Before leaving the building, I decided to reload the camera with a fresh roll of film, only to discover that there had been no film in the camera. So I had to go back and retake all the photographs.

Know the type of film you have in your camera. While photographing Marilyn Monroe years ago, I was using two cameras, one loaded with color film and the other with black-and-white. At some point during our session I got the cameras mixed, and only half the pictures were correctly exposed. My normal procedure, which I forgot that time, is to stick a piece of adhesive tape on the camera for identification. It is also a good practice to check that the exposure meter is set to the ASA speed of the film when you start photographing.

All the above mistakes were easily avoidable. The point is that when you are actually taking pictures, especially if you must work quickly, it is easy to overlook those little things that appear to be obvious.

GLOSSARY

Aperture: An opening, controlled by the diaphragm, which regulates the intensity of light passing through the lens to the film during exposure (see *f-stop*).

ASA (American Standards Association): A numerical rating which denotes a film's sensitivity to light. This ASA rating, which is printed on boxes and packs of film, follows direct arithmetic progression (e.g., a film with an ASA rating of 200 would be twice as sensitive to light as one with an ASA of 100).

Available light: Light which happens to be available in a scene to be photographed, obviating additional artificial light such as strobes or flood lights.

Back lighting: Lighting which illuminates the subject from behind, giving a silhouetted effect.

Blocked-up: Refers to highlight areas in a photograph which have received so much exposure that detail has been lost.

Blur: An unsharp image, intentional or otherwise, caused by either camera or subject movement at the moment of exposure. An area of the picture that is not in sharp focus will also be blurred.

Bounce light: Light which is reflected or bounced off a ceiling, wall, or other surface onto the subject. Such lighting produces a softer, less "contrasty" light than direct illumination.

Bracketing: A method used to obtain a correct exposure when it is not possible to ascertain the proper exposure. The normal technique is to make three different exposures; one at the assumed correct exposure, one overexposed, and one underexposed. Exposures should vary by one full f-stop for black-and-white films and by half an f-stop for color.

Camera angle (Viewpoint): The position of the camera in relation to the subject being photographed.

Catadioptric: (see **Mirror lens**)

Clogged: Refers to shadow areas in a photograph which have not received enough exposure to show detail.

Close-up lens: A filter-type attachment which increases the magnification of the subject without any loss in light reaching the film (see **Extension tubes**).

Color temperature: (see **Kelvin**)

Crop: To eliminate some unwanted portion of a print; generally to improve composition.

Daylight film: Color film designed for use in daylight or with a light source balanced to daylight (5400° K).

Depth of field: The area between the closest and most distant point which are in acceptably sharp focus. The smaller the size of the aperture, the greater the depth of field.

Diaphragm: A set of movable blades which provides for adjustment of the lens aperture.

DIN (Deutsche Industrie Norm): A numerical rating which denotes a film's sensitivity to light. Each number in the DIN rating indicates a 1/3 difference in sensitivity to light (e.g., a film of DIN 20° would be twice as sensitive as one of DIN 17°). The DIN rating, which is widely used in Europe, is printed on the film container along with its ASA equivalent.

Electronic flash: A portable artificial light source designed for use with black-and-white or daylight color film.

Emulsion: A light-sensitive solution which is applied to photographic film and paper.

Exposure: A combination of the intensity of light and the length of time it acts on the emulsion. The length of time is controlled by the shutter; the intensity is regulated by the aperture.

Exposure meter: A device that measures the intensity of light reflected from or falling on a subject and converts this information to a range of usable shutter-speed and aperture-size combinations.

Extension tubes: Metal tubes mounted between the camera and the lens to allow closer-than-normal camera-to-subject distances. Extension tubes reduce the amount of light reaching the film, requiring an increase in exposure. A through-the-lens metering system will automatically compensate for any exposure increase. (See also **Close-up lens** and **Macro lens**)

Film speed: (see **ASA**)

Flatness: Lack of contrast in a print or negative, generally resulting from flat or even lighting.

Flood light: A tungsten or quartz artificial light source.

Focal length: The distance between the lens and the focal plane of the camera. The shorter the focal length of a lens, the greater the angle of view covered.

Focal plane: The plane on which the image passing through a lens, set to infinity, is in sharp focus. This plane is at a right angle to the optical axis of the lens.

Focusing: Moving the lens in order to form a sharp image on the film.

f-stop: The relative aperture of the lens. (See p. 171.)

High key: A type of photographic print in which there are predominantly light tones.

Highlights: The bright areas in a photograph.

Incident light: The light that falls on a subject. Incident light can be measured by an incident-light meter pointed away from the subject and toward the camera position. Reflected-light meters often have an accessory enabling them to measure incident light.

Kelvin: A scale of measurement used to indicate the color temperature of a light source. Daylight has a color temperature of 5400° Kelvin while the yellower light from a tungsten bulb is rated at 3200° K. This system is based on the color of light emitted from a filament that has been heated to specific temperatures.

Latent image: The invisible photographic image produced on the emulsion by exposure and made visible by developing.

Lens shade: A device attached to the front of the lens which helps to prevent unwanted light from striking the surface of the lens.

Light meter: (see **Exposure meter**)

Low key: A type of photographic print in which shadow tones predominate and there are only a few highlight areas.

Macro Lens: A lens which can be used for photographing all the way from infinity down to very close distances. With some macro lenses it is possible to photograph an object at one-half life size (1:2 ratio) without additional attachments.

Mirror (catadioptric) lens: A lens constructed with mirrored surfaces which allow for a very long focal length in a compact size.

Monopod (Unipod): A camera support with a single telescoping leg. A monopod is more compact and maneuverable than a tripod but less steady. It is convenient to use when photographing from a sitting position.

Panning: A technique which reinforces the feeling of movement by keeping the subject sharp while causing the background to blur. The camera is swung, keeping the moving subject in the desired position within the frame while the shutter is released.

Parallax error: The difference between the image as seen by the picture-taking lens and by the photographer looking through the camera's viewing system. This slight difference is most apparent when the camera-to-subject distance is short. The only viewing systems completely free of parallax error are those in which you view directly through the picture-taking lens.

Perspective Control (PC) lens: A lens which can be shifted off center, allowing a degree-perspective correction. Such a lens is useful in architectural photography to minimize the convergence of parallel lines which occurs when the camera's lens is not perpendicular to the subject.

Rangefinder camera: A camera with an optical device used to measure the distance to a subject. The rangefinder is commonly coupled with the focusing of the lens so that the subject is in focus when the two images in the rangefinder are aligned.

Reflex camera: A camera which uses a mirror to reflect the image onto a screen for focusing and viewing.

Relative aperture: (see **f-stop**)

Shutter: A mechanical device which controls the length of time that light is allowed to reach the film during exposure. (See p. 171.)

Spot meter: An exposure meter capable of taking a reflected-light reading within a very narrow angle of view. This type of meter is good for taking a reading of distant objects.

Telephoto lens: Used to get a larger-than-normal image of the subject without changing the camera position. For a 35-mm camera a lens with a focal length of 90 mm or more would be considered a telephoto lens.

Tripod: A three-legged camera support, which is essential when the camera must remain still during long exposures.

Tungsten film: Color film designed for use with tungsten light of 3200° K.

Unipod: (see **Monopod**)

Wide-angle lens: A lens covering a wider-than-ordinary angle of view, used to include more of a scene without changing the camera position. For a 35-mm camera, a lens with a focal length of 35 mm or less would be considered a wide-angle lens.

Zoom lens: A lens with adjustable focal length.